YAN JIAQI
and
CHINA'S STRUGGLE
for DEMOCRACY

CHINESE STUDIES ON CHINA

THE CHINESE COMMUNIST PARTY'S NOMENKLATURA SYSTEM
Edited by John P. Burns

THE ASIATIC MODE OF PRODUCTION IN CHINA
Edited by Timothy Brook

BASIC PRINCIPLES OF CIVIL LAW IN CHINA
Edited by William C. Jones

MAO ZEDONG ON DIALECTICAL MATERIALISM
Edited by Nick Knight

ZHU WEIZHENG
COMING OUT OF THE MIDDLE AGES
Translated and edited by Ruth Hayhoe

ANTHROPOLOGY IN CHINA
DEFINING THE DISCIPLINE
Edited by Gregory Eliyu Guldin

YAN JIAQI AND CHINA'S STRUGGLE FOR DEMOCRACY
Translated and edited by David Bachman and Dali L. Yang

YAN JIAQI
and
CHINA'S STRUGGLE
for DEMOCRACY

Translated and Edited, with an Introduction,
by **DAVID BACHMAN** and **DALI L. YANG**

M. E. Sharpe, Inc.
Armonk, New York London, England

Available in the United Kingdom and Europe from M. E. Sharpe,
Publishers, 3 Henrietta Street, London WC2E 8LU.

Library of Congress Cataloging-in-Publication Data

Yan Jiaqi and China's struggle for democracy / edited and translated, with
 an introductory essay, by David Bachman and Dali L. Yang.
 p. cm. — (Chinese studies on China)
 Includes bibliographical references and index.
 ISBN 0-87332-780-2. — ISBN 0-87332-781-0 (pbk.)
 1. Yen, Chia-ch'i—Political and social views. 2. China—Politics and
government—1949– 3. Democracy. I. Bachman, David M. II. Yang,
Dali L. III. Series.
JC273.Y46Y36 1991
320'.092—dc20
 90-9051
 CIP

Printed in the United States of America

HA 10 9 8 7 6 5 4 3 2 1

This volume was prepared under the auspices of the
CENTER OF INTERNATIONAL STUDIES
Princeton University

Contents

DAVID BACHMAN AND DALI L. YANG

Introduction: Yan Jiaqi and the Chinese Democracy Movement

The careers of reformers in contemporary Chinese politics have not been characterized by successes.[1] Over the course of the twentieth century, three types of reformers have sought to bring about reform in China. The first type is the foreign adviser.[2] Though significant in many ways, the foreigner as agent of change in China is not central to the discussion here.

A second type of reformer is that of the "outsider" to the existing political system. The outsider invokes a moral critique of the existing regime, suggests ways that morality might be restored, demands fundamental changes in the system, and counts on the system to transform itself once its errors have been brought to its attention.[3] In the People's Republic of China, the outsider as reformer generally starts as political insider but gains, often reluctantly, his status as outsider because he is forced out of the system by the Chinese Communist Party (CCP) for views the system is not prepared to tolerate. Sometimes the outsider reformers also engage in various social or economic experiments in an effort to demonstrate that theirs is the correct course for the nation.

Finally, the majority of reformers in China in recent years are those who occupy positions of authority in the existing system and attempt to influence the evolution of the political system from within. These insiders face formidable political constraints and obstacles; nonetheless, their experiences are no less a part of reform politics than are those of the outsiders.

For their bold criticisms, their often extreme degrees of courage in baldly stating the failings of the regime (knowing full well that the regime does not deal kindly with its critics), and their outspoken support for Western values, the outsider reformers have so far received the most attention among Western scholars and journalists. Their criticisms of the regime, showing above all their concern with the cultivation, elaboration, and development of alternative potentialities in an oppressive society, are seen as proof of their intellectual status, and appear similar to the tensions characterizing relations between intellectuals and power in the West.[4] These external critics are regarded, at home and abroad, as the intellectual keepers of social conscience.

In contrast, reformers working to change the system from within have received much less attention, and are valued somewhat less by outside observers. Implicitly, they are seen as mere bureaucrats willing to compromise, not real "intellectuals" with a conscience. The compromises among integrity, influence, and access which insiders must make to retain their positions is felt no less clearly in Beijing than in Washington. To retain access, the insider must soften his criticisms, or "pull his punches." While speaking truth to power is a noble ideal, rarely in any government is it ever consistently followed by policy advisers. Yet this pressure to temper one's remarks may be so invidious that the adviser loses his sense of perspective, and remains mute too often.[5] Instead of a bold, comprehensive moral critique, the insider must advocate change at the margins of policy developments, in an ad hoc manner, facing the formidable constraints imposed by political leaders who are opposed, for policy and personal reasons, to the proposed changes. If the outsider as reformer is the moral critic, the insider, to be effective, is and must be the politician. Even then, the insider as reformer may still be in a precarious position. Political leaders facing political trouble may turn on their advisers as scapegoats in efforts to retain their leadership positions. At that point, the insider has no choice but to take the outsider path to reform. Indeed, few are outsider reformers who have not expe-

rienced the agonies and frustrations of seeking to change the system from within.

Because the insider works within the rules of the political game, and because those rules in China still prescribe opaqueness about internal decision making, the role and activities of insiders as reformers are doubly difficult to determine. Not only do insiders use veiled rhetoric and adopt a compromise or consensus-building strategy of reform-mongering, which may seem quite trivial to outside observers, but the system still requires that much of its activity is privileged, and should therefore not be reported at all. Data limitations thus reinforce the relative lack of attention to the careers of insiders.

Until he broke with the CCP in May 1989, Yan Jiaqi, China's foremost political scientist, was a reformer largely working within the existing structure of power in China. Yan's political personality had outsider elements to it, but arguably his influence was felt most strongly in Chinese think tanks and the centers of power. Since the Beijing Massacre of June 3–4, 1989, and the subsequent repression of the population, Yan has escaped from China, and, as president of the newly formed Front for a Democratic China (*Zhongguo minzhu zhenxian*), is one of the principal leaders of the opposition movement. Yan is no longer a reformer; he hopes for a democratic revolution. Not surprisingly, the CCP has denounced Yan and his writings, and no doubt would take extreme measures if he fell into the regime's hands.[6]

Yan Jiaqi is less well known to Westerners than are such dissident/opposition figures as Fang Lizhi, Liu Binyan, and Su Shaozhi.[7] Partly this is because Fang, Liu, and Su were forced to become outsiders earlier than was Yan.[8] Partly this is because the latter figures have had more of their work translated into English. Fang Lizhi's blunt outspokenness captured the interest of foreign reporters and academics. The literary quality and poignancy of the works of Liu Binyan and Wang Ruoshui, another prominent dissident, which forced readers in China and the West alike to confront the nature of communist rule on several levels, attracted much attention.[9] Even Su Shaozhi, whose role in the political

system and the reform process most nearly resembles Yan Jiaqi's, was much better known than Yan because of Su's ambitious attempt to redefine Marxism (reformist Marxism with Chinese characteristics) in order to provide the basis for reform in China.[10]

If Yan Jiaqi was not well known to the public in the West prior to the Beijing Massacre, he was well known in China. Yan and Gao Gao's (his wife) book *"Wenhua da geming" shinian shi* (A History of the Ten-Year "Cultural Revolution") was a cause célèbre in China, as conservatives tried to suppress the work, the first extensive history of the period to be published in China. It sold 800,000 copies on the mainland alone, and has been published in Hong Kong, Taiwan, and translated into Japanese, Korean, and English. Another one of Yan's books, *Shounao lun* (On Heads of State), ran through six printings and 310,000 copies on mainland China alone. It was a best seller and won a number of prizes on both the mainland and Taiwan.[11] In short, prior to his flight into exile, Yan Jiaqi, author or coauthor of ten books, was a widely read and highly influential reformist intellectual, and one who was closer to the centers of power than were other better known dissident/reformers.

I

Yan Jiaqi was born on Christmas Day, 1942, in Jiangsu Province.[12] In 1959, he entered the newly founded Chinese University of Science and Technology, where Fang Lizhi, six years Yan's senior, had just started teaching. He majored in basic particle physics, graduating in 1964. But Yan's career as a natural scientist ended before it began.

After the disastrous Great Leap Forward of 1958–60, the Chinese leadership returned to a more conventional Leninist approach to economic development. These and other developments increasingly distressed Mao Zedong and his allies. One of Mao's efforts to return the political and economic systems to a path he was more comfortable with was to launch a series of philosophi-

cal debates on the general issue of the relationship between "idea" and "existence." The most important aspect of the debates concerned the question of whether "two combined into one" or "one divided into two." Mao saw this seemingly arcane aspect of dialectics as crucial. If the two elements of a contradiction combined into one synthesis, then there was no point in struggle. Combination and integration were the fundamental processes of life and development. But if Mao's position, one divided into two, prevailed, then struggle was a constant. There was no such thing as stability. Flux was the basic aspect of existence.[13]

Whether Yan was aware of the broader political implications of the on-going debates on philosophy in the early 1960s is unclear. These discussions did capture Yan's attention, and in late 1963 and early 1964, he published two essays on dialectics, one in *Renmin ribao* (People's Daily), the official CCP newspaper. It was not a small achievement for a college student to be published in the official national paper, and Yan's essays attracted the interest of Yu Guangyuan, then the director of the science section in the party Propaganda Department and a senior research fellow in the Institute of Philosophy of the Chinese Academy of Sciences.[14] Yu encouraged Yan to apply for postgraduate work in philosophy in the Philosophy and Social Sciences Division of the Academy of Sciences. Yan obliged and was successful in the graduate entrance examinations.

Upon admission, Yan studied with Yu and Gong Yuzhi,[15] focusing on the dialectics of nature. How much studying he did, however, is open to question as Yan was almost immediately dispatched to rural areas in Hubei and Beijing to take part in the ongoing campaigns in the countryside. At the end of May 1966, Yan returned from the countryside to Beijing as the Cultural Revolution (CR) was erupting. Mao and his allies had just removed the mayor of Beijing, Peng Zhen, from power, but the mass demonstrations and the formation of the Red Guards characteristic of the CR had not yet developed.

For the twenty-three-year-old Yan, as with millions of his

countrymen and women, the CR was a profoundly shaping experience, though Yan appears to have survived the "ten years of turmoil" relatively unscathed. Upon his return to Beijing, Yan was assigned to an editorial committee compiling a work entitled *Quotations on War and Revolution*, containing excerpts from the works of Marx, Engels, Lenin, Stalin, Mao, and Lin Biao, the commander of the Chinese army. As Yan noted in later years, his return to Beijing in May 1966 marked a move from the "kingdom of philosophy to the kingdom of theology" (i.e., the Mao cult).

Yan's assignment to the editorial committee reflected political trust placed in him and his colleagues. The social and political turmoil into which Mao had plunged China during the CR soon led Yan to question the established Maoist orthodoxies, though he could not express his questioning in public. From 1967 to 1971, Yan borrowed banned books from friends, reading widely in the areas of world history and biography, Western political theory, and pre-1949 Chinese history. These readings would form the basis for Yan's later works on comparative leadership and ideas on political reform. He was also a careful observer of what was going on and avidly collected the numerous pamphlets and booklets put out by Red Guard groups. This material would be the primary sources for his book on the CR.

In 1970, Yan was dispatched to a May Seventh Cadre School in Henan that housed colleagues from the Philosophy and Social Sciences Division for reform through labor. He and his wife returned to Beijing in 1972, after the fall of Lin Biao. During the next four years, Yan was occupied with two tasks. The first, apparently his official duty, was to study and write about energy and energy policy. With the rapid rise in world oil prices in 1973 and China's own surge in oil production, the Chinese leadership became increasingly concerned with energy issues. Yan's study (in collaboration with others), published by China's Science Press in 1976, thus filled an apparent need. In the meantime, drawing upon his broad readings, Yan was busy preparing a manuscript on "The Question of Political Systems in Socialist Theories."[16]

II

As with all Chinese citizens, Yan's work was interrupted by the tumultuous developments of 1976, culminating with Mao's death in September, and the arrest of Mao's closest followers, the Gang of Four, in October. China's widely respected premier, Zhou Enlai, had died in early January 1976. Seizing the political initiative, the radical Gang insisted that only minimal funeral arrangements be made for Zhou, leader of the moderate faction. Many Chinese people were widely affronted by the lack of respect paid to Zhou, and they used the traditional festival of *Qingming* (Pure Brightness), when Chinese pay respect to their ancestors, to honor Zhou's memory. Between March 25 and April 7, a series of spontaneous demonstrations burst forth throughout the country, with the ones in Beijing receiving the most attention. There, in what later became known as the April Fifth Movement, ordinary citizens in the thousands flocked to the Monument of the People's Heroes in Tiananmen Square to express their affection for Zhou and Deng Xiaoping and their anger at the Gang, and implicitly, Mao. For the short term, the demonstrators were suppressed, and Deng Xiaoping was blamed for the protests and purged, but for the longer term, this April Fifth Movement marked the political death knell for the Gang.

Yan Jiaqi was an avid chronicler of the mass movement in Beijing. He snapped photographs, copied poems, and recorded the activities of the people in Tiananmen Square. "On Tiananmen Square," Yan later wrote, "I breathed the fresh air of science and democracy that is lacking in the entire kingdom of theology."[17] Deeply moved by the spectacle of people power that was unfolding before his eyes, Yan, on the spot, resolved to write a history of the movement.

Not until after the fall of the Gang of Four was Yan able to begin writing his history of the April Fifth Movement. He spent most of the year from November 1976 to the end of 1977 tracking down and interviewing participants in the movement. But until late 1978, the April Fifth Movement was still branded a

counterrevolutionary incident, and Yan's work could not be pub-
lished. As part of Deng Xiaoping's efforts to achieve preeminent
power in late 1978, the "verdict" on the April Fifth Movement
was reversed, and Yan, joining with several collaborators, pub-
lished a small book entitled *A True Record of the April Fifth
Movement* on the movement's third anniversary. As an indication
of what was to come in his later studies, Yan and his collabora-
tors called for "guaranteeing the people's rights of supervision
over leading cadres at all levels."[18]

The year 1978 marked a watershed for China's philosophical
circles. Beginning in May, an officially sanctioned discussion of
"practice as the sole criterion of truth" unfolded, in connection
with Deng Xiaoping's attempts to undermine the remaining Mao-
ists in power.[19] Yan took part in these discussions and used his
readings in comparative history and political theory to good ad-
vantage. Since the political and intellectual atmosphere was still
far from ripe for direct discussions of political reform, Yan wrote
a "philosophical short story," taking an imaginary trip in time to
visit three legal courts. First he travelled to Italy in the seven-
teenth century to witness the trial of Galileo—the "court of reli-
gion." He then visited the eighteenth century French *philosophes*,
to understand the "court of reason." Finally he traveled into China's
future to visit the "court of practice." China's professional philoso-
phers were unimpressed by Yan's thought exercise, but, when it was
published in *Guangming ribao* (Illumination Daily), the newspaper
aimed at China's intellectual readership, Yan's story drew broad
support for its bold advocacy of the pursuit of truth, and was soon
released in book form.[20]

One result of the growing intellectual ferment in China in
1978–79 was the establishment of the Chinese Academy of So-
cial Sciences and the resurrection of various social science disci-
plines. At a meeting in February 1979, emboldened by the
meeting-room exchanges, Yan delivered a speech about the need
to study the political systems of socialist states from the perspec-
tive of political science. Drawing on his studies done in the early
1970s, he advocated that the "lifetime tenure" system of leader-

ship in socialist states was incompatible with their nominal status as republics. Most of China's important social scientists were in the audience, and Yan's speech was widely praised.[21] After the meeting, Yan elaborated his thoughts on democracy in another story of time travel, visiting the court of Louis XIV, seventeenth-century England, and the United States in the future, where he had a discussion with a fictional president of the American Political Science Association, Richard Bruce. These discussions reinforced Yan's views on the need to establish fixed terms of office in socialist states, something that would be a major theme in Yan's writings over the next three years. Indeed, Yan's strong advocacy for limited terms of office so aroused the party ideologues that at least one investigation was made into Yan's political activities in this period.[22] Moreover, a number of Yan's speeches at this time found their way into "Democracy Wall" publications in late 1978 and early 1979. While Deng Xiaoping originally sanctioned the free expression taking place in Beijing in late 1978, when it was largely aimed at his political rivals, he cracked down on the democratic activists after he consolidated power, beginning in March 1979. Yan's participation in this movement may have put him at political risk.[23] But it was also in connection with his advocacy of limited tenure for China's leaders that Yan met Bao Tong, who was soon to become Zhao Ziyang's effective chief-of-staff.[24]

Throughout 1980, the Academy of Social Sciences laid the groundwork for the study of political science in China, which heretofore had not been part of university curricula, and had been seen as a "bourgeois" field of scholarship, not applicable to China.[25] By the end of the year, the Chinese Political Science Association was established, and Yan was elected one of its executive directors, though his primary affiliation continued to be with the Institute of Philosophy. Not until May 1982 was Yan, with the blessings of Yu Guangyuan, still one of China's leading social scientists, transferred to work in the provisional Institute of Political Science, where he was charged with preparatory work for the institute's formal establishment.

Yan Jiaqi was named director of the Institute of Political Science when it was formally established on July 6, 1985. At the age of forty-three, he was the youngest director of a research institute at the Chinese Academy of Social Sciences. As China's leading political scientist, he travelled widely abroad, meeting his counterparts in other nations. In the Hong Kong edition of Yan's intellectual biography, for example, Yan is pictured at the 1985 International Political Science Association meeting, as part of a group which included three presidents of the American Political Science Association, Philip Converse, Richard Fenno, and Aaron Wildavsky. Other pictures include Yan meeting with Ronald Reagan, Samuel Huntington (Harvard University political scientist), and Billy Graham (evangelical religious leader).

Despite what might be called the diplomatic aspects of his appointment as head of the institute, Yan continued to publish regularly. His controversial history of the Cultural Revolution appeared in 1986, as did his study of comparative leadership. In 1987, a book entitled *Quanli yu zhenli* (Power and Truth) containing a selection of Yan's shorter essays (from which a number of the translations in this volume originate) appeared. His intellectual autobiography was published in Hong Kong in 1988. In scarcely a decade's time, Yan had established one of the strongest publication records among the community of social scientists in China.

Perhaps equally important in light of later developments, in the fall of 1986, Yan was appointed one of four deputy directors in the Political Structure Reform Research Group of the party Central Committee, under the directorship of Bao Tong. The research center was one of the most important think tanks serving Hu Yaobang and later Zhao Ziyang and Yan's appointment to this body reportedly came at the direct instigation of Zhao and Bao Tong.[26] Yan's work in this body is not detailed. Although he could advocate his reform proposals in meetings and internal publications, he was effectively forbidden to publish his personal views on the reforms because of his insider status.

In early 1987, in the aftermath of Hu Yaobang's forced re-

moval from office for not combatting "bourgeois liberalization" sufficiently, Yan was under political fire. As the current regime argues:

> Yan Jiaqi was investigated by the department concerned [presumably the party Discipline Inspection Commission]. He immediately sought assistance from Bao Tong and wrote a letter to Bao to defend his mistakes. On March 20, Bao Tong wrote a report in the name of the Central Political Structural Reform Research Group to Zhao Ziyang, saying that Yan Jiaqi's problems that were being investigated were not true but "were just based on unfounded rumors," and saying that Yan Jiaqi "always observed discipline" [an indirect way of saying Yan was a CCP member] and should be kept in the political structural reform research group to continue his work "as usual." Comrade Zhao Ziyang immediately expressed agreement with this and wrote an instruction to the responsible [organ] concerned. Thus, Yan Jiaqi was shielded and kept in a key position.[27]

Despite his important work as an insider, Yan found his political work stifling, and yearned for the days when he could air his views more freely. While he was able to publish a number of provocative writings in 1986, the only significant piece of writing he published in 1987 was an official exegesis on the meaning of the separation of party and government (see Text 10 in this volume). Frustrated that his ideas for political reform were not adopted, let alone implemented, he wanted to be a scholar who could publish and exchange views with his foreign counterparts. True to his devotion to the right of critical thought, Yan resigned from the post of deputy director of the prestigious research group in late 1987.[28] It was an unusual move in a country where people prize political positions and the perquisites associated with them. In 1988, Yan spent the first two months of the year in the United States, much of the time at the University of Michigan.

Yan did not advocate limited terms of office just for others, but abided by this principle himself. In mid-1988, despite attempts by the academy leadership to persuade him to stay on and his popularity with colleagues, Yan decided not to seek reelection to the directorship of the Institute of Political Science after having served for

two terms. Against a background of rampant official corruption in the Chinese body politic, Yan's rather unconventional step was highly regarded in the Chinese intellectual community.

III

Mid-1988 marked the high point in reforms under Zhao Ziyang, and it is quite possible that Yan (despite his lack of high official position) was heavily involved with the formulation of political reform proposals that were seen by leading reformers as necessary ingredients to making economic reform work. In the fall of 1988, however, surging inflation and other economic difficulties forced a retreat from the deep, rapid price reforms that had just been attempted. Moreover, within the top leadership, Zhao Ziyang, CCP general secretary and prime mover behind the reforms, was gradually forced not to interfere in the economic realm. Instead, Premier Li Peng, widely regarded as a much more cautious and conservative figure, began to institute a full-fledged economic retrenchment program with the support of conservative forces within the party.

Yan and other reformers were very concerned by the retreat from price reform, fearing that it was a retreat from reform in general. Yan made his dissent with official policy known in a widely publicized discussion with another well-known reformer, Wen Yuankai, a professor at the Chinese University of Science and Technology (Yan's alma mater) in December 1988 (included here as Text 16). Yan and Wen both warned that unless the reforms continued, China would stagnate, just as the Soviet Union had under Leonid Brezhnev's rule (1964–82). Frankly critical of those who wished to retrench, Yan and Wen feared that General Secretary Zhao Ziyang would be removed from office through extralegal means by those who only sought power. This forceful criticism of the official policy of retrenchment and attacks on the motives of unnamed party figures would later be held against them by the current regime.[29]

Yan's dialogue with Wen Yuankai marked a turn in Yan's thinking. Impelled by a moral outrage at the Chinese leadership

and a strong sense of social obligation, Yan's role more clearly resembled that of a moral critic of the regime. He expounded on the lack of social justice in China and advocated that democratic politics is the politics of responsibility (see Texts 18 and 19). In a Tokyo interview that was widely printed in the overseas Chinese press, Yan, defying the authority of the Chinese Communist Party, argued that there should not be another government (that is, the Politburo) above the formal government. Instead, he called for the abolition of the Politburo.[30] Thus, at a time of impending social and political crises, Yan resolutely took up the intellectuals' duty to society that has long been sanctioned in Confucianism, rather than abiding by the discipline of the CCP.

On April 15, 1989, Hu Yaobang, former general secretary of the CCP, died of a heart attack, precipitating the student-government confrontation that culminated in the massacre. Yan was not actively involved in the early stages of the demonstrations, but sought to make his views known through the more reform-minded journals, such as *Shijie jingji daobao* (World Economic Herald) and *Xin guancha* (New Observer).[31] His words in April may have encouraged the students, or so the current regime claims.

On April 19, Yan argued at a forum sponsored by *Shijie jingji daobao* and *Xin guancha* that the protests about restoring Hu Yaobang's reputation were correct. He sensed that China was then in a situation that was similar to the one that precipitated the April Fifth Movement in 1976. Drawing on that parallel, he called on China's top leadership to heed the aspirations of the people. In a prophetic statement, Yan was reported as saying:

> At present the people's wish is very simple. Comrade [Hu] Yaobang was treated unjustly. If a correct appraisal is not made, problems may still arise. In 1976 we spoke up for Premier Zhou Enlai and Deng Xiaoping and everyone did his bit, so that Deng Xiaoping was able to resume his duties. Today we place our hopes in the Party Center that, in the interests of the people and the future of the country and for the development of democracy, it will make a fair assessment of Yaobang. If it selflessly recognizes its errors, I feel China has prospects. If not, the old disastrous road lies ahead. I don't feel

that China is hopeless, but on the contrary has great prospects. At Tiananmen Square I saw China's future and I saw the will of the people. The Chinese people's cohesion vis à vis the Chinese Communist Party is also evident.[32]

These and other statements were carried by the liberal *Shijie jingji daobao*. Copies of issue no. 439 carrying Yan's statement were subsequently banned from circulation by the Chinese government.

On April 21, at the urging of Bao Tong, Yan and Bao Zunxin, another reformist intellectual, wrote an open letter to the authorities praising the positive and democratic actions of the students. This, it is said, greatly inspired the students. He issued another open letter criticizing the banning of *Shijie jingji daobao*, and he apparently mobilized intellectuals to come to Zhao's aid.[33]

Yan was very excited by the changes in the media taking place under Zhao Ziyang and Bao Tong's auspices, including the lead article in the May 12 edition of *Renmin ribao* which praised human rights and checks and balances in the government structure. He had often articulated such a view, and may have contributed in some way to the article itself.[34] While a number of insiders expected this article and the authorized press freedom to end the student protests, they miscalculated. When in fact the protests grew, as student hunger strikers occupied Tiananmen Square on May 13, Yan sided with the people against Deng Xiaoping and Li Peng. He and a number of other intellectuals demanded that the authorities grant the students' demands on May 14, and this was broadcast and published on May 15.

On May 15, the day Mikhail Gorbachev arrived in China, Yan led China's intellectual circles, and in particular, a number of China's social scientists, in joining the student protestors. He penned the May 17 Declaration (Text 20), which demanded Deng Xiaoping's resignation, and the creation of democracy in China. While still supportive of Zhao, Yan had basically broken with the regime, as he saw the spirit of democracy he first witnessed in Tiananmen Square in 1976 revived and thriving in the

square once again. Once Zhao lost power and martial law was declared on May 19, Yan's break with the CCP was total, as the documents in this volume demonstrate (Texts 20–26).

With the bloody suppression of the people and the subsequent political crackdown, Yan and his wife, Gao Gao, were able to escape from China with the help of friends, travelling first to Hong Kong and then to France. It was an escape that Yan and Gao describe as the most moving and arduous episode in their life. In his exile, Yan has been elected president of the newly formed Front for a Democratic China (based in Paris).

A number of Yan's comments on the massacre are contained here. Many of these are written in great anger, but they also contain arguments which Yan had been making for ten years about the need to democratize politics in China and to institute the rule of law. The fundamental difference in Yan's position is that now he must act as a revolutionary to bring about these changes in a peaceful way, not as a political insider.

IV

The corpus of Yan's writings are broad and diverse. Directed at the pressing issues and challenges faced by China, these writings are the work of someone who had lived through forty years of communist rule and who read and thought deeply about Chinese history. Scholars may take issue with certain of Yan's arguments. Yet even those arguments that are in doubt should be taken seriously, for they represent how one of China's leading thinkers looks at China and the process of political change.

No short summary of Yan's writings will be attempted here. Rather, several of the themes that recur throughout this collection will be briefly discussed. The transition from traditional to modern types of rule, the rule of law, and democratic government are important themes in the translations presented in this volume and they raise the fundamental question of how to create and expand the scope of civil society in a country where the party-controlled state has long been dominant. Yan's intellectual enterprise begins

with his attempt at understanding traditional Chinese politics (both in the imperial and the modern periods). At times he attempts to elucidate the fundamental characteristics of traditional rule and the characteristic failures and crises created by such rule, such as lifetime tenure for the ruler, the nonindivisibility and the nontransferability of power of the sovereign (see Texts 1, 2, and 14). Relatedly, he criticizes traditional political culture, with its assumption of superiority, its denigration of foreign things, and its unwillingness to face up to its backwardness (Texts 9, 11, and 17). For Yan, many, if not all of these points, are as applicable to China under the CCP as they were to China under the imperial system. One continuous thread in his analyses is the concept of omnipotent or unconstrained power, which both the imperial official and the communist cadre have used to their advantage and to the detriment of civil society (Text 13). Indeed, on breaking with the regime in May 1989, Yan made clear that he considered Deng to be an emperor, and that the current Chinese political system still reflects its imperial past (Texts 20, 24, and 25).

To move from traditional to modern politics, Yan argues for both incremental and fundamental changes. The two should not be understood as contradictory, but reflect the insider versus outsider roles that Yan has assumed during different periods. For Yan the reformist official, as his writings in 1980, 1982, and 1987 indicate, the advocacy of reform entails the refinement and careful calibration of one's arguments within the officially sanctioned realm of discourse.[35] For example, the abolition of the lifetime tenure in office system (with officials, particularly the most powerful leader, holding power for life) and its replacement by fixed terms in office is a basic reform, but not necessarily one that shakes the political system to its very core. Similarly, a responsibility system for officials, separation of the party from the state, and observing the law are ideas about political change that Deng Xiaoping endorsed, though he did not observe them. Even Yan's argument for the respect of the constitution is undertaken within an officially established framework (Text 3).

Yan's advocacy of fundamental reform should be looked at

from the overall perspective of social change rather than just as reforms in the political realm, because Yan is convinced that reforms in the political, economic, legal, and cultural realms are interconnected and interdependent. Political reform, however, is the most fundamental and Yan's model of government is clearly influenced by Western political thought and political developments. He sees these Western ideas and institutions as applicable to, and needed in, China.

Yan arrives at this conclusion about the relevance of external ideas to China's political future through his understanding of what science is and how it progresses (Texts 5, 6, 17). Science, which Yan defines broadly as a spirit of advance, should know no boundaries. It should not be constrained by official views or traditions. People must dare to explore, compare, and analyze. If scientists, especially social scientists, discover unfashionable truths, so be it. Society and government should not persecute truth seekers; on the contrary, they should adapt themselves to truth. Confident that science can provide the answers to all problems China faces in the course of reform, Yan, in a sense, is perhaps closer to such Enlightenment figures as Francis Bacon than to many of his "postmodern" contemporaries in the West (who see "truth" as problematical and who believe that many sociopolitical problems defy solution). In effect, Yan argues that if historical comparison and analysis reveal that China's system of government is inferior to the democratic structures of the West, then China should change its form of government to serve the people better.

In the political realm, Yan called for fundamental changes in four areas (Text 8): the horizontal distribution of power, with China's National People's Congress truly exercising supreme state power; vertical division of power, with a clear sense of the responsibilities of superior and subordinate units; checks and balances or separation of powers within the central government itself; and finally, changes in the relationship between the government and the people, with the people having a great direct say in the affairs of the state. These ideas are not presented at

length, but their thrust is clear, if unstated—ending the monopoly of power held by the CCP. Indeed, he was unambiguous on this point when he advocated the abolition of the Politburo in 1988.

Closely linked to Yan's views on political reform is his belief that the rule of law and the constitution must be observed (Texts 3, 12, 17, 18). Yan's views are very Weberian—rational-legal authority must replace traditional ideas about the wide range of powers people in leadership positions hold. Law serves as the most fundamental check on official arbitrariness. It defines acceptable roles and behaviors, and creates zones of autonomy for the populace.

Associated with Yan's argument for political reform, the rule of law, and his assault on traditional culture (mentioned earlier) are his writings on economic reforms. Indeed, putting together the various aspects of his thought, Yan appears to argue that China needs nothing less than a total transformation of itself. In the economic realm, Yan by 1988 had come to the conclusion that individual initiative on the basis of private ownership (Texts 12 and 15) in the context of free market economics would be for the good of the country.

These aspects of his thoughts on reform, including the separation of power in the government, the expansion of the private realm, the dominance of private ownership, the institution of the rule of law, and the establishment of democracy, ultimately come down to one fundamental purpose—the expansion of civil society at the expense of the omnipotent party-controlled state.

V

Foreign readers of Yan's ideas might be troubled by two aspects of his reformist ideas. The first is Yan's understanding of democracy itself. The second might be called the difference between "being" and "becoming," or in this case the difference between an existing democracy observing the rule of law and the process of becoming a democracy.

Yan's understanding of democracy resonates profoundly with

Chinese views about the nature of democracy developed since the late nineteenth century.[36] In Text 17 for example, Yan argues that democracy enhances the collective spirit and guarantees the cooperative functioning of society. The will of the majority is correct, and serves to further the power and authority of the state. While this point is not developed, democracy seems to Yan to be a means to expanded state power in China, just as it was for Liang Qichao at the turn of the century. Preoccupied with advocating the virtues of democracy, Yan pays scarce attention to discussing the possibility of the tyranny of the majority or the idea of the protection of basic individual rights. Perhaps this is what he means by the rule of law, but the lack of much discussion of the tension between majority rule and individual rights is striking to Western readers of this material.

To Westerners, democracy is often and perhaps best understood as a means of regulating, channelling, and constraining the myriad conflicts which arise among autonomous individuals pursuing their own interests. Democracy becomes an end in itself— the survival of society. It is this view of democracy as rooted in social conflict that has been most troublesome for Chinese intellectuals over the past nine decades. Moreover, many Westerners believe that not only is social conflict ever present; it is also natural and good because conflict itself gives an impetus to historical change, creating progress.[37] The closest Yan came to realizing that democracy was a way of managing ever-present social conflict was when he argued that democratic politics is both the politics of procedures and the politics of responsibility (Text 19). Even here, however, the "principle of majority decision making" is taken for granted.

Indeed, despite his disdain for China's traditional political thought and practice, Yan Jiaqi's ideas on democracy reflect views deeply rooted in Chinese political thought, most importantly, the need for social harmony. Perhaps he, like many other Chinese intellectuals and ordinary citizens, is highly uncomfortable with the notions that conflict is endemic to society and that the naked pursuit of individual interests, unmediated by any other

broader social purpose, is acceptable, even desirable behavior. This is not to say that all Chinese political thought emphasizes harmony and the suppression of egoism and conflict,[38] or that Yan's and others' views cannot or will not change. But some Western readers may doubt the success of any Chinese effort to democratize until the basic philosophical premises of egoism and conflict as endemic to social life are accepted as starting points for the establishment of democratic politics and institutions.

Just as it is important to examine Yan's ideas about democracy critically, it is equally appropriate to examine the views about democracy in the West critically. Does democracy require the explicit acceptance of individualism and egoism? Certainly the case of Japan since World War II should give Westerners cause to pause. Moreover, a philosophical premise may not be accepted or recognized but this does not mean that people do not act according to these premises just the same. Democracies in the United States and England owe a great deal to John Locke and Thomas Hobbes, but *The Second Treatise on Government* and *Leviathan* did not create democracy; rather the actions of the people of the United States and Britain, sometimes contradicting these and other works of political philosophy, instituted democracy in these countries.

Yet the skepticism Westerners might have about Chinese democracy on philosophical grounds is compounded by the failure of scholars like Yan Jiaqi to distinguish between ''being'' and ''becoming.''[39] It is one thing for Yan to argue that democracy and the rule of law are what China needs to modernize. Few would find this argument objectionable. The problem lies in the fact that China does not become democratic merely by proclaiming itself a democracy and laws do not become authoritative merely by their promulgation. Certain norms and expectations must be established if democracy and the rule of law are to take hold, such as impartiality in legal proceedings, equality among citizens, minority rights, etc. In the West, the struggle against traditional authority in the form of feudalism or the divine right of kings took centuries. It would be naïve to expect that traditional sources of power and authority will

disappear in China merely through the formal establishment of new institutions and sets of rules.

This problem of "being" versus "becoming" is particularly acute for Yan Jiaqi now that he is an explicitly democratic revolutionary. He must lead a movement for democracy in China by arguing how much better off China would be under democratic rule. To build support, he may have to make utopian claims about what China under democratic and legal rule will be like, and what China can achieve under these systems. But as a potential leader of a democratic China he must also realize that the promises a democratic revolution may make during the struggle for power may not be matched by reality upon the establishment of a formal democratic system. Otherwise, Yan and other democrats run the risk of failing to deliver on their promises, and the potential loss of popular support for nascent democratic institutions may fatally weaken them, with the appearance of a strong man, saying that he can bring order and harmony. Yan and his compatriots thus face a dilemma: they must promise their supporters something they cannot realistically deliver in the short run, but if they discuss how arduous the struggle to institutionalize democratic and legal authority will be in China, they run the risk of losing support.

VI

The conspicuous role Chinese intellectuals like Yan Jiaqi, Liu Binyan, and Su Shaozhi have played in China's democratic movement in the past decade raises the issue of the proper role of the Chinese intellectual in China's future. As we mentioned earlier, Chinese tradition as epitomized in Confucianism has always placed a high premium on the activist role for the scholar-official. Every high school student in contemporary China is taught to memorize the famous maxim by Fan Zhongyan, the great Confucian reformer of the Song Dynasty (A.D. 960–1279): "A scholar should be the first to become concerned with the world's troubles and the last to rejoice in its happiness."[40] Despite the many frontal attacks on various aspects of the Chinese tradition

during this century, the historical burden Chinese intellectuals feel on their shoulders has paradoxically gained added weight. Chinese intellectuals have "accepted the rhetoric of relevance, with participation and activism appearing as the authentic way to engage in the struggle to save the nation."[41] Within the community of Chinese democratic aspirants, a sizable number yearn for direct action in their self-defined mission of saving China. They hope to find the *one* solution to China's problems and pull China out of backwardness. The dramatic changes occurring in East Europe offer encouragement to those who hope as much for China.

Yet is this the proper role for the Chinese intellectual in China's democratic movement? Some have offered alternative arguments. True, Chinese intellectuals have always been drawn directly into the political realm in this century, but they are always subjected to the whims of rulers who control both words and swords.[42] Despite the ideals and aspirations of the intellectuals, the Chinese body politic has appeared to have followed its own logic. Reflecting on this haunted history, Chen Fangzheng, of the Chinese University of Hong Kong, has recently argued that the intellectuals are a transitional force with only a temporary mission: to voice criticism while other social groups find and express their own voice. They will be left without a special calling when others can speak for themselves.[43] Wan Runnan, the intellectual-entrepreneur who founded the Stone Corporation, perhaps China's largest private enterprise, and now secretary-general of the Front for a Democratic China, would perhaps agree. He argues that the future of democracy depends crucially on the expansion of the middle class, hence the need to encourage private businesses in China. The role of intellectual elites, Wan seems to argue, is to articulate such a need and prepare for the days of change.[44]

Chen and Wan are thus willing to settle for a less activist and exalted role for the intellectuals. They appear to realize that the march to democracy is a long drawn-out process of transformation. The same choice faces Yan Jiaqi and the entire Chinese democratic movement.

VII

These articles by Yan Jiaqi and the ideas they provoke, in the critical dialogue between Yan and his readers, bring us back to the question raised at the beginning of this essay. That is—how to change China? One of the major contributions Yan's writings make, though he could not say so explicitly when he was in China, is that a socialist revolutionary strategy of changing China did not work. The continuities between imperial China and China ruled by the Communist Party are great indeed. In particular, traditional authority patterns continue to flourish. But if revolution did not work, the record of reformers, be they outsiders, external critics, or internal advocates, is hardly much better. The difference between being democratic and becoming democratic suggests that a democratic revolutionary strategy will also face severe problems as well. Yan Jiaqi, the Chinese democratic movement, foreign observers, and even the CCP will not easily resolve the question of how to change China. Even more difficult will be making the changes work in the desired direction. Yan Jiaqi's career and his ideas raise profound questions about China's history and its future. We should be grateful that he and his colleagues, conscientious and committed thinkers, still have the chance to grapple with the question of how to change China. Yan's and others' efforts deserve our serious attention.

A Note on the Texts and Translations

The present project was conceived well before the democracy movement of 1989 came into being. It was originally intended as a project to introduce Western scholars to the development of political science in China, and Professor Yan Jiaqi's writings were chosen as the medium because of his prominent yet not uncontroversial role in the development of political science as a discipline in China during the past decade.

The editors were most fortunate in having Professor Yan's full cooperation in supplying original texts and in allowing the editors freedom to select the texts for translation. Professor Yan

originally sent us over forty articles, from which we chose the bulk of the texts translated here. A number of the translations come from *Quanli yu zhenli* (Power and Truth) (Beijing: Guangming ribao chubanshe, 1987). We have also included a number of texts that Professor Yan originally did not intend to have translated (Texts 5 and 6) as well as several interviews with Professor Yan published after the June Massacre. Our emphasis in selection is on essays dealing with aspects of China's political, economic, and cultural reforms. As a result, most of Professor Yan's voluminous writings on streamlining administration are not included. Some others were not selected because of overlaps with essays already chosen. Scholars who are interested in a fuller presentation should look at the collection of Professor Yan's essays in Chinese, *Zouxiang minzhu zhengzhi* (Toward Democratic Politics), Dali Yang, ed. (Teaneck, NJ: Global, 1990), which also includes a list of Professor Yan's published works.

Professor Yan made generally minor changes in the texts before they were translated, removing often outdated comments. Some of the changes are significant, such as changed titles, and in particular the striking out of positive references to the CCP and Deng Xiaoping. He made few, if any, additions to the original documents. Thus, these are not translations of the historical texts, but translations reflecting Yan's modifications (as of the spring and summer of 1989) of previously written material.

We have aimed at fluency and consistency of style in our translations, though we are fully aware that no translation can completely convey the range of subtleties in the original, despite the addition of brackets and notes. We will be happy if this work is of help to readers who wish to have a better understanding of the hopes and frustrations facing the Chinese.

The editors have added introductory remarks at the beginning of most of the essays to help put the original writings into context. In the texts, we have used brackets to add words or short phrases that are deemed helpful to the English-language reader. All notes are those of the editors, unless they are specifically noted to be those of Professor Yan.

Acknowledgments

In addition to Yan Jiaqi's wholehearted cooperation with this project, we wish to thank the Center of International Studies, the Council on Regional Studies, and a faculty research grant from Princeton University for financial support for the preparation of this volume. We are grateful to Douglas Merwin of M. E. Sharpe, Inc. for his support of this project and to Nancy Hearst for her meticulous copy editing. The views expressed here are those of the original author or, in the case of the introductory essay and the brief introductions, those of the editors. They do not represent the views of the sponsoring organizations and should not be construed as such.

Notes

1. For an insightful overview of historical continuities of various reform efforts in China over the course of this century, see Paul A. Cohen, "The Post-Mao Reforms in Historical Perspective," *Journal of Asian Studies*, 47 (August 1988): 518–540.

2. The foreign agents of change and their lack of success have been well described in Jonathan Spence, *To Change China* (New York: Penguin, 1980). See also James C. Thomson Jr., *While China Faced West* (Cambridge, MA: Harvard University Press, 1969).

3. See the discussions of, and interviews with, Fang Lizhi, Liu Binyan, and Wang Ruowang, in Orville Schell, *Discos and Democracy* (New York: Pantheon, 1988), as representative of this type of reformer. For other examples, see David A. Kelly, "The Emergence of Humanism: Wang Ruoshui and the Critique of Socialist Alienation," and Kyna Rubin, "Keeper of the Flame: Wang Ruowang as Moral Critic of the State," both in Merle Goldman, with Timothy Cheek and Carol Lee Hamrin, eds., *China's Intellectuals and the State*, Harvard Contemporary China Series, no. 3 (Cambridge, MA: Council on East Asian Studies, Harvard University, 1987), pp. 159–82 and 233–50, respectively.

4. On this theme, see Edward Shils, "The Intellectuals and the Powers: Some Perspectives for Comparative Analysis," *Comparative Studies in Society and History*, 1 (October 1958): 5–22.

5. For a brilliant discussion of the stakes involved in the insider/outsider debate on reform in the Polish context, see Piotr Wierzbicki, "A Treatise on Ticks," [an attack on insiders] and Adam Michnik [a leading Solidarity intellectual, partially defending insiders], "Ticks and Angels," both in Abraham Brumberg, ed., *Poland: Genesis of a Revolution* (New York: Random House, 1983), pp. 199–211 and 212–18, respectively.

6. Several of the CCP's heaviest attacks on Yan are found in Li Jiansheng, "Yan Jiaqi: The 'Elite' of the Turmoil," *Renmin ribao* (Overseas ed.), August 3, 1989, pp. 1, 4; translated in *Foreign Broadcast Information Service, Daily Report, China*

[hereafter FBIS], August 3, 1989, pp. 18–22; Zhong Hai, "A Program for the Vain Purpose of Establishing a Bourgeois Republic," *Guangming ribao,* September 2, 1989, pp. 1–2; FBIS, September 14, 1989, pp. 18–23; and Wu Daying and Li Yanming, "The Socialist Republic Cannot Be Toppled," *Renmin ribao,* September 21, 1989, p. 6; FBIS, September 22, 1989, pp. 14–19.

7. A brief profile of Yan is found in Edward Gargan, "In China, Ideology Takes a Backseat to New Realities," *The New York Times,* May 31, 1988, pp. 1, 9.

8. Before they were stripped of their official posts in 1987, Fang Lizhi was vice president of the Chinese University of Science and Technology in Hefei, Liu Binyan worked as a senior journalist for the official *People's Daily,* and Su Shaozhi was the director of the Institute of Marxism-Leninism–Mao Zedong Thought of the Chinese Academy of Social Sciences. Yan Jiaqi survived this purge only because of the high-level protection that was accorded him (see text below).

9. See Kelly, note 3, and Liu Binyan, *People or Monsters,* ed., Perry Link (Bloomington, IN: University of Indiana Press, 1983). Liu's recent works include *"Tell the World": What Happened in China and Why* (with Ruan Ming and Xu Gang) (New York: Pantheon Books, 1989), and *A Higher Kind of Loyalty: A Memoir by China's Foremost Journalist* (New York: Pantheon Books, 1990).

10. In this way, Su Shaozhi was similar to Kang Youwei, a leader of reform efforts in 1898. Kang attempted to reinterpret Confucianism, arguing that the fundamental spirit of Confucianism was change. Su's attempt to reformulate Marxism to suit a reforming China might be seen as an analogous intellectual endeavor, with the same political implications as Kang's activities (which unfortunately have led to the same result—exile—for their proponents). See Su Shaozhi et al., *Marxism in China* (Nottingham: Spokesman, 1983); Su Shaozhi, *Democracy and Socialism in China* (Nottingham: Spokesman, 1982); Su Shaozhi, *Democratization and Reform* (Nottingham: Spokesman, 1988); and "A Symposium on Marxism in China Today," *Bulletin of Concerned Asian Scholars,* 20 (January–March 1988): 11–35.

11. See Zhong Hai, "A Program for the Vain Purpose," p. 18.

12. Most of the biographical data on Yan Jiaqi comes from *Quanli yu zhenli* [Power and Truth] (Beijing: Guangming ribao chubanshe, 1987), pp. 345–59, which is enlarged upon in Yan's *Wode sixiang zizhuan* [My Intellectual Autobiography] (Hong Kong: Sanlian chubanshe, 1988). Other materials come from interviews with Yan Jiaqi and people who have known him.

13. For a Maoist account of this debate, see, *Three Major Struggles on China's Philosophical Front (1949–1964)* (Beijing: Foreign Languages Press, 1973), especially pp. 48–66. One of the key participant's version of the debate is presented in Yang Xianzhen, *Wode zhexue 'zui'an'* [My Philosophical 'Crimes'] (Beijing: Renmin chubanshe, 1981), especially pp. 296–317. For biographies of leading figures in this debate, see Joshua A. Fogel, *Ai Ssu-ch'i's Contribution to the Development of Chinese Marxism,* Harvard Contemporary China Series, no. 4 (Cambridge, MA: Council on East Asian Studies, Harvard University, 1987) and Carol Lee Hamrin, "Yang Xianzhen: Upholding Orthodox Leninist Theory," in Carol Lee Hamrin and Timothy Cheek, eds., *China's Establishment Intellectuals* (Armonk, NY: M. E. Sharpe, 1986), pp. 51–91.

Many more works on this debate could be cited here.

14. Xu Xing, "Yan Jiaqi fufu shou tingzhi chufen?" [Are the Yans being suspended from their posts?] *Jiefang yuebao* [Emancipation monthly] (Hong Kong), 1 (January 1987): 29. Yu Guangyuan has occupied important staff positions in the State Science and Technology Commission, and has played a major role in science planning in China. For his biography, see Wolfgang Bartke, *Who's Who in the People's Republic of China* (Armonk, NY: M. E. Sharpe, 1981), pp. 481–82, and Donald W. Klein and Anne B. Clark, *Biographic Dictionary of Chinese Communism* (Cambridge, MA: Harvard University Press, 1971), pp. 1021–23.

15. Since 1988, Gong Yuzhi has been a deputy director of the Party Propaganda Department.

16. This was later published in the December 1979 issue of *Zhexue yanjiu* [Philosophical Research]. It appears in *Quanli yu zhenli*, pp. 34–57.

17. Yan Jiaqi, *Quanli yu zhenli*, p. 350.

18. Yan Jiaqi et al., *Siwu yundong jishi* [A True Record of the April Fifth Movement] (Beijing: Renmin chubanshe, 1979), p. 143.

19. For background on this debate, see Brantly Womack, "Politics and Epistemology in China since Mao," *China Quarterly*, no. 80 (December 1979): 768–92.

20. Yan Jiaqi, *Kuayue shidai de feixing* [A Flight Across Eras] (Shanghai: Shanghai renmin chubanshe, 1979).

21. The Chinese consider many disciplines a part of the social sciences which are not usually considered "social sciences" in the West, such as journalism, literature, and history. In a sense, the Chinese meaning is closer to what in many Western universities are the divisions of the humanities and social sciences.

22. Yan Jiaqi, *Wode sixiang zizhuan* (Hong Kong: Sanlian chubanshe, 1988), p. 36.

23. For Yan's participation in the 1978–79 Democracy Wall movement, see Andrew J. Nathan, "Chinese Democracy in 1989: Continuity and Change," *Problems of Communism*, 38, no. 5 (September–October, 1989): 16–29. See p. 18, note 10. For background on the Democracy Wall movement, see Andrew J. Nathan, *Chinese Democracy* (New York: Alfred A. Knopf, 1985), especially chapters 1 and 2.

24. The meeting took place in October 1979, when Zhao had just been elevated to the premiership of the PRC. At that time, Bao worked in the premier's office. Later he would be secretary of the State Council, secretary to the Central Committee, and head of the Political Structure Reform Research Group of the Central Committee. He was Zhao Ziyang's closest political adviser and aide. He is currently reportedly under detention.

25. What Chinese universities offered in the area of "politics" was largely heavy doses of party history and Marxism-Leninism.

26. Li Jiansheng, "Yan Jiaqi, the 'elite' of the Turmoil," p. 18. Such assertions which aim to discredit Yan, Zhao, and Bao must be treated with caution, but it seems likely that at least Bao Tong was active in Yan's appointment to this body.

27. Li Jiansheng, "Yan Jiaqi, the 'Elite' of the Turmoil," p. 18.

28. Personal interview with Gao Gao, Chicago, July 29, 1989.

29. See the criticisms of this dialogue in Chen Xitong, "Report on Checking the Turmoil and Quelling the Counter-Revolutionary Rebellion," *Beijing Review*, July 17–23, 1989, p. II.

30. Yan Jiaqi, "Bu rongxu zhengfu zhishang haiyou yige zhengfu" [There should not be another government above the government], *Ming Pao* (Hong Kong), February 25, 1989, p. 1.

31. Chen Xitong, "Report on Checking the Turmoil," p. V.

32. Kate Wright, "The Political Fortunes of Shanghai's 'World Economic Herald,' " *Australian Journal of Chinese Affairs*, no. 23 (January 1990): 121–32; quotation is from insert at p. 124.

33. These claims are made in Li Jiansheng, "Yan Jiaqi, the 'Elite' of the Turmoil," pp. 18–19.

34. Nicholas D. Kristof, "China Update: How the Hardliners Won," *The New York Times Magazine*, November 12, 1989, pp. 38–41, 66, 68, and 71. See p. 66.

35. More of Yan's earlier essays can be found in *Quanli yu zhenli* and in *Zouxiang minzhu zhengzhi: Yan Jiaqi Zhongguo zhengzhi lunwenji* [Toward Democratic Politics: Essays on Chinese Politics by Yan Jiaqi], Dali Yang, ed. (Teaneck, NJ: Global, 1990).

36. See Nathan, *Chinese Democracy*, chapter 3.

37. This idea of inevitable human progress is as vulnerable to criticism as are some of the Chinese views of democracy. For an overview of problems with this view of progress, see Robert Nisbet, *History of the Idea of Progress* (New York: Basic Books, 1980).

38. For a comprehensive presentation of the different schools of political thought in ancient China, see Kung-chuan Hsiao, *A History of Chinese Political Thought*, vol. 1: *From the Beginnings to the Sixth Century A.D.*, F.W. Mote, trans. (Princeton, NJ: Princeton University Press, 1979).

39. On the significance of the difference of "being" versus "becoming," see Chandler Morse, "Being Versus Becoming Modern: An Essay on Institutional Change and Economic Development," in Chandler Morse et al., *Modernization by Design* (Ithaca, NY: Cornell University Press, 1969), pp. 238–382.

40. This English translation of the maxim is in James T.C. Liu, "An Early Sung Reformer: Fan Chung-Yen," in John K. Fairbank, ed., *Chinese Thought and Institutions* (Chicago, IL: University of Chicago Press, 1957), p. 111.

41. Tu Wei-ming, "Iconoclasm, Holistic Vision, and Patient Watchfulness: A Personal Reflection on the Modern Chinese Intellectual Quest," *Daedalus*, 116, no. 2 (Spring 1987): 82.

42. Vera Schwarcz, "Memory, Commemoration, and the Plight of China's Intellectuals," *The Wilson Quarterly* (Autumn 1989): 125–26.

43. Schwarcz, "Memory, Commemoration," p. 123.

44. Speech at the First Congress of Chinese Students in the USA, Chicago, July 29, 1989.

1980

1 | On Abolishing "Lifetime Tenure"

Editors' Introduction: In this essay, Yan expounds on the deliberations of the Fifth Plenum of the Eleventh CCP Central Committee on abolishing life tenure (the failure of the CCP to establish a fixed term of office for party and state officials). He provides the historical background to the phenomena of life tenure and points to the inevitable corruption such a system creates. In the concluding sentence he notes that the abolition of life tenure will not solve all problems.

Given the failure of Deng Xiaoping and other older leaders to really "retire," discussion of actual retirement mechanisms (and their implementation) are required before life tenure is abolished in China. Yan, however, is noticeably reticent on the transition mechanisms necessary to make reform possible. Nor does Yan discuss what type of personnel system will replace life tenure here (because it was still under debate in the party at the time), though he will soon identify the institution of a civil service system in China as a major research topic. As soon as he took charge of the provisional Institute of Political Science in 1982, he authorized the formation of a research group to specialize in the comparative study of civil service systems in the world.

This essay was originally published in *Xin shiqi* [New Era], no. 3 (January 1980) and reprinted in *Quanli yu zhenli*, pp. 65–70.

* * *

The Fifth Plenum of the CCP Eleventh Central Committee was an important meeting in CCP history.[1] At the meeting, the question of "abolishing the de facto lifetime tenure of cadre appointment" was raised explicitly for the first time. Time will make people realize more and more clearly that the decision to abolish "de facto lifetime tenure" has far-reaching implications not only for the Chinese Communist Party, but also for China. In this essay, I will deal with the significance of the abolition of lifetime tenure by focusing on the relationship between life tenure and the national political system.

<div align="center">I</div>

The "lifetime tenure" system dates back to ancient history. Life tenure for heads of state had already become a custom during the era of slave ownership. Top leaders in ancient Egypt, Babylon, Persia, India, and China all had life tenures. There were exceptions, to be sure. From the end of sixth century B.C. to the first century B.C., the Roman Republic had two top executives who had one-year terms and were elected each year. From a historical viewpoint, the life tenure system of state leaders had a close relationship with the monarchical system. Historically, almost all countries ruled by monarchies relied on the life tenure system. Moreover, in a republic, establishing life tenure was often a precursor to the revival of monarchy, for without restrictions on the tenure of state leaders, a republic would degenerate into a monarchy. In the late Roman Republic, the military leaders who rose during the civil war tried hard to abolish the strict tenure limitations of the Republican Period. First, they began by prolonging their own tenures time and again and eventually declared they were appointed for life. With life tenure for state leaders, the Roman Republic finally became the Roman Empire by the end of the first century B.C. Besides ancient Rome, Napoleon Bonaparte and Louis Napoleon Bonaparte in France, and Yuan Shikai in China after the 1911 Revolution also started by the prolongation of their office, then the declaration of life appointment for them-

selves, leading in the end to the destruction of the republic and their enthronement. Life tenure, along with monarchy, is an ancient system being eliminated by history.

In the development of human history, the abolition of the life tenure system is a significant reform in terms of the national political system. This reform was accomplished in many countries during the bourgeois revolution or soon thereafter, resulting in different terms of office for the various heads of state. In Switzerland, the highest administrative organ is the Federal Council, whose chairman has only a one-year term. The American president has a four-year term, while the French president has a longer term of seven years. Great Britain is nominally a monarchy, but the highest power does not reside in the monarch's hands, but in Parliament, the Cabinet, and the prime minister who has limited tenure (5 years).[2] The abolition of life tenure for the highest power holders has effectively prevented the rebirth of autocracy.

II

How should national political power be constituted in a socialist country? May the heads of party and state keep their lifetime tenure? Ready answers to such questions cannot be found in the works of Marx and Engels. Marx and Engels only raised a general principle that, after seizing power, the proletarian class can only adopt the "republican system" of government, which Marx referred to as a "socialist republic." Marx referred to the Paris Commune of 1871 as a "certain form" of "socialist republic." The Paris Commune not only did not allow life tenure, but also explicitly restricted the tenure of the chairmanship of the Commune Committee, the highest power structure in the Commune. Since it lasted for only a brief period, in reality, the Paris Commune did not establish new forms of state power. Marx and Engels's idea of the "socialist republic" is of great import both in theory and in practice. The proletariat does not want merely to replace bourgeois dictatorship with proletarian dictatorship. After the seizure of power by the Communist Party of China, the People's Republic of China was established. Since the

Communist Party of China is the ruling party, the de facto lifetime tenure of party leaders has inevitably affected the national political system and political life.

There are historical reasons for the de facto lifetime tenure of the highest party and state leaders in our country. Owing to strong feudal traditions, the old idea of lifetime tenure had deep roots. Moreover, the Chinese revolution relied on armed struggle. Under such circumstances, it was necessary for party leaders to have continuous appointments. Indeed, there existed a certain objective necessity for such de facto lifetime tenures in order to consolidate revolutionary achievements and effectively conduct socialist transformation in a new revolutionary regime.

III

Despite the historical reasons for its existence, the de facto lifetime tenure system has proved in socialist practice to be a factor hindering the healthy development of socialism. Owing to lifetime tenure, cadre ranks easily ossified; such feudal phenomena as "one person lays down the law," "patriarchal behavior," and "the special privilege mentality," could multiply; elections of party and state leaders at all levels soon became meaningless; responsibility for the party and the people usually became personal loyalty to leaders, especially the top leader himself. While socialism demands that the leader be devoted to the party's cause and the people, as a result of lifetime tenure, party members and the people at large had to be devoted to the leader. Under such circumstances, when large-scale propaganda for the personality cult was orchestrated during the Cultural Revolution, democratic centralism was wrecked, collective leadership became formalistic, and all kinds of mistakes could not be corrected through the usual practices of democracy. Since our party and state leaders often served for over ten years or even decades, careerists such as Lin Biao[3] and the Gang of Four[4] would actively devise various political conspiracies to seize party and state leadership. Along with such conspiracies came numerous unjust, false, or wrong cases, even disrupting economic construction.

In the annals of socialist countries, life tenure started with Lenin and Stalin. For a while after Lenin's death, the Soviet Union had a leading group based on collective leadership. However, in the 1930s, the personality cult of Stalin gradually developed to the detriment and even eradication of party collective leadership, thereby strengthening the de facto lifetime tenure system.

Within the Chinese Communist Party, personal idolatry and modern superstition (*geren chongbai* and *xiandai mixin*[5]) spread like a plague because of the existence of a de facto lifetime tenure system and because of Lin Biao's efforts to "glorify" [Mao] with his "theory of innate genius." Waving the banner of "holding high . . . ,"[6] Lin Biao and the Gang of Four took advantage of the Cultural Revolution to change China's political system: the National People's Congress, the highest organ of state power, was not convened for a long period, the constitution and laws were trampled upon, and the personal utterings of the supreme leader took on the force of law. The Cultural Revolution did not merely result in slanders and persecution against the president of the republic [Liu Shaoqi],[7] but also smeared the republic itself; Lin Biao wanted to build his feudal, fascist dynasty of hereditary rule, and Jiang Qing wanted to emulate the Empress Lü and Wu Zetian and become empress.[8] Socialism does not permit emperors, but lifetime tenure could create them. The painful lessons of the Cultural Revolution made the people realize that, to prevent the rebirth of people like Lin Biao, a truly effective system must be established to remove the soil favoring their emergence. Abolition of de facto lifetime tenure is an effective measure that the CCP has adopted. Only in so doing, can the revival of autocracy be prevented systematically. (To be sure, not all problems are solved.)

Notes

1. The Fifth Plenum of the Eleventh Central Committee was held from February 23 to February 29, 1980. Among other things, the plenum added Hu Yaobang and Zhao Ziyang to the Politburo standing committee, reestablished the party Secretariat (headed by Hu), promulgated the "Guiding Principles of Inner-Party Political Life," and discussed the abolition of lifetime tenure.

2. The prime minister must call a national election every five years. As long as the prime minister's party wins the election, the prime minister may remain in office. There is no limitation on the number of terms a prime minister may serve, in contrast to the two-term limit to which a U.S. president is subject.

3. Lin Biao (1907–71) was Minister of Defense and top military commander of the People's Liberation Army, 1959–71. It was Lin who authorized the compilation of "Mao's Little Red Book" to glorify Mao. Lin also formulated the "theory of innate genius" to apply to Mao, thus helping fan the Mao cult. Lin was quoted as saying that all people must obey Mao's every word, the product of genius, even if they did not understand Mao's ideas.

4. The Gang of Four, Mao's wife Jiang Qing, Zhang Chunqiao, Yao Wenyuan, and Wang Hongwen, were Mao's strongest supporters in the mid-1970s. These ideologues were arrested shortly after Mao's death in 1976 and put on trial in 1980. All remain in prison.

5. These phrases are terms used in the 1980s to refer to Mao's personality cult.

6. "Holding high the banner of Mao Zedong Thought," a slogan of the 1960s was part of his personality cult.

7. Liu Shaoqi (1898–1969) was the principal target of the Cultural Revolution. He was the number two party leader from 1949 to 1966 and head of state from 1959 to 1966. He died while in solitary confinement during the Cultural Revolution.

8. The Empress Lü, widow of Gao Di in the imperial house of Liu, reigned from 188–180 B.C. in the Han Dynasty (206 B.C.–A.D. 23). During her reign, she appointed family members to high positions and made a bid for the elimination of the imperial house of Liu. The bid was thwarted. The Empress Wu, consort of the sick Gao Zong of the Tang Dynasty (A.D. 618–907), was able to establish herself as the sovereign empress (A.D. 691–705) after Gao Zong's death. She practiced a tyrannical and repressive style of government. Scholars and statesmen alike have used the examples of the Empress Lü and the Empress Wu to warn of the dire consequences of permitting an empress dowager or a princess to rise above her station.

2 | "Imperial Power" and "Imperial Position": Two Characteristics of Autocracy

Editors' Introduction: This early essay by Yan is a stark call for reform and democratization of China's political system through elections, "checks and balances," and the separation of power. While Yan's references to the abuses characteristic of autocracy in China are all taken from premodern times, his readers were well aware that the same flaws were also found in the People's Republic of China. Yan's concluding paragraphs make clear the connection between the imperial system and the Maoist system. By expressing his admiration for the establishment of democracy in the West, which he calls "an epoch-making achievement in human history," Yan makes obvious his belief that China should borrow institutional arrangements from the West.

Also of interest is Yan's use of comparative history and careful conceptual distinctions. He marshals an impressive repertoire of historical materials from both Chinese and Western history to arrive at an inductive understanding of the nature and characteristics of autocracy in China. Please note that his use of the word *fengjian*, loosely translated as feudalism, contrasts with its use in the West. Whereas in the West the word feudalism is used to refer to the premodern period that saw numerous states contending with one another, the Chinese generally use the word feudalism to refer to the long period during which China was ruled by a unified and centralized empire.

This essay was originally published in *Xin shiqi* (New Era), no. 6 (1980) and was reprinted in *Quanli yu zhenli*, pp. 91–96.

* * *

As soon as people mention autocracy, they associate it with feudalism. In Chinese history, autocracy and feudalism never parted from each other during the two thousand years since Qin Shihuang [the First Emperor of Qin] established a centralized feudal empire based on autocracy. In our history, this was the archetypical autocracy—that is, feudal autocracy. However, in world history, autocracy was not a political phenomenon that belonged solely to feudalism. Politics in both the slave-owning Roman Empire and fascist Germany was dictatorial. Yet feudalism did not necessarily have an inseparable relationship with autocracy. In medieval Europe, such independent city-states as Venice, Genoa, Florence, and Novgorod were feudal republics rather than autocratic political systems.

No matter the social system, autocracy as a national political system has two characteristics. First, the authority of the sovereign is indivisible. The supreme powers of the state, including legislative, administrative, and judicial powers, are all gathered in the hands of one person, called the sovereign (i.e., monarch, emperor, czar, or sultan). Second, the power of the sovereign is nontransferable. Once in power, the sovereign has a lifetime position, or enjoys what we call "life tenure." Under autocratic rule, the ministers and ordinary officials do not enjoy life tenure, however. In Chinese history, the *zaixiang*, or prime minister, who assisted the emperor in running administrative affairs, was often replaced by the emperor after a number of years, though exceptions existed. This was even more true of ordinary officials; sometimes the terms of office for local officials were explicitly stipulated. For example, the first year of the Northern Wei Dynasty [A.D. 386] saw the establishment of a system whereby local magistrates, whatever their performance, were replaced every six years. During the Sui Dynasty [A.D. 581–618], a system was in effect for replacing magistrates at the prefectural and county lev-

els every three years. Thus, in practice, life tenure in feudal times applied to the emperor only.

The centralized power of the emperor (king), or the indivisibility of power, is what we usually call "imperial (kingly) power"; the non-transferability of imperial power, or the life tenure of the emperor's office, is what we usually call the "imperial (or kingly) position." The indivisibility and nontransferability of the supreme state power, centralized in the hands of one person, are the basic characteristics of all autocratic political systems.

Feudal autocracy in China also took on another important feature, namely, the hereditary nature of imperial power. Each emperor during his reign placed primary importance on choosing a successor. In world history, however, the power of the emperor or king was not necessarily hereditary. In ancient Rome, the Antonine emperors (A.D. 96–192) did not choose successors based on blood. Father could not pass his throne to his son, but had to pass power to whomever was chosen by the patrician Senate. In some medieval European states, the emperor or king was elected; this kind of monarchy differed from the hereditary one and was called an "elective monarchy." Generally speaking, the hereditary transfer of imperial power was not an intrinsic feature of autocracy.

Nevertheless, without both the indivisibility and the non-transferability of supreme state power, there would not be autocratic politics. In the ancient Roman Republic, when the state was seriously threatened by outside enemies or internal chaos, the Senate usually appointed a "dictator" who held supreme state power. When the dictator was in office, no dissent was allowed and his decisions were final. However, the power of the dictator was non-transferable; once his mission was accomplished, his power ended. During the three hundred years after 501 B.C., Roman history recorded eighty-eight cases of dictatorship, with the longest lasting six months. Since there were strict limits placed on the dictator's tenure, Rome kept its republican form of government rather than setting up a dictatorial system, despite the many appointments of dictators. Similarly, countries

that retain an "imperial or monarchical position" without corresponding "imperial power" are not autocracies. The typical example is modern Britain. Although Great Britain retains its queen, the national legislative and administrative powers are vested in the Parliament, the Cabinet and the prime minister who has limited tenure. The life-tenured queen serves as the nominal head of state.

In human history, autocracy once had its progressive effect in creating nation-states and in fighting against separatist forces. Autocratic dynasties also had their era of glory. Nevertheless, whenever a country adopts an autocratic system, it inevitably tends toward political corruption and darkness, both of which are closely related to the twin characteristics of autocracy. Although some autocratic dynasties declared various laws, the emperor could trample on these laws because he retained legislative powers. Thus "defiance of laws both human and divine" and feudal despotism are the products of imperial politics. In order to strengthen imperial power, the emperor often adopts all kinds of sordid and cruel measures to eliminate these elements which resist him. His greatest concerns are that the power-holding prime minister, other ministers, as well as the military generals, may try to seize power from him; therefore, he seeks, by every means, to weaken and divide the power of the ministers and to dissolve the military authority of victorious generals. To strengthen imperial power, the emperor often kills those meritorious ministers and victorious generals en masse. Not only the founding emperor kills with indiscrimination the other founding fathers of the dynasty, but succeeding emperors often find faults with those ministers who rendered exemplary service. Moreover, to strengthen imperial power, the emperor also establishes intelligence services (such as the *Jinyiwei* and *Dongxichang* during the Ming Dynasty), employs oppressive officials, and establishes literary prisons. In feudal society, a number of "enlightened scholar-officials" have repeatedly appealed to the emperor: such prosperous reigns as the Wenjing (B.C. 179–141) and the Zhenguan (A.D. 627–649) years are examples of good feudal rule; to strengthen imperial power, the emperor should be happy to ac-

cept advice and be good at making appointments; the best rule is "benevolent rule" whereby the emperor can win the love of the people. However, such advice was mocked in court, since a reign of prosperity was a sort of utopia for a dynasty facing endless calamities and difficulties. The emperor's dearest interest was neither the wealth and power of the country nor the people's happiness, but the security of the throne. Many emperors could not relax and put power in the hands of competent and meritorious ministers; rather, they trusted eunuchs, relatives, sycophants and cringes. As a result, rule by eunuchs and relatives, control by cunning ministers, and corruption by officials were the incurable diseases of feudal autocratic politics. *Zizhi tongjian* [General Mirror for the Aid of Government, by Sima Guang (A.D. 1019–86)] summarizes four reasons for the rise of treacherous ministers: first, by "currying favor with those eunuchs near the emperor, flattering the wishes of the emperor in order to consolidate his favor"; second, by "closing channels of advice, hiding those who are wise, in order to succeed in his treachery"; third, by "slandering the virtuous and competent, expelling those who differ from him, in order to keep his position"; fourth, by "wantonly resorting to crackdowns, expelling or jailing good officials, in order to enhance his influence." Of these four, "flattering the emperor's wishes" was the most important. For right or wrong, appointment or dismissal of an official always depended on the liking of the emperor or superior. "Appointment on merit" was but one of the political ideals of a feudal dynasty; "appointment based on favoritism" was the actual principle. Hence, those who rose to high positions were usually those who curried favors and played politics.

Because of his life tenure, the death of an emperor often results in tremendous shock. When the emperor acts willfully and yet the old policy cannot be carried out anymore, changes of the imperial throne become harbingers of policy change, followed by large-scale replacements of ministers and officials. "Every new sovereign brings his own courtiers," [as a popular saying puts it]. Hence, fights for the throne and other official positions coincide and crisscross. As a result, court intrigues and palace coups never

cease; the losing side often ends up being slaughtered—from the prince down to the ministers who support him. Even if the emperor chose and decreed his successor, struggles for the throne could not be ruled out. When the imperial authority falls into the hands of others, those who control real power aspire to the throne as a toy and tool; hence, the struggle for control of the throne turns even more cruel. In the late period of the Eastern Han Dynasty [A.D. 25–220], the emperor's relatives took advantage of the emperor's tender age and controlled the court; meanwhile, eunuchs took the opportunity to instigate court coups and replaced the emperor's relatives with themselves. Under such circumstances, those who were made emperors were usually young and inexperienced; relatives and eunuchs were able to control the emperor and use "his imperial will" to their own advantage. In the late Tang Dynasty [A.D. 618–907], eunuchs even acquired the right to establish, dismiss or even kill the emperor. In these situations, though the "imperial position" still existed, the "imperial power" was actually under the eunuchs' control. Besides peasant uprisings that interrupt imperial succession, only warlord betrayal and palace coups could make imperial power change hands.

Under the autocratic political system, various complex political phenomena present a dazzling spectacle. It is generally believed that autocratic politics has almost no legal "rules." Court intrigues were commonplace and the law of imperial succession was often disrupted. "Those who do good may not reap blessing, those who do evil may not suffer from misfortune," as a popular saying puts it. The cunning get promoted, the virtuous minister and official often suffer the fate of being elbowed out and even killed. . . . Nevertheless, autocratic politics has had one unshakable principle running through it for several thousand years: there is in one man's hands supreme state power, indivisible and nontransferable; the struggle in autocratic politics centers and develops around the preservation and seizure of that power. The law of imperial succession only guarantees that the legal successor could attain that power with less effort. In principle, anyone of the imperial household, outside relatives, ministers, and warlords

could try to seize this power and declare himself the new emperor; to make one into a true emperor, however, one has to have the "loyalty" of those who control various military and administrative powers. Although one after another of the peasant wars in Chinese history powerfully struck or broke the old feudal dynasty, they established new power structures that kept the indivisibility and nontransferability of the highest power. Even if peasant wars overthrew the old dynasty, the newly established [political structure] would still be another dynasty.

The modern Western countries established their democratic systems beginning with the eradication of two characteristics of supreme power under autocratic rule. In those countries that have established democracy, the legislative powers no longer rest in the hands of an individual, but reside in a parliament that is periodically elected, thus the supreme state power is divided; even those who hold the supreme administrative power, the president, premier, or prime minister, have their administrative power doubly restrained by the parliament and by tenure of office (in a parliament or cabinet government, the parliament can dissolve the government), or at least strictly limited by the terms of office (in a presidential government, though the legislature cannot overthrow the president because of policy problems, the powers of the president are still limited by the terms of office), therefore, the nontransferability of the highest power no longer remains. The establishment of modern democracy is an epoch-making achievement in human history. In those countries that have set up solid democratic systems, the various vices and evils of autocracy—feudal despotism, court intrigues and coups, usurpation of power, the killing of ministers, and wars of imperial succession—have disappeared.

At present, there exist heavy feudal autocratic vestiges in our country. In addition to cleaning away the influences of feudal autocracy in our thinking, we must also start with the removal of the expressions of feudal autocracy in our national system—the overcentralization and nontransferability of supreme state power—in order to annihilate these feudal remnants.

1982

3 | The Constitution from a Long-term View

Editors' Introduction: This essay typifies the work of Yan the insider as reformer. Gingerly treading within the bounds of official policy, this essay details some of the significant elements of the new PRC constitution in 1982 and brings in some comparative insights about leadership relations in the constitutions of other countries. Yan makes his own suggestion about how to clarify one article of the draft constitution, and basically echoes the official line about the importance of the draft constitution.

This essay originally appeared in *Guangming ribao* (Illumination Daily), May 5, 1982, and was reprinted in *Quanli yu zhenli*, pp. 149–51.

* * *

In drawing up a constitution, every concrete item and detail must be conscientiously vetted; but, more importantly, the questions that have the greatest influence on national political life must be grasped. Today, in our discussion of the revised draft of the constitution,[1] we must take a future-oriented, long-term view.

Each constitution considers certain fundamental questions, among them are the [setup of] the state organs, especially the relationship between the government and the people, the organic form of state institutions and the mutual relations among them, the relationship between central and local governments, and the position and role of the armed forces in the country. How ques-

tions like these are dealt with in the constitution will have far-reaching implications for our country.

Take the relationship between state institutions and the people, for example. If the people cannot influence the choice of the actual power holders, if the actual administrative power holders have lifetime tenure, then the people will be unable to influence state policy and will find it hard to express their wishes and demands through established channels. The revised draft constitution evinces great improvement with regard to the relationship between state institutions and the people. The state president, and the chairman of the Military Affairs Commission will be elected by the National People's Congress, the premier of the State Council will be nominated by the state president and voted upon by the National People's Congress; all these positions will not only be revokable but will also be of strictly limited tenure. In this way, the elective system, the appointive system, and the system of limited tenure are combined. Such a combination is a system of political responsibility. Whether a socialist country has a healthy socialist democracy depends on whether the major state leaders shoulder political responsibility. Broadly speaking, political responsibility is also a kind of legal responsibility, though it differs from ordinary legal responsibility or administrative responsibility. Even without the violation of law or dereliction of duty, an official cannot continue in office if he loses an election or is recalled. This is a kind of political responsibility. The draft constitution stipulates restrictions on terms of office and can cause the system of political responsibility to develop in practice.

The draft constitution has many new characteristics with regard to the organic forms of state institutions and their mutual relations. The relations between the state president, premier of the State Council, and the chairman of the Central Military Commission will influence national political life in the future and therefore need to be carefully studied. Four main models exist in the modern world with regard to the mutual relations among the head of state, the head of government, and the highest power holder in the administration. First, the head of state and the head

of government can be combined to hold the highest administrative power in the nation, such as in the United States. Second, the head of state and the head of government can be separated, with major power held in the hands of the head of state, such as in France, North Korea, and Romania. Third, the head of state and the head of government are separated, but the head of government has actual power, as in Great Britain and Japan. Fourth, neither the head of state nor the head of government holds actual power, which is controlled by some other people not explicitly stipulated by the constitution. To ensure the authority of the constitution, the fourth model is totally without merit.[2]

The newly publicized draft revision of the constitution adopts the limited terms of office system; this is a very significant improvement. The abolition of lifetime tenure of the highest offices and the adoption of a system of limited tenure are epoch-making events in the history of socialist countries and unprecedented in Chinese history. Though the 1911 Revolution deposed the emperor, it never solved the question of lifetime tenure for the highest office. After the Fifth Plenum of the CCP Eleventh Central Committee decided to abolish the lifetime tenure of leadership positions,[3] this revised draft version of the constitution further stipulates explicitly that the top leaders will be subject to limited tenure. This is a very important event in our Chinese history. Its influence will gradually reveal itself as time passes, since numerous calamities in our country's history were closely related to the lifetime tenure of the highest office. In the history of our country, when people look back on the twentieth century, they will see that China abolished the lifetime tenure of the highest office, which has thousands of years of history, after the CCP convened the Third Session of the Eleventh Central Committee [in December 1978].

Abolition of lifetime tenure means two things. First, a "retirement system" will be adopted for those offices that carry no limit in tenure. Second, "a system of limited tenure" will be applied to those elective or elective-appointive offices [officials whose appointment is subject to legislative approval]. With regard to the

later, if the election law and the election system do not specify an age limit, then the abolition of lifetime tenure does not mean retirement but entails the limitation of tenure. The revised draft constitution provides that the state chairman and the premier of the State Council "cannot stay in office for more than two consecutive terms." Because this provision can be interpreted in two ways, I suggest that the word "consecutive" be struck from the text, thus becoming "cannot stay in office for more than two terms."

Who has the authority to discuss and decide on the constitution? The people. The present discussion of the constitution fully reflects the principle that the people are masters. We must attach importance to and use our democratic rights, and actively participate in the discussion of the revised version of the draft constitution, in order to make the fourth constitution since the establishment of the new China better and more suitable to national conditions.[4]

Notes

1. A draft of China's 1982 constitution was published "for discussion" in April 1982. It was revised and promulgated in December of that year. For translations of the respective versions, see *Beijing Review*, no. 19 (May 10, 1982), pp. 27–47 and no. 52 (December 25, 1982), pp. 10–29.
2. In other words, party leaders should not control state activities.
3. See Text 1, "On Abolishing 'Lifetime Tenure,' " in this volume.
4. Prior state constitutions were promulgated in 1954, 1975, and 1978.

1983

4 | On the Leadership Responsibility System

Editors' Introduction: Again, unlike most essays in this volume, this one is a product of Yan writing within official bounds. This essay is an exegesis on the nature of the "leader responsibility system" for the State Council, as incorporated in the 1982 Constitution of the People's Republic of China (Article 86). The concept is largely self-explanatory, and emphasis on the leadership responsibility system in the government apparatus was part of the efforts to separate party and state tasks and roles, and to improve the efficiency of the government. Yan's praise for the State Council policy is matched by his failure to discuss one of the more prominent features of any responsibility system: those who fail to live up to their responsibility should be replaced. Furthermore, he scarcely pays attention to the thorny issue of to whom these leaders are accountable.

This essay was originally published in *Renmin ribao* (People's Daily) on January 31, 1983, and reprinted in *Quanli yu zhenli*, pp. 203–8.

* * *

The new constitution [of 1982] explicitly stipulates that the "leader responsibility system" will be implemented in state administrative organs and the Central Military Commission. This stipulation, by clearly defining the leadership system of these state organs, will certainly play an important role in preserving

the centralized and unified authority of state administration and in raising work efficiency in state administrative organs.

Two Different Kinds of Responsibility System

The leadership system in state organs may take different forms according to the number of persons having the highest decision-making power; the "collegial system" and the "leader responsibility system" are two typical ones. When the highest decision-making power of an institution belongs to an organization composed of several persons, the leadership system is the "collegial system." When the highest decision-making power of an organ belongs to its leader, the leadership system is the "leader system." The "collegial system" is also called "the committee member system," or "collective responsibility system," while the "leader system" is also called the "leader responsibility system." Our state administrative organs adopted different leadership systems in various periods. Just after 1949, the Government Administrative Council—the supreme state administrative organ—pursued the "collegial system." It was stipulated that "the Government Administrative Council meetings can only be held when more than half of the council members are present. Resolutions can only be approved by more than half the council members present at the meeting." Members of the Government Administrative Council exercised equal power and the highest decision-making power of the council did not belong solely to the premier, but to all council members. When council members held divergent views on certain problems, the decision was reached on the principle that the majority prevails over the minority.

The constitution adopted by the First Session of the First National People's Congress held in 1954 changed the leadership system of our state administrative organs. The supreme administrative organ of the state changed its name to the State Council. It held plenary and executive meetings. Although the premier led the State Council's work and presided over its meetings, all State

Council resolutions and edicts had to be approved at its plenary or executive meetings. It was obvious that the State Council's leadership system, as stipulated in the 1954 constitution, was not the "leader responsibility system," but it was not entirely the same as that found in the Government Administrative Council. Thus some thought that the leadership system in the State Council resembled the "Council of Ministers." For the first time, the new constitution states explicitly that our central and local state administrative organs adopt the "leader responsibility system." In the State Council, the prime minister has overall responsibility, directing its work, convening and presiding over its executive and plenary meetings. All ministries and commissions adopt a system of responsibility for the minister or chairman, who heads the work of the respective organ, convenes and presides over the plenary and executive meetings of the ministry or commission. The new constitution also provides for the responsibility system for the [provincial] governor, mayor, and heads of counties, districts, townships, and towns at various levels of the local people's government. Administrative organs in national minority autonomous areas will also practice the "leader responsibility system." The constitution also establishes the state's Central Military Commission (CMC) to provide leadership over the armed forces. The CMC carries out a similar "leader responsibility system."

Basic Features of the Leader Responsibility System

In comparison with the "collegial system," the "leader or leader responsibility system" has two basic features.

First, under the "leader responsibility system," when a policy decision is made on various matters falling within the sphere of the institution, the leader and other leading members are not equal in power. The leader has the final power of decision. Under the "collegial system," members of the collegiate organization have equal or basically equal power. The chairman of the collegial organization has the right to convene and preside over the

organization's meetings. Some even have the right to handle the important day-to-day affairs of the collegial organization. But they have no power of final decision on matters of fundamental importance.

Second, under the "leader system," the leader is personally responsible for the various significant decisions falling within the organ's jurisdiction. The "Organic Law of the State Council of the PRC" provides: "The premier signs the resolutions, orders, administrative regulations, and proposals presented to the NPC or its standing committee, and makes personnel appointments and dismissals." The premier's personal signature is a manifestation of his individual responsibility. This is fundamentally different from the "collegial system," under which every member assumes common responsibility for the final decisions of the collegial organization. All members have the obligation to play their role in the collective decision-making process, but they are not individually responsible for the collective decision. If a member's (including the presiding officer's) proposal is accepted and adopted as a collective decision, that member himself will not be personally responsible for the decision. Therefore, the collegiate system is a collective responsibility system, whereas the leader responsibility system is an individual responsibility system. Under the People's Congress system in our country, an administrative leader's individual responsibility takes two forms: he is responsible to the people's representative organs as an institution and he is responsible to the leader at a higher level. For example, the various ministers and commissioners in the State Council are responsible to the premier. Heads of divisions, bureaus, and departments of the State Council's ministries and commissions are not directly responsible to the People's Congress, but they are responsible to their administrative superiors. Consequently, under the leader responsibility system, the administrative power of the State Council and various local state administrative organs is highly centralized and unified. The leader responsibility system is one that strengthens the power and responsibility of the leader.

The Applicability of the Leader Responsibility System

The leader responsibility system is not applicable to all organizations and institutions. The National People's Congress and its standing committee, the CCP Central Committee, the CCP Politburo and CCP committees at all levels do not adopt the leader responsibility system. Take the NPC standing committee as an example. While the NPC chairman is in charge of the standing committee's work, convenes its meetings, and handles the important day-to-day affairs of the standing committee, he does not possess the highest decision-making power over matters under the jurisdiction of the standing committee. Any bill or motion presented to the standing committee for examination and discussion can only be adopted by a simple majority of the standing committee members. For instance, while the constitution provides that the NPC standing committee has the right to decide on the ratification and abrogation of treaties and important agreements concluded with foreign states, the chairman cannot arbitrarily ratify a treaty if a majority of the standing committee members refuse to ratify it. Similarly, the central and local party committees and the party's leading core—the Politburo—pursue a collective leadership system. Members of a CCP committee enjoy equal rights, and decision making on all important matters must be through collective discussions. When committee members hold divergent views, the majority-rule principle applies and, like other members, the secretary of a CCP committee can cast only one vote. However, it is also necessary for the party's routine work organizations and other functional organizations to adopt some kind of individual responsibility system.

There is a certain limit to the applicability of the leader responsibility system. "When making a decision, draw upon advice from far and wide; when undertaking a task, make specific assignments." Generally speaking, when we enact laws, rules, regulations and principles or decide upon important matters, it is advisable for us to discuss them fully in order truly to pool the opinions from all quarters and avoid making mistakes arising

from hasty decisions. However, when we execute a policy, direct the actual work or make decisions on specific administrative matters, we should act expeditiously and make clear the individual responsibilities in order to raise work efficiency. This principle is reflected in the new constitution where it differentiates decision making in organs of state power and decision making in state administrative organs.

The Leader Responsibility System in Our Country

Our new constitution and the "Organic Law of the State Council" enacted in accordance with it, explicitly state that on the one hand, the State Council pursues a prime ministerial responsibility system; on the other, decisions on all important matters can be made only through discussions carried out in executive or plenary meetings of the State Council. In his "Report on Restructuring the State Council," Zhao Ziyang pointed out: "The State Council standing committee is the State Council's day-to-day leading organ. Presided over by the premier, it exercises leadership over and makes decisions on various important affairs within the State Council's jurisdiction." This shows that the State Council leadership structure has drawn upon the merits of the usual leader responsibility system as well as the collegial system but avoids their weaknesses; it is a kind of leader responsibility system that possesses the virtues of the collegiate system. Lenin once said: "While we need the committee to discuss some basic problems, we also need individual responsibility and individual leadership to avoid the phenomena of procrastination and the shirking of responsibility." With its executive and plenary meetings to "discuss some basic problems" as well as the premier responsibility system to "avoid the phenomena of procrastination and responsibility-shirking," our State Council has adopted a leadership structure that conforms to our national conditions.

The adoption of a leader responsibility system is an important reform in the leadership system of our state administrative or-

gans. This reform should be closely integrated with the reform of state administrative institutions. If the setup of state administrative organs is irrational, if the functions, powers and responsibilities of various departments and units are not clearly defined, if the chain of command within administrative organs is chaotic, then it is impossible to implement effectively the leader responsibility system. It is thus necessary to make the structure of state administrative organs at all levels scientific. Administrative activities of the same nature should be governed by the same organ; the power of leaders at all levels should be commensurate with their responsibilities. Under normal circumstances, issuing orders and instructions, requesting instructions and submitting reports should follow regular procedures while the bypassing of the immediate leadership (level) should be avoided in directing work and requesting instructions. Channels of information inside an organization should be kept unimpeded; the powers and responsibilities of each position in an organ should be clearly defined and effective criteria for evaluation, award and punishment should be worked out. In short, the State Council and all levels of local government should set systematic administrative laws and regulations, clearly defining the functions and powers of each administrative organ and its leaders, as well as the units and their personnel within the organ. In so doing we will be able to reform further the state administrative organs at all levels and cause the people's governments organizations to be highly efficient in administration and to serve the people wholeheartedly.

1986

5 | Science Is the "World of Three-Nos"

Editors' Introduction: This brief essay is a concise statement of Yan's ideals for doing research in spite of the obstacles facing the development of political science in China. Yan criticizes "some people," probably referring to the likes of CCP ideologists Hu Qiaomu and Deng Liqun, who wish to make it a "political question" to study political phenomena in China (thereby excluding politics from legitimate intellectual inquiry and contention). Yan wants to free contemporary Chinese political science from the shackles of dogmatic Marxist theory and open up all questions of politics to investigation. No question has been definitively answered, there is no subject that cannot profit from further examination, he argues.

Written at about the same time as the publication and subsequent banning of Yan and his wife's book on the Cultural Revolution (the publisher withdrew the book from distribution for a few months on instructions from the party commissars in 1986), this essay can also be read as a personal statement in defiance of the ideological control by the party ideologues. In this connection, Yan is perhaps calling for further investigation into Mao's role and the nature of the political system in China. The 1981 Resolution on the History of the CCP, which identified Mao as a great revolutionary who made serious mistakes in his later years, is probably an implicit target here.

Originally published in *Jingji ribao* (Economic Daily), May

24, 1986, p. 2. Reprinted in *Quanli yu zhenli*, pp. 334–35.

* * *

Scientific research must promote "three-nos": science should have no forbidden zones, no idols, and no pinnacles. On scientific questions, power cannot automatically bring truth to those in authority. Power cannot limit the scope of scientific investigation, nor can it transform the power holder's wrong views into truth, and it cannot limit the development of truth.

Science has no forbidden zones. For those of us studying political science, "politics" itself is the object of investigation. Whether it is the form of government, administrative management, party-state relations, international relations, or even the politicians or leaders themselves, all of these are objects of study in political science. Some people like to draw a dividing line between political questions and academic questions, affirming that there can be free discussions and contending schools on academic questions, but not on political questions. This brings insurmountable difficulties to those of us who study political science. Reform of both the economic system and the political system entails crucial political questions in our country: how can we not investigate and study them? Science has no forbidden zones. In political science, even political questions should be discussed and different views on them aired.

Science has no idols. In theology, God is the idol and the Bible is truth. In science, however, no classical theory is an idol for adoration. When theory cannot account for the various new phenomena and new problems found in practice, this is not a "crisis" of theory, but a new starting point for theoretical development. Marxism is a science, not an ossified dogma. Currently, our country is reforming the economic system and encountering numerous new phenomena that old theories cannot explain. Theoretical workers should rejoice in this, break the fetters of old theories and old ideas, and bring forth new theories and new ideas.

Science has no pinnacles. Because science has no forbidden zones and no idols, its development should have no limits. The

view that existing scientific theories can account for everything is a sort of "scientific pinnacle" theory. It is a theory of the slothful in the scientific realm. When some make new discoveries and bring forth new achievements in scientific research, the newcomer has the opportunity of making even newer discoveries and bringing yet greater achievements. The same problem, the same topic, can be studied and discussed by different people; any researcher may make greater contributions on the basis of the research achievements others have made. China's modernization is the greatest research topic facing contemporary China and all researchers have the right to create yet new pinnacles on the pinnacles of research in this area.

In the scientific world of the "three-nos," the basic principle of scientific research is free discussion and letting a hundred schools contend. Human history has shown time and again that truth cannot be monopolized. Any "theoretical edifice" propped up by power is an edifice built on sand. It will disintegrate as soon as the strong spring wind of free discussion and contention blows.

6 | In Pursuit of Truth and Beauty

Editors' Introduction: This statement is a demand for intellectual autonomy in all fields of creation. There can be no creativity without a sense of freedom by intellectuals, both internally and externally. Yan draws on Einstein for this distinction. (External freedom refers to not being punished for saying controversial things; internal freedom refers to being free from the weight of tradition and social prejudices.) Truth and beauty are ends in themselves, he argues. Fang Lizhi, China's most prominent dissident from 1985 to 1989, also spoke of internal and external freedom. (See Orville Schell, *Discos and Democracy* [New York: Pantheon, 1988], p. 134.)

Originally published in *Renmin ribao* (People's Daily), June 13, 1986, p. 5, with the title "Zhuiqiu zhenli he mei de yuanwang youxian yu yiqie" (The desire for the pursuit of truth and beauty takes precedence over all else). Reprinted in *Quanli yu zhenli*, pp. 336–39. The present title was chosen by the editors.

* * *

For scholars and theoretical workers pursuing academic research, adoption of the "double-hundred principle" guarantees their academic freedom.[1]

Academic freedom is not merely an important condition for scientific development; in itself it is a much-prized goal for scholars seeking truth. All academic researchers hope to express

their opinions and views freely and straightforwardly, hope for an environment in which one will not be punished for pursuing and standing by truth, an environment in which one can work for the development and prosperity of science and culture in China, and hope to see giants of science and culture sprout and grow one after another in our great motherland. For many years, the academic and theoretical circles in our country have been disgusted with the phenomenon of relying on power to support one viewpoint while prohibiting another. If we believe that no wrong opinions can exist for long after free discussions, if we believe that people can correct their wrong views and opinions through free discussions, if our journals and newspapers can allow free debates among different academic viewpoints and permit criticisms and countercriticisms without the interference of power, then not only will there be the development of scientific and cultural endeavors in China, but it will also be greatly advantageous for the building of a highly democratic political system. The question of how to build a highly democratic socialist political system is both political and academic. Without full academic freedom, there will not be the study and investigation of what is politically highly democratic, let alone the actual construction of high levels of democracy in the political sphere.

The eminent scientist Albert Einstein once said: "Scientific development, and the development of creative spiritual activities in general," not only need "external freedom," "i.e., one would not suffer from danger or harm because of expressing views and opinions on general or specific questions of knowledge," but also need another kind of freedom, that is "inner freedom." "This spiritual freedom means that one's thought is not bound by authority or social prejudice, nor by illogical common beliefs and habits."

For those engaged in scientific and cultural endeavors, the degree of China's scientific and cultural richness not only depends on the degree of "external freedom" created by our society, but also depends on the degree of "inner freedom" in the hearts of thousands upon thousands of intellectuals. All inven-

tions, discoveries, creations, and progress begin with the thinking by people engaged in practical activities, and come from "inner freedom." Without such "inner freedom," mankind could not have made the huge achievements of today's science and technology, nor could it have produced such giants of thought and culture as Shakespeare, Voltaire, Tolstoy, Beethoven, Marx, and Lu Xun.

Science, to arrive at truth, must go through practice and make its choices in the ocean of thought; art, to reach beauty, must go through practice and make its choices in the ocean of images. Without the freedom of choice, there will be no creativity. If we say "academic freedom" is based on the principle that the desire for truth takes precedence over all other desires, then, similarly, we can say that the "freedom of creation" in art is based on the principle that the desire for truth and beauty takes precedence over all other desires. Only on such bases can science and art develop and human civilization progress continuously. Today, if we make our choices not in search for truth and beauty, but carefully choose our words in order to prevent possible attacks and injuries and gain political security, if we carefully quote Marx and Lenin here and there only in order to enhance the authority of our own opinions and to prevent criticism from others, then such choices cannot bring any creation, nor are they "academic freedom" and "creative freedom."

Note

1. The "double-hundred principle" is the abbreviated reference to "Let a hundred flowers bloom, let a hundred schools [of thought] contend." This principle served as the keynote to two brief campaigns of liberal expression in 1956 and 1957.

7 | Further Reflections on the "Cultural Revolution"

Editors' Introduction: Ostensibly a response to critics of Gao Gao and Yan Jiaqi's book, *A History of the Ten-Year "Cultural Revolution"* (for example, Wang Nianyi, "Ping 'Wenhua da geming' shi nianshi" [An Evaluation of *A History of the Ten-Year "Cultural Revolution"*], *Dangshi tongxun* (Party History Bulletin), no. 4 (1987), pp. 18–29), this essay calls for an intensification of reforms in all spheres, particularly in economics, politics, and foreign exchanges. Despite the achievements of the 1950s and early 1960s, (Yan ignores the calamity caused by the Great Leap Forward of 1958–60, when millions died of starvation in the years 1959–61), Yan strongly argues that China cannot return to the path of that period because the methods then adopted created conditions that were conducive to the onset of the Cultural Revolution. He advocates radical economic reform—establishing labor and capital markets as well as commodity markets, and more expansively, political reform. In so doing, Yan is advancing his own interpretation of Deng Xiaoping's revived call to discuss political reform in mid-1986 (Deng Xiaoping, *Jianshe you Zhongguo tese de shehuizhuyi* [Build Socialism with Chinese Characteristics] (Beijing: Renmin chubanshe, 1987), expanded edition, pp. 135–41, 144–48). Whereas Deng views political reform as bureaucratic rationalization, Yan favors checks and balances and borrowing foreign culture that transcends national borders—implicitly, democracy.

" 'Wenhua da geming' zai si" originally appeared in *Wenhui bao* (Literary Gazette) (Shanghai), July 15, 1986, p. 2. Co-authored with Gao Gao.

* * *

Twenty years ago, an unusual movement, called the Great Proletarian Cultural Revolution, originated and swept through the whole of China like a typhoon. China was then all meetings of criticism, struggle, lectures for practicing Mao Zedong Thought, and gatherings of denunciation. Big-character posters as well as handbills covered government institutions, schools, factories, and the countryside. Red Guards carrying the Little Red Book [of Mao's quotations] travelled hither and yon, speaking, shouting, and exchanging revolutionary experiences. Party and state leaders as well as numerous kind and upright people suffered from injustices, attacks, persecutions, and torture. The strong tide of the Cultural Revolution confused people's minds and made them wonder: why was the president of the republic [Liu Shaoqi] not protected by the constitution and laws of the People's Republic? Why would the "deputy commander" [Lin Biao] of the Cultural Revolution and [Mao's] heir apparent go so far as to betray the party, the state, and the people? As the wild tide of the Cultural Revolution gradually subsided, more and more people started to use their own minds to explore seriously the causes for the origins of the Cultural Revolution and all that happened around them. The "Criticize Lin Biao and Criticize Confucius Campaign," actually aimed at Zhou Enlai, and the "Campaign for 'Countering the Rightist Trend to Reverse Correct Verdicts,' " actually aimed at Deng Xiaoping, finally caused people to think hard and realize that the Cultural Revolution was a wrong movement launched for the wrong purpose and with the wrong means. The spread of this idea eventually led to the outbreak of the "Tiananmen Square Incident [of 1976]"[1] that shocked China and the world; afterwards, the wild tide of the Cultural Revolution began to recede. After going through a full ten years of turmoil, Chinese history slowly started to

enter a period that is completely new both ideologically and behaviorally.

The Road of the 1950s Was One Leading to the Cultural Revolution

Without exception, those who lived through the scourge of the Cultural Revolution recall the 1950s and early 1960s as a quiet and wonderful era in comparison to what was to come. During the Cultural Revolution, the more the newspapers criticized the "seventeen years of the revisionist line," the more people realized how precious were the various achievements made during the [first] seventeen years. In fact, the seventeen years saw earth-shaking changes in China (Taiwan excluded); not only was a socialist system established, but also an independent and more or less complete industrial system and national economic system built. There was also great progress in science, education, culture, health, and physical education. However, as the Cultural Revolution becomes history and as we study how to prevent the revival of the Cultural Revolution in any form, we cannot but believe that its origins owe not only to the leaders themselves but also to social factors not subject to human will. The concrete form and methods adopted in the Cultural Revolution may be due to the personality, nature, psychology, and idiosyncrasies of Mao Zedong and other individual figures, but that "revolution" had deep roots in the economic and political system formed in the 1950s and early 1960s and China's traditional culture.

Prior to the Cultural Revolution, it was believed that socialism had two characteristics: 1) public ownership of the means of production; 2) implementation of the principle of "to each according to his work." In fact, prior to the Cultural Revolution, the "socialism" established in our country had three more distinct characteristics:

1. In the economy, planning and administrative means were the basic method for the "allocation of economic resources," with little room for the "market";

2. In politics, the party and the state were not separated and power was highly centralized;

3. In ideology and culture, the personality cult gradually grew, the "Double-Hundred Principle" was shelved, and foreign culture was denounced and denigrated.

To consolidate this sort of "socialist system," the dominant ideology became: "Take class struggle as the key link," "Give prominence to politics," "Criticize bourgeois [legal] right," "Two, rather than a hundred, schools contend,"[2] etc. Moreover, the influence of feudal despotism, which has a long history in our country, was not well dealt with after 1949. Under these circumstances, one political movement came after another one, the highest powers of the party and state gradually became concentrated in one person and the phenomena of personal arbitrariness and the personality cult became more pronounced with each passing day. The outcome of such a complex interaction of these and other factors finally led to the "unprecedented Cultural Revolution."

As we examine the Cultural Revolution as a historical phenomenon and study the causes for its origins, we may say that while the road of the 1950s led to great achievements in our socialist construction, it also led to the Cultural Revolution.

The Road of Reform and the Open Door Is the Road for Preventing the Recurrence of the Cultural Revolution and for Realizing Modernization

How is the recurrence of the Cultural Revolution to be prevented? Ten years after the end of the Cultural Revolution, the Chinese people, under the leadership of the Chinese Communist Party, finally came upon the road that would prevent the recurrence of the Cultural Revolution and make China prosperous. This is the road of reforming the economic and political systems that have been established since the 1950s, and changing a China of self-seclusion into a China of openness.

No economic system can long exist without the efficient "al-

location of economic resources." Up to now, two efficient ways for "allocating economic resources" have been found: one is to rely on the market, the other is to rely on planning and administration. Under conditions of perfect market competition, the government adopts laissez-faire policies that do not interfere with the economy, while the "economic resources" are efficiently allocated. Theoretically, without markets, the only way to allocate economic resources efficiently is to rely on planning and administration. The long history of capitalist development shows that the appearance of monopoly enterprises divides up the market of perfect competition and thus results in "a market of imperfect competition." In the market of imperfect competition, the efficient allocation of economic resources must rely on governmental interference in the economy rather than going back to Adam Smith. Meanwhile, seventy years of socialist practice has shown a truism of the opposite nature—that it is impossible to "efficiently allocate economic resources" by completely relying on planning and administrative means without using market mechanisms; it is a theoretical ideal, a sort of "economic utopia." Based on this realization, there has been an irresistible tide of economic reform in certain socialist countries for the past several decades. The Cultural Revolution was exactly a last-ditch opposition to this tremendous tide of economic reform.[3] After paying a heavy price during the decade of Cultural Revolution, the CCP and the Chinese people finally saw through the "Utopia of Universal Planning" and realized the significant effect of developing a commodity economy and strengthening the market on the "efficient allocation of economic resources" and modernization.

At present, in the course of economic system reform, new problems and obstacles are inevitable since the market mechanism is in the process of formation and "economic resources" cannot yet be efficiently allocated. Under such circumstances, should we return to the 1950s and revert to the old ways or resolutely push reform forward? This is a question of universal concern in present-day China. Now we have seen that the road of the 1950s cannot lead China to modernization, but can only

strengthen the economic functions of the government, obstruct economic development, and lead China to the Cultural Revolution. Today, our only alternative is to stick resolutely to the road of reform, develop the markets for commodities, capital, technology, and labor step-by-step, establish a scientific relationship between plan and market so that ''economic resources'' can be efficiently allocated, and make the economy grow smoothly and rapidly.

To prevent the recurrence of the Cultural Revolution and create a political environment which can guarantee steady economic development in our country, our political system must also be reformed. We should institutionalize democracy according to the law, establish and safeguard the authority and dignity of the constitution; change the situation in which power is overly concentrated, use power to check power, in order to establish democratic politics. Of course, at present, in reforming the economic system, in order to pursue economic system reform we must first reform the cadre system, further reform the setup of governmental institutions, change the phenomena of nonseparation between state and enterprise, and between party and state, in order to eradicate the various man-made obstacles to economic system reform.

Reform in China must not only import foreign science and technology, but also all cultural achievements that ''go beyond state and national boundaries'' and belong to all mankind. For this purpose, we must persevere in the open-door policy, develop political, economic, scientific, technical, and cultural ties with other peoples. At the same time, we must promote seeking truth from facts and emancipate our thinking. We must resolutely carry out the ''double-hundred principle'' in order to advance academic freedom and the freedom of [artistic] creation.

After many years of practice, we have come to realize that the road of reform and the open door is not only the road for preventing the recurrence of the Cultural Revolution, but also the road for transforming a poor and backward China into a China that is prosperous, democratic, and unified. We believe that the Chinese

people, having suffered the tribulations of the Cultural Revolution, will resolutely discard the practice, popular in the Cultural Revolution, of "rushing headlong into mass action," carry out reform in a planned way, overcome the various problems and defects found in reform with the spirit of science, and bring the cause of reform to success on the basis of strengthening the legal system.

Notes

1. The best Western account of the 1976 Tiananmen Incident, also called the April Fifth Movement, is Roger Garside, *Coming Alive* (New York: Mc-Graw-Hill, 1981), chapters 1–8. See also Ann Fenwick, *The Gang of Four and the Politics of Opposition* (Stanford University, unpublished doctoral dissertation, 1984).

2. The two schools refer to socialism and capitalism, with socialism bound to win, by definition.

3. With the exception of Yugoslovia, Yan's chronology is inaccurate. The most extensive economic reforms in East Europe were launched in Hungary and Czechslovakia in 1968, after the onset of the Cultural Revolution in China. Moreover, until the 1980s, economic reform was hardly irresistible in East Europe.

8 | Conversation with *Guangming ribao* Correspondent on China's Political Structural Reform

Editors' Introduction: In this interview, Yan presents the four central components of his view of political reform: horizontal distribution of power (roughly equivalent to checks and balances); vertical division of labor and responsibility systems; excluding certain social activities from government and party political intervention (establishing a certain degree of individual autonomy); and increasing popular involvement in government decision making. Of particular interest is Yan's knowledge and praise of the handling of the Watergate Affair during Richard Nixon's presidency.

"Yu *Guangming ribao* jizhe tan Zhongguo de zhengzhi tizhi gaige," was originally published in *Guangming ribao* (Illumination Daily), June 30, 1986, p. 2.

* * *

Correspondent Dai Qing[1]: In a symposium on cultural development held in May this year, you talked about reform of the political system. Comparing it with the current reform of the economic structure, do you think the call for reform of the political structure is equally pressing?

Yan: Reform in the political system touches on many questions. Some are very pressing, such as the separation of party and government, reform in the cadre system and the administrative

structure. Others should be carried out step-by-step. The central issue is to solve the problem of power over-centralization with the aim of building a socialist political system with a scientific political decision-making structure. The occurrence of the "Great Cultural Revolution" was related to the lack of a highly democratic political structure. Whether a country is democratic or not has a direct bearing on the state's important decision making and economic development. A nation or region without political democracy may experience temporary economic prosperity, but its long-term development will inevitably be hindered.

Dai Qing: The excessive centralization of power seems to be the combined effect of a certain structure, concept, and even cultural tradition; decentralization is easier said than done. Even some people who have great power but little effectiveness to speak of are complaining themselves . . .

Yan: It is necessary to correct the phenomena of power over-centralization step-by-step and in four aspects. First, the horizontal powers must be rationally distributed; and yet the administrative power must be unified to prevent "multiheaded politics" from emerging. The National People's Congress is the supreme organ of state power; however, the question of horizontal "division of power" exists whether in the center or the province, municipality, or autonomous region. During the Cultural Revolution, horizontal division of power was out of the question; under the slogan of consolidating the party's centralized leadership, state power was concentrated in the hands of a few people within the party. Doing a good job of horizontal division of power involves not only the relations among the legislative, administrative, and judicial institutions, but also the relations between party and government. In all countries of the world, the ruling party holds the state administrative power. How to separate the party from state administration is a major theoretical and practical question to be effectively dealt with in political structural reform.

Second, implement the vertical division of power. Power and responsibility are interrelated with each other; a certain position

implies a certain power and a certain responsibility. Higher-level administrative organs may revoke the decisions made by lower-level administrative organs, but cannot always make decisions for the lower-level organs. It is correct for us to oppose bureaucratism and require leading organs and responsible cadres to personally solve concrete problems, but the norm of vertical division of labor must be established; [higher-level organs] should not take the place of lower-level organs and undertake matters that are within the authority of lower-level organs. Some of our leading cadres believe that they can decide on whatever issues in a region or department, thereby violating the principle of vertical division of power. Deng Xiaoping says: "Our leading organs at various levels have handled numerous affairs that they should not and cannot deal with," while "the overwhelming majority of people have often failed to handle independently and responsibly problems which they should have dealt with." In my opinion, the rise of these phenomena is related to the absence of the concept and structure of the vertical division of power. We should start by reforming the system, make explicit the power and responsibility of organs at various levels, and implement the vertical division of power.

Dai: If the concept [of centralization of power] cannot be changed for the time being, couldn't we at least draw up a set of regulations to limit it?

Yan: You may perhaps remember the U.S. Watergate Affair: At the time the District Court of Washington D.C. ruled that the president turn over the tapes relating to the Watergate Affair. Nixon not only declined to provide the tapes, but demanded that the attorney general remove Special Prosecutor Cox from office. When the attorney general refused the order and resigned, Nixon asked a deputy attorney general to do it; but he, too, refused and resigned. Finally, another deputy attorney general removed Cox from office, acting on Nixon's order. As most Chinese see it, a president "has power, and therefore he has everything," so why didn't Nixon personally give a direct order to remove Cox from office? This is because in the United States the concept of divi-

sion of power has struck deep in people's minds. Within ten days of Cox's removal, Washington had received half a million telegrams angrily condemning the president, and an avalanche of mail overwhelmed Congress criticizing the president. Then the House Judiciary Committee voted to impeach the president on three charges. Under these circumstances, Nixon could not help but announce his resignation. . . . In my opinion, the political structural reform is aimed at preventing, once and for all, the recurrence of such a phenomenon as the "Cultural Revolution" in whatever guise. We must ensure long-term political stability and steady economic development through reforms.

Dai: So, in this sense, the change in concept is very important. "Power is everything" quite clearly differs from "the vertical division of power." . . .

Yan: Exactly. We have too little understanding of ideas like "division of power" and "restricting power with power." I have said that the discussion centering around cultural issues will serve as a guide to the reform of the political structure, and reform will inevitably lash at old ideas. In my opinion, political structural reform will definitely strike at the idea that "power is everything."

Dai: I think certain matters that do not properly belong to the realm of horizontal or vertical division of power, such as the power holders' arbitrary intervention in people's life or administrative intervention in academic research, literary and artistic creation, should also be reformed. If these problems are to be treated theoretically . . .

Yan: This is precisely my third point: the realm of government functions and power is limited. The realm that government power should not violate is that of "human rights," which varies according to country and time. During the "Cultural Revolution," governmental, or political power reached into all aspects of private life. Even paying tribute to the late Premier Zhou Enlai and expressing one's grief were interfered with. What "human rights" were there to speak of? You remember that, during the "Cultural Revolution," such organs of power as the Revolution-

ary Committees, the Workers' Propaganda Teams, the PLA Propaganda Teams, or the so-called Cultural Revolution Leading Group and their like not only brutally intervened in people's fashions, hairdos, hobbies, habits, and private life, but also reached into people's ideological realm—compelling people to express their loyalty to Mao, ask for Mao's instruction in the morning and report one's thoughts in the evening. People were deprived not only of their right to joy and thought, but also the right to grief. Hence, the outburst of the 1976 Tiananmen Incident. In the course of the economic structural reform, we have come to understand that government power is restricted to a certain realm, and various government departments should no longer directly operate and manage enterprises. This limit to government power actually entails a "division of power," between "governmental organs" and nongovernmental "social organs." I think that, through political structural reform, there should be a limit to the government's power over not only the economy but also social affairs. Only then will it be possible to realize "academic freedom" and "creative freedom" with guarantees.[2]

Dai: Don't "academic freedom" and "creative freedom" depend first of all on an openness in thinking and speech?

Yan: Yes. Promotion of the "double-hundred" policy is precisely to open up the path for "academic freedom" and "creative freedom." However, freedom should be guaranteed by law. "Freedom is the right to do whatever is possible within the parameters of the law" and this idea is a product of human civilization and progress. In the course of reforming the political and economic structures, this idea should be deeply cultivated in the hearts of the people. Therefore, we must place legal construction in a very important place during reform.

Dai: Has division of power in the above-mentioned three respects summed up the reform of the political structure?

Yan: Not yet. There is a fourth, and most fundamental and important point, that is, the relationship between the people and the government. It is imperative to enable the people to participate better directly or indirectly, and in ever-increasing numbers

in the decision making of state affairs. This naturally gets at China's basic system and the problem of how to strengthen the People's Congress system. Democracy should be guaranteed by the rule of law, though legal rule does not equal democracy. Building a highly democratic political system precisely means expanding citizen political participation. This concerns a host of questions such as the nomination, selection, and qualification of people's deputies.

From a long-term perspective, political structural reform involves chiefly the following four aspects: the horizontal division of power; the vertical division of power; the division of power between government and social organs; and the degree of people's participation in political decision making. Reforms of the political and economic structures together will become the two giant wheels pushing China's modernization forward.

Notes

1. Ms. Dai Qing is an outspoken journalist. She has been criticized and was put in custody after the Tiananmen Massacre of June 1989 until May 1990. Her political position has changed over time. She is well known for a series of interviews she undertook with prominent reform intellectuals. A profile of her career is found in the *Far Eastern Economic Review*, August 10, 1989, pp. 29–30. For criticism of Dai Qing, see "Guangming ribao Exposes Dai Qing's Activities During Turmoil," Zhongguo xinwenshe [China News Agency], September 13, 1989, *Foreign Broadcast Information Service, Daily Report China* (FBIS), September 13, 1989, p. 22.

2. Creative freedom refers to the freedom of literary and artistic creation.

9 | The Cultural Background to China's Political Structural Reform

Editors' Introduction: This essay, appearing in a journal largely designed for foreign consumption, makes the argument that it was the excesses of the Cultural Revolution which brought forward the reform movement in China. Yan's view that the Cultural Revolution was a product of traditional ideas of absolute power in the guise of a "modern" socialist state means that fundamental changes in China's political system must be introduced in order to counteract the influence of tradition. In contrast, others may blame Mao or more transient factors for the Cultural Revolution, and therefore argue that fundamental political changes are not really necessary. Unfortunately, the current Chinese leadership seems to subscribe to this later view.

The Chinese version originally appeared in *Zhongguo jianshe* (China Reconstructs), no. 10 (1986).

* * *

In the two long decades from 1966 to 1986, China lived through two different periods. 1966 to 1976 was the decade of the Cultural Revolution, while 1976 to 1986 has been the decade of preparing for and undertaking reform.

The Tremendous Differences in Political and Cultural Ideas in the Two Decades

Disregarding certain details, one sees a world of difference in

Chinese behavior and thought in these two decades. During the first decade, the dominant ideology was "Grasp class struggle everyday, every month, and every year," the "personality cult," the criticism of so-called "bourgeois rights," and the denial of the necessity to develop a commodity economy. In the second, "Take class struggle as the key link" has been discarded, knowledge and talent have been respected, and "the development of a socialist commodity economy" has become a matter of principle. Among these, we see a tremendous difference hidden deep in people's minds: In the first decade, it was believed that China would be able to avoid crisis and calamity as long as it had a perfect "person," an heir apparent who met the five conditions set forth by the "Great Leader [Mao]."[1] While politically, people believed that the leadership of a great country like China needed a perfect leader, people also believed that, economically, only reliance on a planning mechanism and a perfect plan that took into consideration every detail in the national economy could effectively manage the national economy; therefore, commodity production and market mechanisms were rejected as "capitalist." In the second decade, however, after the calamitous Cultural Revolution, people gradually began to realize that systems and structures were more fundamental than cadre training and selection.

The Idea of Comparing Political Systems Was Absent from China's Traditional Political Culture

Because of differences in political systems, in some countries power is highly centralized in the hands of one or a handful of persons; in other countries, the various institutions of state power check and balance one another, and no individual holds supreme state power.

The history of Western countries has seen various forms of political systems. In the poleis of ancient Greece differing political forms coexisted as well as alternated. Aristotle's *Politics* was a study of political systems using the comparative method. Since Aristotle, "the idea of comparing political systems" has become a major element in Western political culture.

The situation in ancient China was different. Whether unified or divided, China had basically the same form of political system and, therefore, the idea of comparing and classifying political systems never had a basis for development. Ever since Qin Shihuang, the First Emperor of Qin, unified China, the Chinese political system had always been highly centralized in terms of power. For thousands of years, China's neighbors were considered barbarian and the idea of comparing China with others never occurred. In China's traditional culture, the political system characterized by highly concentrated power was seemingly regarded as the only possible model, to the neglect of other forms. Even such thinkers as Deng Mu (between the Song and Yuan dynasties) and Huang Zongxi (between the Ming and Qing dynasties) did not go beyond the confines of the traditional Chinese political system, though they severely criticized feudal autocracy. Thus the doctrine of comparing and classifying state political systems never emerged in China.

In China's traditional political culture, it was believed that the good or bad of politics and the rise and fall of nations were not related to political systems, but were closely tied with the good or bad of rulers and ministers, the emperor in particular. "Good government comes from capable rulers," said Confucius [551–479 B.C.]. Mencius [390–305 B.C.] added that "Where there is a good ruler, there is peace and prosperity in a state." Similarly, China's numerous feudal rulers advocated "benevolent rule." Thus, this doctrine has long been corrupting and benumbing the Chinese people. For centuries, the common people either rose in rebellion to overthrow tyrants and corrupt officials or sought the emergence of "upright officials" and "honest rulers." Long propagated, this traditional idea made impossible any thought of changing the political system where power is highly centralized. Consequently, a major feature of ancient Chinese politics was that "good government comes from the right people."

Changes of Chinese Political Culture in Modern Times and the Revival of Old Ideas under New Conditions

After the Opium War [1839–42], the introduction of Western

culture into China made people pay attention to comparing political systems. At the end of the nineteenth century, the reformist leader Kang Youwei [1858–1927] declared that autocracy was the root cause of China's corruption and weakness. The heart of the [1898] Kang Youwei–Liang Qichao reform was, in today's words, "the reform of the political structure."[2] Since the 1898 Reform and the 1911 Revolution, advocates of different classes and political persuasions have fought ferociously over the question of political system and have tried different systems in actual political practice; all these, however, have yet to root out the cause of China's corruption and weakness. Influenced by the October Revolution in Russia, certain vanguard elements in China came to realize that socialism was the only road to China's prosperity.

With the establishment of the People's Republic of China [1949], Chinese history entered a new period. However, the socialist political and economic system established in China was heavily influenced by the Stalinist Soviet model. It was long believed that the socialist system and the system of planned management must exercise highly centralized control over the economy, politics, culture, and society. This idea of socialism coincided with China's traditional political culture; as a result, China's ancient political system of highly centralized power, after some changes, donned the mantle of "socialism." . . . Under the banner of "socialism," the Chinese people, being inured to China's traditional culture, soon were intoxicated with the search for perfect leaders who met the five conditions [set forth by Mao]. Their hope for economic development in China was placed on planned management, rejecting or neglecting the market mechanism and relying on "omnipotent" administrators. While the socialist world was undertaking far-reaching economic reforms, self-contented China relapsed into the unprecedented Cultural Revolution. The Cultural Revolution not only totally rejected the commodity economy, but also accepted as "treasures" such concepts as "unlimited power," "personality cult," and "revolutionary successors," all tainted by the ancient Chinese political culture.

The Proposal of "Political Structural Reform"
Marks a Profound Change in China's Political Culture

The calamitous Cultural Revolution awakened the Chinese people. Speaking of its causes, Deng Xiaoping once said: "Stalin seriously violated socialist law; as Comrade Mao Zedong put it, this could not have happened in such Western countries as Britain, France, and the United States. Nevertheless, since he was unable to solve the problems of the leadership system, not to mention other reasons, he still launched the decade-long scourge of the Cultural Revolution. This was a profound lesson."[3] As we push China's economic and political reforms forward, we clearly see that China's political culture is undergoing a far-reaching transformation with regard to "legal rule versus personal rule." The Chinese people now clearly understand that China's modernization and prosperity depends on changing the long existent phenomenon of the party taking over all government affairs without separating the party and government affairs, and on building a highly democratic political system. Meanwhile, they are reforming the highly centralized system, developing a planned commodity economy and strengthening the market mechanism.

China at the end of the twentieth century faces tremendous changes in its political and economic systems. To suit these changes, we must continue to cherish the valuable parts of China's traditional culture while discarding all backward ideas. We should also open to the whole world and absorb all outstanding cultures from all countries of the world.

Notes

1. The five characteristics a potential successor would have to possess, as put forward by Mao, appeared first in 1964 as part of the Sino-Soviet polemics. They included being: genuine Marxist-Leninists; revolutionaries who served the people; proletarian statesmen; models in applying democratic centralism; and modest and prudent. See *The Polemic on the General Line of the International Communist Movement* (Beijing: Foreign Languages Press, 1965), pp. 478–79.

2. The Reform of 1898, also known as the Hundred-Days Reform, was a brief attempt to restructure the Chinese political system while retaining dynastic rule. Its major catalyst was China's defeat by Japan in the Sino-Japanese War of 1894–95. Kang and Liang allied themselves with the emperor and provided the intellectual impetus for the reform. Conservatives eventually killed the reform program by rallying around the Empress Dowager Cixi, who put the emperor into custody. Kang and Liang escaped abroad.

3. We have not been able to locate the source of this quotation.

1987

10 The Scientific Meaning of the "Separation of Party and Government"

Editors' Introduction: This essay explains and expands upon one central point raised by then CCP General Secretary Zhao Ziyang in his report to the 13th CCP Congress in October 1987, namely, the removal of the party from direct administration of governmental affairs. Here Yan, who apparently contributed to the drafting of the Zhao report, is performing the function of explaining the report to the public via the *People's Daily*, the party newspaper.

Despite its official purpose, this essay is a good example of Yan writing as a political scientist. He draws distinctions, categorizes, makes broad comparisons, and deals with the question of party-state relations analytically, while at the same time making clear his commitment to political reform.

The issue of separating the party and state had been raised several times since 1978, with little or no effect. Zhao (and to a lesser extent, Deng Xiaoping) revived it in mid- to late 1987 in an effort to encourage broader political reform, which had been sidetracked by the student demonstrations of late 1986 and early 1987, and Hu Yaobang's forced resignation as party general secretary at that time. Zhao's report, including the section on political reform, was approved at the congress; nonetheless, Zhao is currently being criticized for doing exactly what the party approved of in 1987, abolishing party organizations in state organs.

Originally published in *Renmin ribao* (People's Daily), November 27, 1987.

* * *

The lack of separation between the party and the government and the displacement of the government by the party are fundamental realities in Chinese politics. Since we have always advocated "unified" party leadership, nothing can be done without the party issuing instructions and making decisions. During the revolutionary war, when the goal was to seize political power, the practice of "unified" party leadership was necessary. However, in the era of socialist construction, our work, tasks, and problems are becoming increasingly complicated and "unified" party leadership, the absence of party-government separation, and the displacement of government by the party exhibit more and more defects. The Thirteenth CCP National Congress proposed the reform of the political structure; and the separation of party and government is an important link to political structural reform. But what exactly is the separation of party and government? People hold different views on this question. Some think that separation of party and government means that party secretaries cannot concurrently serve as government administrative heads; if so, then there is separation. Others hold that separation means that the party no longer participates in the building of state political power and no longer makes decisions on government administrative affairs. Still others argue that the CCP as the ruling party has the leading role in the country's political activities and this must remain unchanged. Thus separation is utterly impossible.

To separate party from government, give impetus to China's political structural reform, and build democratic politics, we should start from some basic theoretical issues and have clear ideas of what are parties and governments and what is their role in state and social activities. By doing this, we can, from a theoretical perspective, arrive at the scientific meaning of the separation of party and government.

What Are Parties?

Here what we refer to as "parties" are "political parties." The existence of political parties is not a matter of course; they are

products of a certain level of socioeconomic development. The *dang*, or "parties" in ancient China referred to "local organizations"; it was later extended to cover groups of people helping each other politically. "Party associates" and "cliques" refer to groups of people who help each other politically and are narrowly partisan. These differ from political parties in the modern sense, which are sociopolitical organizations of people representing the political interests of different classes or different strata and factions in various classes. Political parties usually share three major characteristics. First, political parties have political programs or systematic political propositions which they use to express to society their political positions, attitudes, views and opinions. Second, organization and discipline are indispensable to political parties. Third, political parties must implement their political programs and propositions through channels of political participation and by taking over or controlling organs of state political power. A ruling party is one that forms a government and controls government power; it puts into practice its program, policies, principles, and views in the daily activities of government organizations.

In modern Chinese history, the CCP, the democratic parties, and the Guomindang (KMT) are political parties with completely different political programs. The Revolutionary Committee of the Chinese Guomindang, the China Democratic League, the China Democratic National Construction Association, the China Association for Promoting Democracy, the Chinese Peasants and Workers Democratic Party, the China Zhi Gong Party, the Jiu San Society, and the Taiwan Democratic Self-Government League are China's democratic parties. Most of them were founded during the War of Resistance Against Japan and the struggle against reactionary KMT rule; their political programs at the time of their founding were mainly anti-imperialist and patriotic, with demands for democracy—this was by and large consistent with what was in the CCP program during the new democratic revolution. On the eve of the country's founding, after summing up historical experiences, these democratic parties

revised their constitutions and decided to adopt the "Common Program of the Chinese People's Political Consultative Conference" (CPPCC) as their own. Since the founding of the PRC, they have taken the general programs of the constitution and the CPPCC constitution as their political program. Against the historical background of long-term cooperation between the democratic parties and the CCP, a multiparty cooperation system has come into existence under CCP leadership.

Political parties differ from ordinary social organizations which can be political (that is, sociopolitical organizations) and nonpolitical. An entrepreneurs' association, a go-players' club, a physics society, and the Federation of Literary and Art Circles are generally nonpolitical social organizations. In contrast, trade unions, the CYL (Chinese Youth League), and women's federations are ordinary political organizations; they are different from political parties in that they normally do not directly implement their policies through direct control of the organs of state power. Rather, they usually organize their activities to back the political parties they support or try to influence state political activities by putting pressure on organs of state power.

What Is Government?

Generally speaking, government means two things. In a broad sense it refers to organs of state power, which are empowered to make and enforce laws. A government includes the legislative, executive, and judicial institutions. Government in a narrow sense means the administrative organs. In some countries, government sometimes refers to the core of the executive branch, or the cabinet. In China, government means the state administrative institutions. The State Council is the central people's government and is the country's supreme administrative organ. Various levels of local governments are local administrative organs.

Governments and political parties have different functions. Government functions consist of state administration, that is, to manage the daily public affairs of a country or region as the

representative recognized by the whole society. According to the provisions in China's constitution and laws, a government is empowered to adopt administrative measures, enact administrative rules, issue decisions and orders, exercise leadership over the administrative activities of its various departments and lower-level administrative organs, draw up and implement state plans and budgets, and direct and administer state administrative affairs. In various countries, the relationship takes different forms between the government as state administrative organ on the one hand and organs of state power and the legislature on the other. In China, the National People's Congress is theoretically the supreme organ of state power and the local people's congresses are local organs of state power; the government as state administrative organ is the executive organ for the organs of state power, including enforcing the will of the organs of state power. To put it in a nutshell, as the representative recognized by society as a whole, the government is an organization that is engaged in state administrative affairs. Unlike the government, a social organization makes decisions that only have binding effect on its own members; similarly, the decisions of a political party have effect only on its party members. However, the administrative measures, decisions and orders issued by a government have binding effect on all lower-level administrative organs under it and on enterprises, institutions, political parties, social organizations, and all citizens—they must obey and implement them.

In the vocabulary of political science, a ruling party is one that forms the government (of course, in doing so, it can recruit members of other political parties and nonparty people into government). A ruling party always implements its program, principles, policies, and propositions by virtue of the government power under its control. In some countries, the central government and local governments are not in the hands of the same party, that is, they are formed by different parties. As the ruling party, the CCP can invite members of other parties and nonparty people to join the government. The many major principles, policies, and decisions of the CCP must be converted into state laws and policies

in accordance with procedures prescribed by the constitution and laws and implemented through the government. Over the past few years, the CCP Central Committee's decision on the reform of the economic structure and its proposals concerning the Seventh Five-Year Plan have been converted into laws, plans, and administrative measures in accordance with constitutional and legal procedures. The decision on political structural reform made at the Thirteenth CCP National Congress can be implemented by the party itself so far as the provisions on the party are concerned; the parts of the decision that deal with national political activities must be converted into state laws, policies, and measures by following legal procedures. For example, the Thirteenth CCP National Congress proposed that a national civil service system be established; this requires the speedy formulation of national civil service regulations and corresponding complementary measures, the establishment of national civil service administrative institutions, and preparations for the establishment of a National College of Administration. All these cannot be directly implemented by the CCP; rather, in accordance with constitutional and legal procedures, the NPC or its standing committee will enact the national civil service regulations and decide on the establishment of a national civil service administration, then the State Council will decide on the formation of a National College of Administration.

What Is the Purpose of "Separation of Party and Government"?

Party and government perform different functions in state political and social activities. Yet, for a long period, the practice of "unified" party leadership has meant that the party directly exercises state power and particularly government power—that is, it plays the governmental role. This is a circumstance that came into being and gradually developed in the years of war. Moreover, it has remained unchanged since 1949. In many localities, departments, and units, since power is overconcentrated in the

party committee, the party has done a lot of work that it should not and could not do, thus constantly miring the party leading organs in tedious and heavy administrative affairs. At present, the State Council and most of the departments, committees, offices, and bureaus under various local governments have their own party organizations that are usually responsible to the party committees that approved their formation. This practice affects the uniformity and efficacy of government work. Many local party committees usually have secretaries or standing committee members who are put in charge of specific government work; party organizations usually have "departments corresponding to various government departments" and they overlap. As it is often the case, party "secretaries and standing committee members in charge of government work" and the various "corresponding departments" bypass government departments of the same level to issue directly specific administrative orders and instructions to enterprises, institutions, social organizations, and lower-level government departments. Similarly, the lower-level government departments, enterprises, institutions, and social organizations usually report directly to and ask instructions from their party committee "secretaries or standing committee members in charge of government work." In actual political life, there are thus two overlapping organizational hierarchies in charge of state administrative affairs. Having become inured to this phenomenon, however, many people feel uneasy about the proposal for party-government separation and for clarifying their respective functions.

The absence of party-government separation appears not only in the party-government relationship, but also in the relationship between the party on the one hand and the people's congresses, judicial organs, enterprises, institutions, and various social organizations on the other. For instance, as far as the cadre personnel system is concerned, we have always stuck to the practice of centralized management of the cadres of party organizations, governments, people's congresses, enterprises, institutions, and mass organizations by the organization departments of party committees at various levels. Another example is that the rela-

tionship between the party and judicial organs is also characterized in varying degrees by the absence of party-government separation. The constitution explicitly stipulates: "The people's courts shall, in accordance with the law, exercise judicial power independently, without interference by administrative organs, public organizations, or individuals" [Article 126]. "The people's procuratorates shall, in accordance with the law, exercise procuratorial power independently, without interference by administrative organs, public organizations, or individuals" [Article 131]. However, in a sizable number of regions, the judicial and procuratorial organs usually find it difficult to perform their functions independently.

In China, the lack of party-government separation is mainly a problem concerning the party-government relationship. The party and the government have two different leadership systems. The party practices the principle of collective leadership; from the Central Committee to all other levels of the party committee, each member is entitled to only one vote in elections and in decision making on major problems, and the principle of the majority prevails holds. In contrast, the constitution specifically stipulates that all levels of government adhere to the practice of leadership responsibility. When government members disagree on important matters, the administrative head has final authority. Thus, if a provincial, city, or county party committee has secretaries and standing committee members in charge of government work, lower-level government departments will have to face both the party and the government leadership. Therefore, a system where the party and government are inseparable will make it difficult for the government to function independently, ensure consistent leadership, and put into practice the system of leader responsibility as prescribed by the constitution.

The Scientific Meaning of Party-Government Separation

In countries that have political parties today, the party system and the state power system are two related and yet distinct systems.

All political parties must study and make decisions on important national and local affairs. Yet, in different political systems, political parties occupy different places in state politics and convert their decisions into the will of the state in different ways. In China, the separation of party and government entails the following:

1. Party-government separation is first of all a division of functions. The party is neither a state organ, nor an administrative or productive organization. Organizationally, the party has no superordinate-subordinate relationship with the government, various state organs, enterprises, institutions, and social organizations. Party leadership is political leadership, that is, "leadership over political principles, directions, and major decisions and the recommendation of important cadres to organs of state power." In addition, the party is also supposed to exercise leadership over party organizations, including leadership over the party members in state organs, enterprises, institutions, and various social organizations, manage party affairs and, through party organizational activities and through the exemplary role of its members, mobilize the people into implementing its line, principles, and policies. The organs of state authority, including organs of state power, and administrative, judicial, and procuratorial organs, perform different functions. The government is the state administrative organ and it handles public administrative affairs as the representative of the whole society. Enterprises and institutions are not organs of state power. Party organizations in enterprises and institutions should play the role of supervisor and guarantor and help their directors, managers or administrative heads exercise overall leadership.

2. Party organizations should extricate themselves from specific state administrative affairs. Of course, the party should study and examine major national and local issues and formulate its own policies on them. However, the party should convert its views into the will of the state—laws, regulations, and administrative measures and decisions—in accordance with constitutional and legal procedures. The leaders (not necessarily its secretaries) of the CCP, the ruling party in China, can become

administrative heads; they then exercise government power not as leaders of the party but as administrative leaders of the government. To ensure the consistency and efficiency of government work and harmonize the party-government relationship, it is necessary to abolish gradually the party organizations in government departments and the various party committees which have secretaries and standing committee members who are put in charge of government work without being in government organizations. In addition, party departments that overlap with government organs should be abolished.

3. Concerning the cadre personnel system, there should be two separate systems for the party and the state. Leaders and workers of party organizations should be managed by party committees at various levels. Leaders and workers of organs of state authority should be separately supervised according to organs of state power, administrative organs, judicial organs, or procuratorial organs. Government cadres should be divided into administrative civil servants and professional civil servants. The party Central Committee and local party committees should, in accordance with legal procedures, recommend to people's congresses candidates for various types of administrative vacancies and supervise and manage the party members employed as administrative civil servants. Professional civil servants should not be subject to terms of office since they are permanent government employees. Their appointments should not be influenced by party committees, nor be managed by the party organization departments on the same level; instead, they are appointed according to legal regulations and supervised, according to grade, by the personnel department of the government.

4. When it comes to the relationship between the law, political discipline, and party discipline, the party's discipline inspection departments should concentrate on party discipline rather than handle legal and political disciplinary cases. The party's leadership over judicial work should be to formulate correct guiding principles for judiciary work, and uphold the unified legal system and the sanctity of law through the exemplary role

played by organizations and members in observing and enforcing the law. The party should help judicial organs exercise their power independently and support the courts and procuratorates so that they can exercise their judicial and procuratorial power independently, without interference by administrative organs, social organizations, individuals, party organizations, or party leaders.

. . . In conclusion, only by separating the party from the government, clearly distinguishing between the functions of party organizations and those of organs of state power, and harmonizing the relationship between party organizations on the one hand and people's congresses, governments, judicial organs, mass organizations, enterprises, institutions, and various social organizations on the other can we ensure that each department performs its specific functions and can we gradually move toward institutionalization. Only in so doing can our organs of state power and government work efficiently and the party effectively play its leading role.

1988

11 | China Is No Longer a Dragon

Editors' Introduction: The dragon is commonly regarded as a symbol of Chinese culture. The Chinese people, myth has it, are the descendants of the dragon (*long de chuanren*). According to Chinese reckoning, 1988 was the year of the dragon, the most benevolent of years in Chinese cosmology. In this essay, however, Yan Jiaqi presents us with a scathing commentary on the glorification of the dragon.

The iconoclasm contained in this essay is strikingly reminiscent of the antitraditional stance of the May Fourth Movement of 1919, when China's intellectuals and students decidedly broke with China's Confucian past, and advocated science and democracy for China. Yan argues that China would be much better off without the complacency and closed nature of China's past—"the middle kingdom syndrome." He argues that such self-satisfaction only impedes China's progress, and that the legacy of the dragon only inhibits China's necessary learning from the outside world. Yan's comments preview the themes found in the very controversial Chinese television series, "He Shang" (River Elegy), which was broadcast in June 1988. Both Yan's essay and "He Shang" have been the subject of intense academic and political debate.

In the aftermath of the Tiananmen Massacre, the views Yan expresses here and those in "He Shang" have been extensively criticized, with the ironic effect that China's self-professed revolutionary party, the CCP, is now defending traditional Chinese

culture. (On "He Shang," see *China News Analysis*, no. 1376 [January 1, 1989].) One of the rejoinders to Yan's essay is Zhou Yihuang, "Long zai jintian de xiangzheng yiyi" (The Symbolism of the Dragon Today), *Ta Kung Pao* (Hong Kong), June 13, 1988.

Also worth noting here is Yan's view that China and Taiwan will never be reunified until China is developed and democratic. This is an implicit rejection of Deng Xiaoping's ideas of "one country, two systems" proposal, meaning that the mainland and Taiwan will consider they are part of one entity, but with each area having a high degree of autonomy. Indeed, Yan's position is closer to that of the Guomindang on Taiwan than to that of Deng.

This essay was originally published in *Shijie jingji daobao* (World Economic Herald) as an interview on March 21, 1988 and was excerpted in *Renmin ribao*, May 23, 1988, p. 5. This is a translation of the excerpted version entitled "Zhongguo buzai shi long."

* * *

With the arrival of 1988, a "dragon wind" is sweeping over China. "Dragon lantern festival," "dragon boat race," "dragon song," "dragon cup award," "dragon feast," "dragon meal," "dragon food," and "dragon dessert" are found everywhere, not to mention dragons found on top, on the porches and pillars, and in the halls of every tourist hotel—dragons that are golden, silver, angry-eyed, wide-mouthed, flying, perched, or flashing because of the light bulbs attached. . . . The dragon is being revered by Chinese as the symbol of China's traditional culture in the late 1980s.

But what, after all, does the dragon represent of traditional culture?

Intuition tells me that the image of the forbidding and yet magnificent dragon continues to symbolize imperial authority or unlimited power. Even if it represents part of Chinese culture, that part belongs to the dregs. I think it highly inappropriate to compare a republic, with advanced democracy and civilization as its goals and marching toward modernization, to a dragon. The image of China should not be a dragon that is aggressive and gilded with gold or silver, and pearls and jewels. China's image

should be modest and ordinary; it is vast and yet poor, tenacious and industrious. China's prosperity does not need the protection or encouragement of a god dressed as a dragon, but requires our millions to reform steadfastly our political and economic structures and build a durable stable domestic environment; it relies on the superior wisdom and hard work of the rank and file. . . .

I believe that not only the fine traditions in Chinese culture are precious to contemporary China, but so too are the superior cultural achievements, values and ideas that go beyond state borders and belong to all mankind. China is no longer the China of yesteryear. A China that is ever more open cannot afford to leave again the great road of world civilization and be intoxicated with contentment with the "culture of the dragon" being surrounded by holy clouds. The reverence for the ubiquitous, omnipotent, and purely imaginary dragon is a modern version of totem worship. It appears that some Chinese are at a loss as to what to do without some kind of worship; but it is exactly this sort of worship that is unwittingly leading China off the road of world civilization. What is this dragon after all? In the world of "animals," it is the ruler over the masses of other animals and is the symbol of sacred and inviolable authority. The image of the dragon reveals completely the mentality of self-centeredness, self-conceit, of regarding oneself as being in a special position in the world rather than as being an ordinary member of the international community. What the "dragon culture" expresses is a self-consciousness that regards China as the center of the world, with other countries as mere embellishments, barbarians, and ordinary and undeifiable bears, eagles, cows, and elephants. This self-consciousness is just the outward manifestation of the parochial arrogance and complacency hidden in the hearts of some Chinese.

Yet, is not this blind arrogance, refracted from ignorance and a sense of inferiority, difficult to understand, appearing as it does in the year of 1988, when reform, openness, thought emancipation, and practice are resolutely promoted?

Indeed, thousands of years of feudal tradition and reverence of authority still linger undeterred in the subconsciousness of our na-

tion; the dragon is precisely the symbol for supreme and omnipotent personal authority. To be sure, any society needs authority. The authority of scientists, entrepreneurs, politicians, and social activists derives from their superior wisdom and hard work; the people praise and respect them because they have rendered outstanding service to the motherland and the people. It needs to be emphasized that what a modern society needs is depersonalized authority [eds.—Max Weber's rational legal authority]; and legal authority should replace the authority symbolized by the dragon. Laws are behavioral norms enacted or recognized by the state and enforced with the backing of state power. An individual, a government, a political party, an enterprise, or a social organization, must act within the confines of the constitution and other laws. The concept that the law is supreme should be established.

After thousands of years, personalized authority worship has become as natural to China's people as dressing and eating. The seniority mentality, officialdom, and personal dependency, all of which are derived from worship, have caused much more harm to the development of the Chinese nation than people have yet realized. The most worrisome of the damages is the inertia formed from the above-mentioned mentality—following in the same old rut, making do, shirking responsibility, and always chiming in with others. From government to enterprise, from organization to individual, we find people flinching from making decisions on matters that they could decide on by following the constitution and other legal regulations. In today's China, "the ask-for-instruction disease" is a heavy burden. The "dragon culture" has made us so inured to waiting for the administrative instructions from our superiors. The sometimes self-contradictory administrative instructions from one level to another actually invalidate the "rules of choice" as provided by law. No choice, no creation. The freedom of choice is the premise for all creativity. Besides its "prohibitory rules" and "imperative rules," the law also allows us the freedom of choice; this freedom, however, is being negated by the "dragon culture." As a result, the enthusiasm and initiative of the individual can hardly be brought into play,

leading naturally to the sluggish development of society. When we are intoxicated with the modern totem worship of the dragon, we could forget that the goal of reform is to encourage the full enthusiasm, creativity, and initiative of the people. This ferocious and omnipotent "dragon" hanging over the heads of millions makes people abandon their initiative and abstain from decision making even when they should make decisions; instead, people bathe in the hope for imperial favors and God-given fulfillments. We ought to change the concept of authority worship as represented by the "dragon culture," and make all levels of government and all enterprises and individuals shoulder their decision-making powers within their respective domains and make their own decisions when the legal "rules of choice" permit. Only in so doing can we reduce, to a bare minimum, the number of mistakes in decision making.

As a way for celebrating a festival or a business trick for attracting customers, the "dragon lantern festivals," "dragon boat races," and "dragon cup races" are blameless. The problem is that the image of the dragon in people's minds is yet to be set apart from feudal tradition; the repetitive proliferation of that blustering dragon wastes our energy, numbs our will, lets us feel conceited and intoxicated, and makes us shrink from obstacles. China is too obsessed with its own long history, too intoxicated with its "Ma Wang Tombs"[1] and "terracotta warriors,"[2] too satisfied with its "dragon culture"! This is a China lacking any urge to progress, a China complacent and conservative, a China hugging its ancient debris and broken relics, and a China regarding the dragon as its cultural symbol. When it is attacked, however, China can only groan in agony. Chinese on both sides of the Taiwan Straits are [in fact] not the "descendants of the dragon." How then can the unification of China be helped by such phrases as "dragon culture" and "descendants of the dragon"? China will achieve unification, but the premise of unification lies in the civilization, progress, democracy, and prosperity of the whole of China. The "dragon culture" cannot lead to the unification of China; instead, the self-conceit of the dragon obstructs unification.

In the real world, no one is perfect. Only god, the idealized image

of man, is perfect. Human capabilities are limited and human personalities are not immune to all sorts of weaknesses. A good political system must take into consideration the fact that humans are not gods and therefore must "be restrained by systems." The concept of the idealized dragon is apparently entirely different. The idealization of the dragon amounts to the indoctrination among the people of the idea that there is a master over all humans. Religion needs intoxication, needs to make people content amid equivocation and speciousness. The idealized dragon satisfies this sort of human psychological need.

Science is the enemy of equivocation and speciousness because it uses an exact and clear language. Even when there is "vagueness," "chaos," and "uncertainty" in the world, the scientific mission seeks to understand them with reason. For science, all that is not understood can be understood. With science, no concrete problem is beyond solution. Meanwhile, the "dragon culture" can only intoxicate us with a play of equivocal and vague language and concepts.

I am disgusted with the heaps of shoddily made "dragons." The dragon of today corrodes the Chinese nation. The dragon creates intoxication and makes us seek no progress! It makes us complacent and self-conceited! It lets us be content with our broken relics. The longer it stays in the Chinese spirit, the further it obstructs China's modernization. Unlike the mysticism and imperiousness of the dragon, science will not intoxicate us and truth is simple. China is no longer a dragon! We are no longer the descendants of the dragon! We are the sons and daughters of the Chinese earth! Let us rouse ourselves, walk out of the world of the dragon surrounded by holy clouds, and make China's future with our wisdom and hands.

Notes

1. The "Ma Wang Tombs," *Ma Wang Dui*, are the extensive dwelling remains excavated in the late 1950s and early 1960s. These finds, dating from the Western Zhou period (c. 1122–771 B.C.), were located in Ma Wang Village near the city of Xi'an.

2. These refer to the clay "soldiers" found in the tomb of the First Emperor of Qin, Qin Shihuangdi, near present-day Xi'an.

12 | How China Can Become Prosperous

Editors' Introduction: Yan paints a panoramic picture of the reforms that need to be implemented for China to become prosperous. The spirit of optimism infuses this essay, which was Yan's speech given at the *Ta Kung Pao* anniversary gathering in early 1988, when China was soon to launch a number of major policy initiatives, including an ill-fated price reform. The optimism here contrasts sharply with the pessimism found in "A Conversation with Professor Wen Yuankai," published in December 1988 (Text 16). By the end of 1988, spiralling inflation had frightened the Chinese leadership into adopting a stringent economic austerity program.

Yan starts with the premise that "to err is human" and that certain systems must be created that allow for mistakes to be discovered and rectified. He argues that with democratic politics, the rule of law, and the extensive use of the market, China will rapidly become rich. Yan's concluding example somewhat undermines his own argument, however. While Hong Kong emphatically relies on the market and the rule of law, as a colony it is hardly governed by democratic procedures. This essay originally appeared in *Ta Kung Pao* (Hong Kong) on March 19, 1988.

* * *

The topic of my talk for today is "How China Can Become Prosperous." This is a big subject and my basic belief in this

speech is that truth itself is simple and easily understood. I do not believe that a set of extremely complex but not accessible methods can make China rich and powerful. China's wealth and power must be created by the Chinese people using their wisdom and their labor; if the Chinese people themselves cannot know what they can do and how they should go about doing it, cannot know the road to making themselves rich, then China cannot become rich and powerful.

Give Free Play to People's Initiative

China is at present engaged in a reform of its political and economic structures. However, if this reform cannot bring into full play the enthusiasm and initiative of individuals, then it is of little use. Each person comes to know politics through his personal experiences. A successful reform must be conducive to bringing into play the initiative of the individual. Suppose, as I speak, I worry about the right or wrong of each word or sentence, exercise overcaution rather than freely express myself, then I will have little enthusiasm and initiative; I will then think it meaningless to give a talk or speech. I have always thought that China may have been overly strict with each person, as if one had to utter "absolute truth" when speaking at the podium. Under such circumstances, I think I would have only two choices: either not speak, knowing one's ability is limited, or add a footnote or two to what is socially believed to be the truth. Such a practice is the road to hindering our realization of truth and progress. I also think there are journalists from scores of newspapers present here. How can it be guaranteed that every one of the journalists will make an accurate report? Before leaving for Hong Kong, I have long heard that Hong Kong journalists are quite formidable and they will report on everything. Once there is an inaccurate report, however, there will be someone in China pointing to the Hong Kong paper and saying: How can this be? How can someone say so in Hong Kong! As I think this over, I believe some people are just too harsh with journalists. Journalists have their professional requirements, to be sure. But no one is perfect and

mistakes are inevitable. The diversity of journalists from scores of papers as well as the diversity of news sources are effective mechanisms for correcting the errors in reports. The freedom of speech and freedom of the press are what we should highly value; the basic point here is that we should recognize that no one opinion maker or journalist is the epitome of "absolute truth." Such "freedom" not only makes us recognize the truth, but also allows us to correct our mistakes in a timely manner.

Use Systems to Limit the Tenure of Leaders

China has a very long history. However, despite the differences among the political systems of the various dynasties, they were all built on the foundation of the "perfect man." Whenever Chinese society is faced with all sorts of serious problems, the only remedy that comes to the mind of the Chinese is to hope for the appearance of a morally upright and perfect leader, whose efforts will then change the status quo. For all the complexities of the "Cultural Revolution," its guiding idea is exceedingly simple, that is, China must search for a perfect leader in order to transfer the highest state power. The tremendous calamities caused by the "Cultural Revolution" shook this idea to its very foundations. As I see it, the starting point for China's political structural reform is to admit that no one is perfect. Since human beings have all kinds of defects and weaknesses, a system is needed to restrain them. The 1982 constitution [of China] explicitly stipulates that the tenure of office for the state president and government head will be two terms at most. The forthcoming Seventh National People's Congress will use predetermined procedures to effect the transition of powers held by the state and government heads. If the separation of party and state is successful in the future, the great significance of using systems to limit the tenure of state leaders will be seen more clearly.

Democracy Is an Error-Correcting Mechanism

Though it promoted "big democracy," the "Cultural Revolution" actually was a period of the total destruction of democracy.

To call the destruction of democracy "big democracy" was a great invention in human history. Therefore, I think there is a need today for clarifying the meaning of "democracy," to prevent certain people from using the banner of "democracy" to trample on "democracy." I believe the most important foundation for "democratic politics" is to recognize the imperfectability of human nature—to err is human. In an organization or group that cannot fully agree on goals, opinions, or values, the adoption of democracy means the making of group decisions according to agreed-on procedures and the will of the majority. The practice of democracy often requires people to bow to mistakes. When a majority of the people realize that the original decisions were wrong, then they can be corrected according to procedures that are agreed on by most people and predetermined. Needless to say, certain procedures may entail that some mistakes cannot be righted immediately, and democracy calls on us to tolerate this for a period (during which, we should not be barred from expressing our opinions on the wrong decisions). After a certain period (such as the change of government leadership), we can right the wrongs. Therefore, democracy is a mechanism for timely correcting errors and democratic politics is the politics for correcting errors by following certain procedures. The practice of democracy must follow procedures; even when errors cannot be righted for the moment, the minority must not use violence, or violate preset procedures, in order to impose its will on the majority. Of course, procedures are formulated by the people and inappropriate procedures may be revised by following predetermined procedures. When a country or an area has such an error-correcting mechanism, it has democracy; when a political party or a social organization has this kind of error-correcting mechanism, it has democracy. There are various forms of decision making in human society; on questions where there are clear goals and no disagreements over values, decision making should be left to science, advisory groups, and think tanks. Consequently, on scientific questions, we will not resort to majority rule, but will have to follow the dictates of truth constantly; on

questions of democracy, however, we must be constantly ready to follow mistakes [made by the majority]. The premise of democracy, like those procedures of freedom of speech and freedom of the press, as I just related, is to recognize the imperfectability of human nature, recognize that the decision makers possess different cultural levels and capabilities, recognize that people may freely express their opinions, desires and emotions, and make or revise decisions through established procedures.

Change "Personal Rule" to "Legal Rule"

Whether to recognize "human imperfectability" or not is also the foundation determining whether a country or area can establish "legal rule." The idea of "legal rule" is to establish the idea that laws are supreme; political parties, the government, enterprises, organizations, and individuals all have to obey the law without exception. The law establishes certain behavioral rules for us. Generally speaking, there are three kinds of laws: one is "rules of command" that order you to carry out certain activities; a second is "prohibitory rules" that forbid you from doing certain things; a third is "rules of choice." When the "rules of choice" permit, political parties, enterprises, social organizations, and individuals can have independent decision-making powers. Whether it is the party or government in relation to enterprises, organizations, and individuals, or the central government in relation to local governments, including the Special Administrative Region [Hong Kong] after 1997, the higher levels cannot violate the independent decision-making powers ordained by law. On the one hand, such independent decision-making powers permit the decision maker himself to forecast the outcomes of his actions, and to know that those actions in accordance with law are protected by the law and he will not be punished or sanctioned. On the other, owing to human imperfectability, when human decision making, owing to negligence or inattention, results in errors, the law is called upon to regulate the decision maker's rights and obligations so as to resolve the resultant disputes or conflicts. Today's China is still not

a country ruled by law, hence it needs reform. Inadequacies force leaders at various levels constantly to involve themselves in concrete matters and decide on them. Meanwhile, the lack of a clear line demarcating the scope of decision making for particular leaders results in multiple overlapping and contradictory orders, thereby invalidating the sphere of choice permitted by law. The lack of separation between party and government, between government and enterprise, between center and locality, between administrative organization and social organization causes numerous mayors, county magistrates, township heads, directors of all sorts, factory executives, managers, and school principals not to study the various problems independently, let alone make independent decisions. "The ask-for-instruction disease" is a most serious "organizational disease" affecting modern China. If this situation is not changed, no city, township, factory, or school can grow automatically and constantly. The prosperity of China depends on the development and growth of each city, each township, each factory, and each school. Consequently, I think the numerous, repetitive, tedious, and even self-contradictory orders are a heavy burden on present-day China. Without changing this situation of "personal rule," China cannot truly become prosperous. The Hong Kong Basic Law will explicitly stipulate the high level of self-rule for the Hong Kong Special Administrative Region. To respect this right of self-rule and guarantee it with the constitution and laws is the basis for the long-term prosperity and stability of Hong Kong after 1997. Not only the prosperity and stability of Hong Kong, but that of the whole of China will depend on the constitution and laws guaranteeing the independent decision-making powers of each level of government, each enterprise, each organization, and each individual. Only in so doing can our society be full of vitality and efficiency and the initiative of each of us be given full play.

Use the Market to Regulate the Movement of Resources

China's prosperity not only has to rely on political and legal reforms, but also on economic reform. I believe that economic

reform must also be based on the scientific knowledge of human nature and on the recognition of human material need. Faced with the ever-increasing need, a society can either use economic development to satisfy that demand, or issue moral injunctions and regard the quest for a better life as harmful, so as to restrain that need; these two different views of "human need" are also two different perspectives on "human nature." These two different perspectives will lead a country to entirely different destinations. The latter perspective was in reality a major reason for China's poverty and backwardness. Now that some people have certain social needs, then society itself should have people engaged in professions to satisfy those needs. The market economy is an effective mechanism for satisfying various human demands. In economies where two parties may freely trade, the free exchange through the market can produce an outcome that is most desirable to both parties. China's economic reform is to develop a commodity economy, that is, on the basis of nurturing and giving play to the functions of the market, let the government take on the functions of macrocontrol and market guidance, in order to satisfy the ever-increasing social demands. For a long time in China's economy, numerous opportunities and possibilities existed that would have allowed one to profit without doing harm to the interests of others; but China has had countless administrative restrictions and regulations that have prohibited people from doing so. As a result, the economy in present-day China, especially the economy prior to reform, has been a self-constricting one, one that mocks progress. And our present reform is to transform this economy that mocks progress into one that promotes growth. Only when this picture is fundamentally changed can China's economy develop rapidly. Economic development depends on the self-enhancement of each enterprise; the capability of self-development relies on the continuous renewal in the industrial structure of the whole economy. This needs a market mechanism to determine resource flows and requires giving full play to the initiatives of enterprises and their managers. The problem facing China's economic reform is how, in an econ-

omy dominated by public ownership, to establish an economy where the market determines resource flow, enterprises have self-development abilities, and the industrial structure is continuously renewed. Today, in some areas on the Chinese mainland, some industrial departments will develop the private economy on a larger scale, while using the stock and responsibility systems to reform the traditional public ownership system. I think all these measures are extremely useful explorations.

Using Law to Promote and Guarantee Reform

The press of time has forced me to start from how to know humankind and how to know human nature so as to shed light on China's reform and China's future. If we believe in human reason, believe in the effect of the free expression of all varieties of opinions, believe that people can always find their answers from among the varieties of opinions, then China can become prosperous quite easily. In the 1950s, Hong Kong was not as prosperous as Canton, and Canton was not as prosperous as Shanghai. In just thirty years, however, the picture has been completely reversed. Now Shanghai cannot compare with Canton. Canton is far from comparable to Hong Kong. I think this is inseparable from the quite adequate legal system and the spirit of enforcing that law in Hong Kong. Therefore, a major task facing China's political and economic structural reforms is to improve the legal system and imbue reform with the spirit of the rule of law. Use the law to promote reform; use the law to guarantee reform. I believe, if we do so, then China's prosperity will not be a very distant thing from us. . . .

13 | The Concept of "Omnipotence" Is a Serious Obstacle to China's Progress

Editors' Introduction: This speech by Yan argues for the rule of law in China, and implicitly, why it might be hard to institute the rule of law. The traditional view of omnipotent or unconstrained power is accepted by rulers and ruled alike in China. Power holders would presumably find it hard to give up their unconstrained power. Yet this traditional view of unrestrained power must be discarded before the rule of law can be established.

One is struck by Yan's use of a variety of rhetorical devices in reaching his audience. His speech reached a climax when he asked: "Why did the deputies of the NPC, which is the supreme organ of state power in China, have to 'put forward suggestions and appeals to the authorities'?" It is a question that strikes at the Achilles heel of the Chinese political system—the lack of accountability of the CCP leadership to the Chinese people.

Foreign readers would be particularly interested in Yan's ideas on how the transformation from rule by administrative order to rule by law might be carried out. Unfortunately, no such discussion appears here.

This essay, published in the Shanghai-based *Shijie jingji daobao* (World Economic Herald), May 2, 1988, p. 15, was based on Yan's speech at a conference of social scientists held in Beijing.

* * *

We should hold the following view of the ongoing political and economic reforms. First, we must face the difficulties of reform squarely. Second, we must build reform on the basis of the rule of law and use the spirit of legal rule to push reform forward.

Many measures that are being implemented are actually not reforms. It is indeed a misunderstanding to think that all measures that differ from past practices are reforms. China has always been a country under the control of "administrative orders." The behavior of each individual is determined by the "orders" of another individual, just as the behavior of one institution is determined by the "orders" from another. The "administrative orders" are always "vertical orders." China lacks "lateral connections" and "horizontal flows of information." The development of a commodity economy and the market mechanism will increase "lateral connections" and "horizontal flows of information." In the course of such a transformation, the legal system, especially the formulation of administrative and economic laws, ought to be strengthened in order to change the traditional and unitary "control by administrative orders" into the "rule of law." An inadequate legal system makes the appearance of various forms of confusion inevitable in the course of reform. Without the guarantee and foundation of a legal system, reform cannot succeed.

The reforms we are carrying out are just like the various vehicles running on the road. The present situation is that many of the old traffic rules need to be changed in favor of a new set of rules. However, before the new rules are formulated, many leaders have already started talking about them, that is, issuing various "administrative orders." Some leaders say that the "express lane" and the "slow lane" should be separated; others say that the "express lane" should be divided into the "super-express lane" and the "express lane"; still others say that the "bike lane" should be combined with the "pedestrian lane." Thus all sorts of views on the "new traffic rules" are issued to lower levels. As a result, trucks, motorcycles, bicycles, cars, and trolley

buses now move on the road according to their respective under-
standing of the traffic rules, causing problems to appear. Faced
with the three dilemmas—the "price problem," "the devalua-
tion of knowledge," and various "decadent phenomena in
society"—some leaders believe that the dilemmas cannot be re-
solved![1] In my opinion, no problem is beyond solution by a
competent government. How can there be insolvable problems?
The key issue is the lack of a set of new and scientific "traffic
rules."

Without providing reform with legal guarantees, it will be dif-
ficult to solve the three dilemmas relying on newspapers and
propaganda to guide reform. As soon as problems appear, certain
people [in the party leadership][2] will immediately think that they
were caused by some theoreticians, social scientists, or literary
writers trying to influence public opinion. These certain people,
brandishing the label of "transcending the law," want to punish
the theoreticians, social scientists, and literary writers. Over the
past decade, China's theoretical circles have made great contri-
butions to the emancipation of thought and the impetus of re-
form. Yet, they are always blamed for every problem that
appears. If the difficulties of reform are attributed to these theo-
retical circles, then why would our theoretical workers dare to
speak out?

At the recently convened National People's Congress (NPC)
and Chinese People's Political Consultative Conference (CPPCC)
sessions, many deputies "put forth suggestions and appeals to
the authorities." Why did the deputies of the NPC, which is
[theoretically] the supreme organ of state power in China, have to
"put forward suggestions and appeals to the authorities"? What
does this phenomenon tell us? Many people believe that so long
as they put forward suggestions and invite some leaders to sup-
port their suggestions, problems will be solved. In reality, how-
ever, we know that both the leaders and the deputies live on the
same soil. China's progress depends not only on party leadership
and correct policies, but also on the enthusiasm and initiative of
each level of government, each enterprise, each unit, and even

each person. What else should we rely on? The rule of law and the freedom of choice which legal rule provides us. At present, numerous, and often self-contradictory, administrative orders deprive quite a number of government organs, enterprises, units, and individuals of their freedom of choice—how can they still have initiative and enthusiasm?

The idea of omnipotent [unconstrained] power is a serious obstacle to China's social progress. Given this idea, leaders believe that their various administrative orders can solve all sorts of problems; thus a provincial leader will issue instructions on any matter in that province. Meanwhile, the mayors, county magistrates, and township heads ask and wait for instructions from above on everything. Rather than making independent decisions in accordance with the law and regulations, these lower-level leaders are constantly asking for instructions! Reporting to their superiors! And waiting! This is the phenomenon of "compulsory administrative control" in traditional Chinese society; and this phenomenon is inseparable from the fact that China lacks market forces and horizontal economic connections and is not yet ruled by law. If China is to be developed, the idea of omnipotent power must be discarded in favor of the rule of law in our country.

The idea of omnipotent power is closely related to our traditional culture. Almost all leaders believe that they can decide and issue instructions on any question. . . . During the Chinese New Year and other festivals, those whom we regard as good leaders at various levels will usually pay visits to some households; otherwise, they are regarded as showing no concern for the masses. Such a practice is actually a reflection of the idea of omnipotent power. Such "concern" implies that once you disobey me, I [the leader] can punish you in some other way rather than at your work place, give you "tight shoes to wear" [i.e., make your life uncomfortable] and deprive you of certain opportunities; meanwhile, I can reward those who obey me by showing more concern. Many leaders always believe that they have the duty to show concern for the various problems in people's daily lives. In my view, there should simply be working relations between the

leader and the led; the leader does not need to visit the masses at home (of course, he is free to visit friends). How can a leader have the right to waste other people's time without first getting their approval? The practice of governing society with adminis- trative orders fits in with the idea of omnipotent power. China's development depends on abandoning this idea of power, building reform on the basis of legal rule, and promoting and guaranteeing reform by law, so as gradually to transform China from a society "governed by administrative orders" into one "ruled by the law."

Notes

1. The "price problem" is inflation. "The devaluation of knowledge" refers on the one hand to the lack of respect for Marxist ideology and on the other hand to the fact that most intellectuals earn lower salaries than many workers and some peasants. "Decadent phenomena" refers to things like por- nography and prostitution.

2. Yan apparently had Hu Qiaomu and Deng Liqun in mind here. In the early and mid-1980s Hu and Deng were the most prominent conservative ideologues, though both went into "retirement" in late 1987.

14 | From "Traditional" to "Democratic" Politics—On China's Political Modernization

Editors' Introduction: This is a systematic exposition of Yan's views on the obstacles to democratic or modern politics in China. He sees profound continuities between imperial regimes and politics under Mao, and the implication of his remarks is that while some changes have been instituted since 1978, many continuities which obstruct China's political development remain in place. He advocates the separation of party and government functions, rule of law, use of democratic processes within both the party and the state, limited terms of office, etc., as ways of moving China toward democratic politics. The content of this and other essays by Yan is a clear indication of the degree of freedom of academic discussion that Chinese intellectuals enjoyed prior to the military crackdown of June 1989.

As is apparent in this essay and elsewhere in his writings, Yan does not see the problem in democratic systems of the "tyranny of the majority." Individual rights and their protection, even in the face of majority opinion, do not figure prominently in Yan's discussion of democratic politics, though they may be subsumed under his understanding of the rule of law.

Originally published in *Tianjin shehui kexue* (Tianjin Social Sciences), no. 4 (1988), pp. 3–6 and 29. This essay was based on a paper that Yan presented at the International Symposium on the Political and Economic Modernization in Chinese Societies held in Hong Kong in June 1988.

* * *

1. Basic Characteristics of China's Traditional Politics

While people usually understand past things and historical phenomena easily, they are often baffled by current events and incidents that are occurring. [Therefore,] . . . they strive to make entirely new explanations of ongoing events and changes. Once they appear in new guises, the various old things are immediately looked upon as unprecedentedly novel. Time, however, is a merciless arbiter; when the present becomes the past, reality becomes history; when the defects of "novel things" are seen by more and more [people], the stubborn force of tradition in historical development will eventually be recognized and people will then uncover, from a historical perspective, the various traces of the past hidden in the "present."

In China's history of several thousand years, no tradition lasted longer than the dynasty, no inertia exceeded the dynastic one. The many spectacular peasant wars as well as ever-recurring palace coups, military revolts, and foreign invasions did not interrupt the dynastic cycle. Viewing Chinese history broadly, there were a large number of feudal emperors and politicians whose enlightened policies and management resulted in China's wealth and power—such as the historically famous "Reign of *Wenjing*" [179–141 B.C.], "Reign of *Zhenguan*" [A.D. 627–649], and "Reign of *Kaiyuan*" [A.D. 713–741]. Nevertheless, the ensuing dynasties were ruined by incompetent and stupid emperors. For thousands of years, the Chinese people lived, sighed, and groaned along with the rise and decline of dynasties. The numerous sordid and corrupt phenomena of dynastic politics—the deification of imperial power, murder of meritorious ministers, usurpation of power by eunuchs and imperial relatives, factional strife, appointment of cruel officials, unjust frame-ups, struggles for the throne, and all sorts of palace intrigues—have appeared repeatedly in Chinese history. Whenever a dynasty verged on collapse, the burden shouldered by the Chinese people became heavier. Warlord separatist schemes and fighting also brought the Chinese people unparalleled calamities. Moreover, when a new

dynasty was established or a dynasty was temporarily "rejuvenated" and past calamities seemed to become things of the distant "past," when under the "prosperity" of the dynasty it was believed that another calamity was not to come again, a new scourge may be right in the making. . . . The Chinese nation has suffered such cycles of calamities just as the wealth of the society is cyclically damaged and destroyed. . . .

The periodic rise and decline of traditional Chinese politics are closely related to four characteristics: first, supreme power was concentrated in the hands of one person, undivided and nontransferable; second, the power structure was unitary and pyramid-shaped and people lacked any idea of "horizontal power sharing"; third, there was no limit to the scope of administrative power, which interfered in all aspects of social life; the power concept of "omnipotence" was deeply entrenched in people's consciousness; and fourth, the use and transfer of power lacked procedures.

Though there were dynastic laws, the emperor was never constrained by them, since "the law originates from the emperor." Imperial power soared above all laws and "the defiance of all laws human and divine" [by the emperor] was the result of such unprincipled imperial politics. The supreme power controlled by one individual had no absolute guarantee but was established on the basis of succession principles and moral authority; as a result, the enhancement of imperial power became the intrinsic need of these unprincipled politics. To strengthen imperial power, the emperor often resorted to all kinds of sordid and brutal measures in order to overcome factors which hindered his goal. Since he had life tenure, the death of the emperor often produced tremendous shocks. . . .

2. Twentieth-Century Changes in Chinese Politics

Four significant historical events or facts have influenced twentieth-century Chinese politics: the Revolution of 1911, the establishment of the People's Republic of China, the "Great Cultural

Revolution," and the confrontation between forces on the two sides of the Taiwan Straits. Though the 1911 Revolution overthrew the Qing dynastic rule and spread republicanism in China, it did not actually end China's dynastic cycle and change the four characteristics of traditional Chinese politics. The attempt by Yuan Shikai to revive the throne struck the knell of republicanism;[1] this was followed by the emergence of traditional warlord politics in China. What Chiang Kai-shek built in China was not a democratic republic, but a new dictatorial dynasty with a colonial tinge.[2]

The unification of warlord military power could not interrupt the robust dynastic cycle and eradicate the four characteristics of traditional Chinese politics, nor could peasant wars. Peasant rebellions were either suppressed by dynastic rulers or transformed into the tools of dynastic change. No matter what the family backgrounds and personal qualities of peasant leaders were, all of the victorious peasant wars established new dynasties without exception; not a single one of the peasant wars in Chinese history betrayed this historical law. Until the first half of this century, the armed forces led by the Chinese Communist Party were still mainly composed of peasants. Just as Mao Zedong said, the armed struggle of the Chinese Communist Party was essentially a peasant revolution and peasant war. This was the largest peasant war in modern Chinese history since the Taiping Revolution. Precisely because it was a peasant war, Mao Zedong, during the Yan'an "rectification" of 1944,[3] specifically pointed to the lessons of the degenerative nature of peasant wars. If the ancient tradition of historical development in China were followed, a new and stronger dynasty would have been established in China after the victorious peasant war. However, the ancient historical cycle took on new contents in the twentieth century; in 1949, a new state—the People's Republic of China—was founded in China.

On the Chinese mainland, the 1950s saw a series of prominent achievements in economic development. Beginning in the late 1950s, however, China's "communization" movement transformed the countryside into numerous production units that were self-sufficient, lacking "lateral relations," and isolated. The

planned economy, with its rigid commands, also cut off the "horizontal relations" between enterprises. China's social structure actually veered away from the direction of modernization. The Chinese people took part in a series of campaigns such as the "Anti-Rightist Campaign," the "Four Cleans Campaign," and the "Great Cultural Revolution."[4] It was believed that those movements would speed up China's progress. History, however, has its own laws of development and no one can escape from the restrictions imposed by his era. The calamitous aftermath of the "Cultural Revolution" fully proves this point. Beginning in 1966, under the banner of "Continuing the revolution under the dictatorship of the proletariat" and the slogan of "Oppose the restoration of capitalism," there appeared an extraordinary movement in China that millions or even billions of people took part in. The reverence for Mao Zedong became a kind of religious fanaticism under which people easily accepted the idea of "choosing revolutionary successors." The "September 13 Incident" of 1971 and the infamous "571 Outline Project" deeply shocked the Chinese people, as yesterday's "deputy commander" and "heir apparent" [Lin Biao] revealed his true colors as a great liar and opposing the "supreme commander [Mao]."[5] As the wild tides of the "Cultural Revolution" gradually subsided, more and more people began to understand what occurred around them; by this time, as Karl Marx described in *The Eighteenth Brumaire of Louis Bonaparte*, "An entire people, which had imagined that by a revolution it had increased its power of action, suddenly finds itself set back into a dead epoch."[6] Seeing through the surface phenomena, people finally came to realize that what was called the era of the "Great Cultural Revolution" was actually an era of rampant feudalism; the four characteristics of traditional Chinese politics still remained on the body of the "People's Republic."

3. The Manifestations of "Unprincipled Politics" in Contemporary China

The "Cultural Revolution" was the focal expression of "traditional politics" in contemporary China. In the thirty years since

1949, the de facto supreme power, indivisible and nontransferable, was held in the hands of one individual. In China, owing to the lack of distinction between party and government, and the actual displacement of government by the party, the powers stipulated for the state leader by the constitution were in fact held in the hands of the party leader. The so-called lack of party-government division means that "the party may issue orders over all matters dealt by the government." The Chinese Communist Party, through the "party cells" in all government organizations, can bypass administrative leaders of all levels of government who are not party secretaries and exercise direct leadership over all government departments; the party secretaries and standing committee members often directly issue all sorts of specific administrative instructions to lower-level government departments, social organizations, institutions and enterprises. In China's practical political life, there are thus two overlapping organizations that manage national administrative affairs. The lack of government-party separation and the displacement of government by the party mean that there is another "government" that controls major decision-making powers over and above the "government" set up according to the constitution. Though the Chinese constitution stipulates the powers of the National People's Congress (NPC), State Council, Supreme Court, and Supreme Procuratorate, power is actually still concentrated in the hands of one person. For a long period, politics in contemporary China revolved around the enhancement and consolidation of this supreme power. Its difference with traditional Chinese politics is that this supreme power is neither divine nor hereditary; rather, it is built on the ideological correctness of the person who controls that power. In the circle of supreme power in contemporary China, as soon as a leader is ideologically perceived to have strayed from the Marxist path, his power is gone. In the "Cultural Revolution," the doctrine of "continuing the revolution under the dictatorship of the proletariat" was proclaimed as "the third milestone in Marxism," and all thoughts and opinions that were contrary to this "theory" were declared "anti-Marxist"; after the "Cultural

Revolution," the doctrine of "continuing the revolution" was discarded as were the powers of the propagators of the doctrine. Consequently, only when the supreme leader maintains the position of ideological probity can he consolidate his power. During the Maoist era, Peng Dehuai's criticisms of Mao Zedong's "three banners" were actions that shook Mao's supreme power; to maintain his hold on supreme power, Mao Zedong declared, in the first place, that Peng had betrayed Marxism ideologically. Mao then launched, within the party, an "anti-right opportunism" campaign, until Peng was stripped of his power.[7] In pre-"Cultural Revolution" China, Liu Shaoqi, and Peng Zhen,[8] among others, had formed a power center that was beyond the control of Mao Zedong; as a result, Mao had to launch a big struggle to undermine and even destroy the Liu-Peng power center. During the "Cultural Revolution," when Lin Biao, Huang Yongsheng, Wu Faxian, Li Zuopeng, and Qiu Huizuo coalesced into another power center that undermined the supreme power, the struggle between Mao Zedong and Lin Biao became unavoidable.[9] Even then, Chinese politics still followed the iron law of ancient China: the indivisible and nontransferable supreme power of the state was concentrated in the hands of one person and political struggle unfolded around that power. And yet these struggles did not follow predetermined procedures. At the Second Plenum of the Ninth Central Committee of the Chinese Communist Party, Chen Boda, a member of the Lin Biao clique, sang paeans to Mao Zedong's "innate genius."[10] Chen's paeans, however, were proclaimed to be "a priori idealism" by Mao Zedong and thus became evidence of his betraying Marxism. After the plenum, the Chinese press stepped up criticisms of Chen's "pseudo-Marxism." At that time, it was not important whether one's thoughts and views truly accorded with Marxism; but once the holder of certain views was declared a "pseudo-Marxist" or "anti-Marxist," he was destined to lose his political power.

Nowadays, as we carry out comparative analysis of contemporary and traditional Chinese politics, we discover that [campaigns

such as] "anti-rightist opportunism," "criticize capitalist roaders within the party," and "counterattack the rightist trend to reverse correct verdicts," were far from being "against wrong [political] lines"; rather, they were inevitable struggles arising from the preservation of supreme power in one man's hands. Since Mao Zedong had life tenure, since that supreme power was not transferable, contemporary Chinese politics naturally took on the nonprocedural forms of traditional Chinese politics. The question of the "personality cult" was not one of "exaggerating the historical role of one person," but a necessary measure used to enhance the indivisible and nontransferable supreme power. The choice of such successors as Lin Biao and Wang Hongwen can be compared fully to the installment of "crown princes" in traditional Chinese politics.[11] Hence, when the supreme power of a state is under the indivisible and nontransferable power of one person, the politics of that state must be "irregular."

After the "Cultural Revolution," important changes have occurred in Chinese politics. Since party and government have been distinguished from each other to some extent, supreme state power in today's China is no longer completely concentrated in one person as it was in the Maoist era; in theory, that power is no longer indivisible and nontransferable.

Indeed, in today's China, as the role of the market expands, "lateral relations" among social organizations have also increased day-by-day; however, the second characteristic of traditional Chinese politics—a unitary and pyramid-shaped power structure—continues to exist. According to the Chinese constitution, the National People's Congress [NPC] is the highest organ of state power, and the people's congresses at various levels and localities are the organs of state power there. In reality, however, the NPC and the lower-level people's congresses have far from exerted their influence as organs of state power. When the people's congresses are in session, most of the deputies never realize that they are exercising state power; rather, they incessantly make suggestions, give opinions, and issue appeals. In present-day China, the phenomena of lack of party-government

separation and the displacement of government by the party have clearly been reduced in enterprises and production departments; yet, the powers of party and state administrative organizations have not been fully separated. For a long time now, it is not only China's party and state leaders who believe they have the right of leadership over all matters in a locality, department, or unit and enjoy the "right" to issue various instructions; the people also hope that the leaders do so, inquire into and solve the problems in the area, department, or unit. Influenced by this concept of power, it is as difficult for people to form explicit conceptions of the separation of functions and powers between party and government institutions, between government institutions and enterprises, and among social organizations, as it is difficult for them to have clear conceptions of the separation of powers between different levels of government institutions. In present-day China, the power concept of "omnipotence" has yet to be challenged; and the powers of party and government institutions continue to reach at will into all aspects of social life. In short, contemporary Chinese politics is still rife with factors of "traditional politics."

4. How to Proceed Toward "Democratic Politics"

The "Cultural Revolution" swept one billion Chinese people into a huge storm, causing calamities that remain fresh in our memories. The failure of the "Cultural Revolution" made the Chinese people demand a merciless criticism of all its manifestations, in order that a road leading to China's prosperity might be found. As the harm of one person controlling the supreme power for life was clearly realized, the constitution passed in 1982 explicitly stipulated that the tenure of the heads of state and government will not exceed two terms.[12] This was a decisive step in eliminating the characteristics of traditional Chinese politics and marching toward procedural politics.

"Democratic politics" is a kind of procedural politics. Democratic politics does not have to search for perfect "successors," but emphasizes human imperfectibility; to err is only human.

When members of an organization or group disagree on a goal, view, or value, democracy means decision making and revising through predetermined procedures that members agree upon. Democracy cannot guarantee perfect decisions, but it can guarantee that wrong decisions may be corrected by following predetermined procedures. When a majority of the members discover in practice that the original decision was wrong, the original minority can grow to become the majority, thereby righting the wrong according to set procedures. The practice of democracy means that incompetent decision makers can be replaced by following predetermined procedures; without democracy, the people will not have the right to replace [leaders] according to set procedures. In traditional Chinese politics, owing to the indivisibility and nontransferability of the supreme power held by an individual, major policy changes and the correction of mistakes relied on nonprocedural means. It was generally believed in traditional Chinese politics that the quality of politics and the rise and decline of the state had little relationship with the political system; rather they were closely related to the power holders at all levels, especially the de facto holder of supreme power. Therefore, to advance toward procedural politics, the concept of "personal rule" must be disposed of both in theory and in ideology and the concept of "using the system to restrain" [power] should be established.

A ruling party is one which organizes the government. When doing so, it can draw members of other parties or nonparty members into the government. Any political party has the right to propose its own principles and policies on national problems of major importance. In a society "ruled by law," the ruling party, through channels authorized by the constitution and laws, may turn party decisions into national laws and government policies. In socialist countries, in contrast, the core leading organization of the ruling party is actually the highest decision-making body on national affairs. Changes within this core leading institution often occur when the individual who holds the supreme power disappears from the scene, and "collective leadership" based on one

person one vote replaces personal leadership; with time, however, "collective leadership" will again be replaced by the personal leadership of someone who controls de facto supreme power. The history of socialist countries shows that, within the ruling party, transitions from "collective leadership" to "personal leadership" were always effected by means of "intraparty struggles" that lacked both procedures and principles. Without procedural transfer of power, there is no democracy. Therefore, in contemporary China, the building of democratic politics must start from the establishment of an adequate democratic mechanism within the ruling party so that the transfer of power in the core leading organization of the party is based on predetermined procedures.

The separation of the party from government is an important key to marching toward procedural politics and modernizing Chinese politics. The essence of this separation is not merely the delineation of the functions of the party from those of the government, but the establishment of the constitution and law as supreme in order that the origination, use, and transfer of the state supreme power proceed according to procedures set by the constitution and the law and that rule by person becomes rule by law. The party is not a state institution; party institutions have no organizational superior-subordinate relations with state institutions, enterprises, and social organizations. Nationally or locally, only organs of state power may act as representatives of society and handle day-to-day public affairs. Whereas decisions of a social organization have only binding powers upon its own members, so too the decisions of a party can only have binding powers upon the party members; decisions of state power organs have binding effects upon all member of society. The CCP as a ruling party exercises political leadership and should transform its decisions into state laws and government policies through channels as provided for in the constitution and other laws; party organizations should not replace state organs in their exercise of power. Consequently, only by separating party from government can it be possible for different state organs, rather than party

institutions, to exercise the legislative, administrative, and judicial powers of the state. Only in so doing can it be possible to eliminate the phenomena where power was concentrated in one man's hands in traditional China and therefore make the exercise and transfer of power proceed according to the Constitution and law.

The modernization of Chinese politics is a long-term process: it is at once a process for building "democratic politics" and a process for changing a China of personal rule into one ruled by law. Adoption of party-government separation, improvement of the National People's Congress system, establishment of a civil service, building of an independent judiciary, guarantee of the freedoms of opinion, publication, news, and association . . . all these will aid in changing the four characteristics of traditional Chinese politics in practice. I believe that, in a country that is bent on changing the rigid model of a centralized planned economy, on developing a market economy, and in a country that is more open by day, political modernization is an irresistible trend. Modernized politics does not have one model only; in the future, China will proceed from "traditional politics" to "democratic politics" by following the road deemed most suitable to itself.

Notes

1. Yuan Shikai (1859–1916) was the leader of the Republic of China from 1912 to 1916. He was a powerful military figure in the late Qing era who effectively took power when the Qing dynasty collapsed in 1911. In an effort to hold China together, Yuan tried to proclaim himself emperor (an act which perhaps gained him permanent notoriety in Chinese history), but he died before taking the throne and his death in 1916 opened the door to the rise of warlordism in China.

2. Chiang Kai-shek (1887–1975) led the Guomindang, or Nationalist Party, from 1926 until his death in 1975. From 1927 to 1949 he was the internationally recognized head of state on the Chinese mainland.

3. The Yan'an rectification lasted from 1942 to 1944. It was an attempt by Mao to consolidate and expand his power; eliminate the influence of some of his rivals; silence intellectual critics; and address problems of party work style.

4. The Anti-Rightist Campaign (1957) saw 550,000 people branded as rightists and punished for opposing the party. Most were rehabilitated in 1962

or 1979. The CCP now concedes that it greatly overreacted to popular criticism of the CCP in 1956–57.

The Four Cleans Campaign (1963–66) was supposed to root out corruption in the countryside after the failure of the Great Leap Forward. The Cultural Revolution (1966–1976) was Mao's last attempt to force Chinese society to conform to his ideological vision.

5. September 13, 1971 was the day Lin Biao's plot to assassinate Mao (the "571 Outline Project") was aborted. According to CCP historians, Lin died in a plane crash in his attempt to escape from China.

6. The English version of this quotation is from Robert C. Tucker, ed., *The Marx-Engels Reader*, 2nd ed. (New York: W.W. Norton, 1978), p. 596.

7. For documentation on the dismissal of Peng Dehuai, Minister of Defense, who criticized the "three banners" of the Great Leap Forward, see Union Research Institute, *The Case of P'eng Teh-huai, 1959–1968* (Hong Kong: Union Research Institute, 1968).

8. Peng Zhen was mayor and party secretary of Beijing when he was purged in 1966. Rehabilitated in 1979, Peng retains considerable influence today despite being eighty-nine years old.

9. Huang, Wu, Li, and Qiu were all top military commanders. They were arrested in September 1971.

10. Chen Boda was Mao's close ideological and political ally from the 1940s to the late 1960s. Somewhat mysteriously, Chen shifted from Mao to Lin's side between 1969 and 1970. He disappeared from the political scene in 1970 and died in 1989. On Chen, see Raymond Wylie, *The Emergence of Maoism* (Stanford, CA: Stanford University Press, 1980).

11. Wang Hongwen is the youngest and least experienced of the "Gang of Four," Mao's closest allies in the 1970s. He has been in jail since 1976.

12. See Articles 79 and 87 of the constitution.

15 The Fundamental Question of Ownership Merits Study

Editors' Introduction: This essay surveys writings about the ownership of industrial enterprises in 1987. In pushing for further reform in this area, Yan indirectly advocates greatly expanding share ownership and developing stock markets. His concluding paragraph implies much greater recourse to bankruptcy in China, growing privatization of the economy, and the rapid development of professional factory managers.

It is interesting to note that Yan, a political scientist, is writing about debates among economists. This is a clear indication of the influence of political economy as a tradition in Marxist scholarship. (The Marxist philosopher Su Shaozhi, for example, concurrently served as professor of economics at Beijing University.) Yan apparently sees ownership reform as not just an economic issue, but one that is closely related to fundamental political questions about the relationship between the state and the economy. Moreover, while Yan does not mention the party in this essay, the extension of private ownership and shareholding limits the party's ability to intervene in social and economic life and may help to curb corruption.

This essay was originally published in *Ta Kung Pao* (Hong Kong), June 19–21, 1988 under the title "Zhongguo de suoyouzhi gaige wenti" (The question of China's ownership reform). The present title was selected by Yan.

* * *

We are about to enter the third millennium A.D. In the last century of the second millennium, human society has seen an entirely new phenomenon—the means of production belonging to the state and collectives rather than to private individuals as before. Large-scale investigations were made into the evils of private ownership by Thomas Moore, Tommaso Campanella, Gerrard Winstanley, Morelly, C. H. Saint-Simon, Charles Fourier, Robert Owen, and Karl Marx. While they exposed and attacked the antagonism between the rich and poor, and the anarchic state of production occasioned by a society based on private property and free competition, they also hoped for the establishment of a society that would be free of such antagonisms as between the rich and the poor. Not all pre-Marx socialists wanted to abolish private property, but Marx believed that the first piece of business for the state, established after the working class had taken power, was to nationalize the means of production. The major twentieth-century changes in the Soviet Union, East Europe, China, and North Korea have included the nationalization of land, big factories, transport and communications, banks, and the postal service as ways of reforming private ownership and establishing state and collective ownership of the means of production nationwide.

Basic Characteristics of Traditional Public Ownership

In the Soviet Union, East Europe, China, and other socialist countries, traditional public ownership mainly takes on two forms: state ownership and collective ownership. Stalin in his conversation with Louis Howard in March 1936 called state ownership "ownership by the whole people." Here I will chiefly discuss the basic characteristics of "ownership by the whole people" or "state ownership."

Under socialist state ownership, the means of production belong to the state, but managerial rights are distributed among the central government, local governments, and the enterprises. During the NEP (New Economic Policy) period in the Soviet Union,

Soviet national economic councils in local areas had considerable managerial powers, as did the trusts.[1] The Stalinist state ownership system formed in the 1930s saw the managerial rights mainly vested in the central management departments. (In 1936, ninety percent of Soviet industrial output value was accounted for by the central industries, with the localities accounting for ten percent.) The rights of planning, finance, personnel, and distribution of most state enterprises were under the control of the state management departments in the center. The relationship between state enterprises and higher-level institutions was one of "command and obey," with the enterprises lacking independence in management. In China, the state ownership system established in the 1950s was also one in which all levels of government and managerial institutions possessed the rights of administrative management. In fact, state-owned enterprises in China were, without exception, subordinate to the administrative departments from the center, to the province, city, and county. All economic activities of the enterprise had to await instructions from the higher-level administrative institutions.

Egon Neuberger, in discussing a purely centrally planned economic system in his *Comparative Economic Systems*,[2] referred to this system as "computopia." State-owned enterprises in China were not all managed by the center, but belonged respectively to the center, province, prefecture, and county. Since each level of government or responsible department sought to increase the output values of the enterprises under its jurisdiction and to expand its own powers, the entire national economy was divided into various systems of self-sufficiency. China was unable to set up a planned economy similar to the "computopia," but established an economy divided by numerous central departments and local governments. Such phenomena as irrational location, reduplicative construction, and redundant imports were very serious. This was the first major defect of the Chinese economy under traditional public ownership.

The second major defect of traditional public ownership in China was that, owing to the wanton interference from various

government departments, an enterprise had no clear operational responsibility. The enterprise meekly obeyed every order, even wrong ones, coming from the government or its departments. As a result, no one was explicitly responsible for the management of property under the traditional public ownership system.

The third defect of traditional public ownership was that the enterprise lacked the ability to change its production goals by adjusting to the changes in social demand as well as the ability to reproduce itself without limits. Under the traditional public ownership system, the right to expand or build an enterprise was completely under the control of the government; the state invested in basic construction by means of financial allocations.

The fourth defect of traditional public ownership was that a considerable part of the basic construction investment was wasted since it was allocated as any other kind of administrative expenditure, with no accounting for investment efficiency.

Four Ways for Reforming the Traditional Public Ownership System

The four defects of the traditional public ownership system do not exist in the system of private ownership; yet it is entirely impossible to privatize all state-owned enterprises in today's China. As a result, Chinese economists' explorations into the reform of the traditional public ownership system center on the following perspectives.

First, reform the old public ownership system by separating the rights of ownership from those of management. In the Chinese countryside, the practice of family responsibility entails the "separation of two rights" to the land; almost all the management right (including using the land and enjoying the use of its produce) has been turned over to the farming family, while the land-transfer right, through the transfer of the responsibility for the land, has also been handed over to the farmer to some extent. In urban state-owned enterprises, the responsibility system has also somewhat separated the right to ownership from the right to

management. In the responsibility system, the enterprise signs contracts with the government so that the amount of tax and profit exceeding that specified in the contracts will be retained by the contractor [enterprise]. When the contract expires, a new contract may be signed with changes, depending on the situation, in the amount of tax and profit handed over to the government. In the actual Chinese economy, the degree of separation of the two rights is inversely proportional to the size of the enterprise. In certain small enterprises, the ownership and management rights are totally separated; the enterprise and its employees control all management rights while the state only retains the legal ownership right, on account of which the state obtains certain benefits. The enterprise must shoulder all risks and responsibilities, and be financially responsible. Large enterprises, such as the Capital Iron and Steel Corp., continue to be subject to various restrictions even after signing the responsibility contract. Eighty-five percent of the products made by the Capital Iron and Steel Corp. are state-allocated in terms of state prices, and the company has only the right to sell fifteen percent of its planned products plus all products that exceed the plan. It does not have the right to undertake direct foreign trade, nor does it have the right to decide on its own expansion.

Adoption of a share system is the second route to reforming the traditional public ownership system. The share system can have the state having the controlling shares, with localities, departments, and enterprises participating, and individuals owning shares. In enterprises where the state controls the majority of shares, when the government participates in enterprise management through the board of directors, it is a situation similar to that under the traditional public ownership system. The government can of course entrust its controlling shares to the management of the enterprise and control the enterprise indirectly by means of its economic indicators. Where the state, enterprise, as well as individuals all own considerable shares in an enterprise, the enterprise takes on a dual identity, being the owner of its own shares and the manager of state-owned shares. As owner, the

enterprise will have the goal of expanding itself, thus entering the path of the market; as manager, the enterprise is still subject to state control, thus reflecting the will and interests of the state.

The third route to reforming the old public ownership system is to change state ownership into enterprise ownership. The enterprise will become an entirely independent owner, be responsible for its own management and profits and losses, in the same manner as private enterprises in the market. The difference between enterprise ownership and private ownership is that in private enterprises, the owners are the masters of the means of production and its products, and the growth of the enterprise is up to its owners; under enterprise ownership, however, the assets and products are owned by all employees of the enterprise. Decisions on enterprise investment, wages and benefits will be dependent upon some kind of democratic decision making by enterprise employees.

The fourth route to reforming traditional public ownership is to increase the proportion of the private economy in a region or department. The catering and service industries, for instance, may strenuously encourage the growth of individual and private economies, so that their proportion is increased substantially in the coastal and urban areas. While retaining the public ownership system as the mainstay throughout the country, all forms of private enterprises, Sino-foreign joint ventures, cooperatives, and wholly-owned foreign enterprises can be encouraged. This can be seen, on the whole, as another route to reforming traditional public ownership.

The Differentiation of Tax, Interest, and Profit

For the past decade, the appearance of other economic elements alongside the dominant public ownership system in China, the separation of management from ownership in the system of public ownership, the use of leases, contracts of responsibility, and shares, have provoked much thinking among China's economic circles into the relations among tax, interest, and profit.

Under traditional public ownership, the state was at once the investor and manager of an enterprise; the state derived income from both investment and management. Under such circumstances, there was no need for the state to differentiate profit, interest, and tax; and the enterprise only needed to hand over its "profits" to the state. The enterprise was subsidized by the state when it suffered losses. Moreover, the production funds needed by the enterprise were also allocated gratis by the state.

When ownership and management were separated in a state-owned enterprise, Chinese economists began to rethink the differences among tax, interest, and profit. Economic circles agreed that tax is the income the state derives as manager of society. When the enterprise is leased out, that is ownership and management totally separated, the pure owner can only derive income—interest—by virtue of its ownership. The question thus becomes one of how the state can also get the enterprise's profit beyond the tax and interest. On this, there are four very divergent views among Chinese economists.

(1) Recognition that the "profit is the income for the management." If the state thinks that the profit is too high, it can regulate it by imposing a tax on profits above a certain level.[3]

(2) The state is not only owner of the state enterprise, but also "manager," by being responsible for "macroeconomic functions." The state can not only receive interest by virtue of its ownership, but also must "take part of the managerial income for macroneeds, i.e., macrotransfers." This part of the state income (namely, the collected profits) "derives from the state's macroeconomic functions rather than ownership."[4]

(3) Under the responsibility system, the state, when signing the contract, should also deduct the part of the income that is due to the favorable production conditions of some state enterprises. Some also argue that "the most prominent characteristic of the responsibility system is to contract for the amount of profits handed over. This is the necessary obligation of the enterprise, as part owner of whole-people assets, toward the whole-people owner."[5]

(4) The state takes on two functions toward state-owned enterprises: first is the function of social management, i.e., macro-control, regulation, and oversight over the enterprise; second is the function of management over state-owned property, i.e., government control over the enterprise by means of its power over enterprise personnel appointments and dismissals, and allocation of finances. With the separation of ownership and management, the government, as the social manager, takes in taxes from the enterprise, and, as the manager of state property, takes in profits from the enterprise (not "interest").

Both the first two views in fact believe that "profits" are the "income of the managers"; since the "income of the actual managers of the enterprise" is too high, it needs to be reduced by means such as "taxing profits above a certain level" and "deducting the income derived from the government's function in the macroeconomy." In contrast, the latter two views believe that the state derives income by virtue of its ownership or its managerial rights over state property. Neither recognizes "profits" as "managerial income"—the remainder of total income minus tax, interest paid to the owner, and wages paid out to producers. The size of this remainder depends upon pre-operation investment decisions and managerial operations. . . . Thus, the profit value does not solely depend on the quality of management, but on the combined results of fund raising, investment decisions, and management. Profit is not the income of management, but the income created after management. Whether it is a system of public ownership or a system of private ownership, there should be a conspicuous difference in the amount of this remainder depending on the investment decisions and management of various enterprises. Those enterprises with good investment decisions and good management should be encouraged to make new investments with that remainder and thereby expand; while those enterprises with bad investment decisions and bad management should be eliminated. Whether under a public or private ownership system, the society should use such a mechanism to renew continuously the industrial structure and enterprise scale of the

whole society, so that the level of enterprise management can be raised unceasingly.

The Question of Enterprise Self-Expansion under Conditions of Public Ownership

Profits come from correct investment decisions and efficient enterprise management. After it obtains profits, the enterprise has to make new decisions on how to distribute and use them. On this matter, enterprises have different decision-making powers under different systems of ownership.

Under China's traditional public ownership, when the policy of the "financial remission system" was in place, the enterprise handed all its profits over to the state after retaining the amount for bonuses; the funds that the enterprise needed were allocated by the state by appropriation. Under the "profit-sharing system," the share of profits to be retained by the enterprise were decided by the government department responsible, by taking into account the enterprise's conditions; the share was fixed for a number of years. The share of profits retained by the enterprise could be divided into production funds, employee benefit funds, and employee bonus funds; the use of these funds did not need be approved by various superior levels. Since the share of profits retained by the enterprise constituted only a small portion of total profits, this profit-distribution system did not allow for the enterprise's unlimited expansion.

Enterprise ownership is a feasible way of reforming the traditional public ownership system without solving the question of enterprise expansion. Under the enterprise ownership system, enterprise managers are not appointed or selected by the state, but are selected by enterprise employees by following certain procedures. When these managers take control of enterprise management, they can ill afford to refuse the workers' demands for more benefits. Though the enterprise managerial income mostly will not be handed over to state coffers as under the public ownership system, the actual share of the income going into investment will

be substantially reduced by worker demands for more wages and benefits. The enterprise ownership system provides the possibility of enterprise expansion, but cannot allow for the unlimited expansion of an enterprise.

As a way of reforming the traditional public ownership system, the responsibility system cannot deal well with the problem of enterprise expansion either. The implementation of the responsibility system must rely on signing contracts of responsibility and the first question that arises is to assess the enterprise's assets and decide on the amounts of responsibility. The enterprise, out of its interests, will seek to understate its own assets and technical capability so as to lower the base amount for contract. After the contract is signed, the enterprise, in order to maximize the amount that exceeds the amount of tax and interest handed over to the government, will seek to maximize short-term benefits at the expense of long-term development during the contract period; rather than making long-term, risky investments, it will risk the maximum use of equipment, materials, and labor, thereby increasing the wear and tear of existing assets. Even in the Chinese countryside, the responsibility system has not solved the problem of farmers' unwillingness to invest in the expansion of agricultural production; instead, farmers under the responsibility system have used their accumulation funds to build non-productive houses, with little enthusiasm for productive investment. To overcome these defects, some enterprises, when signing contracts of responsibility, stipulate that, below the contract-specified level, new construction or expansion will be decided by the enterprises themselves, using their own funds. Some also argue for setting out clearly, in the contracts, not only the amount of tax and interest to be handed over to the state, but also the percentage of equipment and installations in good condition, the depreciation funds, the distribution ratios within the enterprise, and the directions and requirements for the renewal and reform of enterprises. Yet, whether these extremely complex regulations are feasible or not, the responsibility system cannot create a mechanism within the enterprise itself so that the enterprise will be concerned with

its long-term development, turning a maximum share of the remainder from the managerial income into new investments.

Analysis of the Trend toward the Joint-Stock System

The joint-stock system does not have a singular form and its nature depends on that of the stockholders. The majority stockholder of an enterprise under the joint-stock system can be an individual, many individuals, a collective, or the state. It is apparent that where individuals hold a majority of the shares of an enterprise, that enterprise is not an enterprise under public ownership. The future development of the joint-stock system in contemporary China has yet to become clear. Some economists believe that the transfer of shares of enterprise assets to enterprise employees and outside buyers will change the socialist nature of the enterprise. A stock company organized on the basis of shares in society and dominated by private shareholders will make the employees hired laborers. If the state allows the enterprise to retain its own funds and permits the fixed assets so accumulated to belong to the collective, then, after ten or twenty years, with the increase in fixed assets, the enterprise owned by the whole people will become a collective enterprise.[6]

Certain Chinese economists point out that, in order to prevent share enterprises from becoming collective and private enterprises, three principles must be adhered to in the implementation of the joint-stock system: (1) the original state assets must be transferred with compensation to avoid "turning the public into private hands"; (2) in important departments and enterprises, adopt the "state majority-share principle," so as to preserve the state's decision-making power; (3) adopt limits on individual shares. An individual may purchase one kind of share but not another; even when an individual can purchase many shares, there must be a limit on the number of shares that may be purchased. In order to manage the shares held by the state, and protect the property under public ownership, the formation of a state property management institution (or State Investment Corp.,

National Stock Corp.) is necessary. Such an institution does not directly interfere in the affairs of the enterprise, but . . . influences the economic decisions and activities of an enterprise by virtue of its control of shares and members of the board of directors representing the government.[7]

The main objective of the stock system is to raise funds. The shares now being issued cannot circulate and are much like bonds. Certain Chinese economists believe that the distribution of profits according to bonds is tantamount to increasing wages. If all publicly owned enterprises use this method to increase wages, consumer funds will expand tremendously, and this is not feasible in China.[8] In today's China, the free buying and selling of stocks and the establishment of large-scale stock markets are not yet a realistic question.

The Fundamental Question of Public Ownership Needs Study

In an era of rapid developments in science and technology, the industrial structure must also constantly change in step with them. In countries dominated by the private sector and the public sector respectively, changes in the industrial structure occur in very different manners. In countries dominated by the private sector, public enterprises are no more than a few isolated islands in the vast sea of private ownership and investment is mainly up to private individuals. For private enterprises, growth depends on correct investment decisions and sound operations and management (including the use of the latest scientific and technical achievements); bad investment decisions and management may result in decline or even bankruptcy of the enterprise. In the whole society, rapid changes in the industrial structure occur as a result of competition among enterprises. In countries dominated by public ownership, changes in the industrial structure are chiefly dependent upon state investment; yet the funds for such investment come from the profits and taxes handed over by the enterprise. In the traditional public ownership system, the invest-

ment in new fixed assets is the monopoly of the state. In the reformed public ownership system, the ownership and management of the enterprise are separated; managers, seeking to increase the amount retained by the enterprise, try to improve operations and management and use part of the retained funds for reinvestment. On the whole, however, countries dominated by public ownership have not been able to change one basic situation, viz., the right to expand production in the whole society is basically controlled by the state (central and local governments).

. . . At present, China in reform not only permits the development of individual and private economies in an economy dominated by public ownership and allows them to maximize their profits, but also allows publicly owned companies to do the same by means of leases, responsibility contracts, and the issuance of stocks. However, the Chinese economic reform continues to face one more vital problem, that is, how to find an automatic mechanism (not determined by the state or government) under public ownership so that enterprises can voluntarily invest the amount above basic consumption into the expansion of the enterprise, and not in nonproductive construction and excessive personal consumption. Only when such a mechanism is found under public ownership can the state permit the enterprise to use its operational income after paying tax and interests on the fixed assets.

Notes

1. NEP lasted from 1921 to 1929, with its effects felt most strongly from 1923 to 1927. It combined state control of the "commanding heights" of the economy with a significant role for markets and private ownership.

2. Egon Neuberger and William Duffy, *Comparative Economic Systems: A Decision-Making Approach* (Boston: Allyn and Bacon, 1976).

3. [Original footnote] Li Yining, "Jingji gaige ruhe xiangqian fazhan" [How economic reforms can advance], *Jingji ribao* [Economic Daily], August 15, 1987.

4. [Original footnote] Lin Zili, "Lun xinxing dengjia jiaohuan" [On equal-value exchanges of a new type], *Renmin ribao* [People's Daily], December 18, 1987.

5. [Original footnote] " 'Qiye chengbaozhi zhiyi' de zhiyi" [Questions on

"questions on the enterprise responsibility system"], *Lilun xinxi bao* [Theoretical Information], November 30, 1987.

6. [Original footnote] Xue Muqiao, "Guanyu shenhua qiye guanli tizhi gaige de yidian yijian" [A suggestion for deepening the reform of enterprise managerial structure], *Jingji ribao* [Economic Daily], June 4, 1987.

7. [Original footnote] Li Yining, "Jingji gaige jiang xiang hechu fazhan?" [Where should the economic reform go?], *Jingji ribao* [Economic Daily], August 15, 1987.

8. [Original footnote] Su Xing, *Lilun xinxi bao* [Theoretical Information], April 13, 1987.

16 | A Conversation with Professor Wen Yuankai

Editors' Introduction: Deeply revealing about the state of mind of reform intellectuals at the end of 1988, this conversation between Yan Jiaqi and Wen Yuankai[1] is perhaps the most interesting document in this collection. It shows clearly the fears and hopes of reform intellectuals.

While both Yan and Wen believe that reform will inevitably triumph in the end, they think the government is "turning back the clock" and they are insistent that the reforms must be intensified despite difficulties. While they fear the long-term costs to China arising from postponing or reversing reform, their confidence in the future of the reforms is strengthened by the rise of a "new class" of reforming intellectuals, entrepreneurs, cadres, and others. In short, they waver between pessimism and optimism.

Commenting on a gamut of issues facing China's reforms, Yan and Wen call for adopting a scientific attitude, instituting democratic decision-making mechanisms, establishing the authority of the constitution and laws, and protecting people's civil rights. They demand the forthright historical evaluation of the CCP, and they see power struggles among the leadership lying just below the surface of recent events. Nonetheless, they make obligatory statements about how reform can proceed under party and government auspices.

Western readers might find their views about law and science somewhat problematic. While no one can deny that China needs

the rule of law, these two reformers do not discuss how the rule of law can become institutionalized. It took centuries for law to gain authority in the West, and proclaiming the rule of law in China will not guarantee that legal norms will govern social and economic behavior. Yan's statement that science is an optimistic spirit or a belief in the possibility of overcoming all difficulties may sound strange to non-Chinese, who are more likely to see science as a method of inquiry and less likely to see it as a panacea.

This conversation between Yan Jiaqi and Wen Yuankai was recorded by Gao Yu, a journalist and deputy editor-in-chief of *Jingjixue zhoubao* (Economics Weekly) (Beijing). It originally appeared in *Jingjixue zhoubao*, on December 4 and 11, 1988, under the title "Guanyu shiju de duihua" [A conversation on the current situation].

* * *

Chinese Reform Cannot Afford a Brezhnevian Stagnation

Yan Jiaqi: You [Wen Yuankai] comment that the chariot of Chinese reform has been mired in a quagmire. Though this metaphor illustrates the serious obstacles faced by reform, China's reform doesn't lack ways out. That everybody sees no outlet and is at a loss as to what is next has become China's main problem.

Wen Yuankai: Chinese reform faces three choices: the first is to stop right here. Yet to stop means to sink deeper in the quagmire. The second is to "turn back the clock," as is being done now. This is intended to retreat from the quagmire in search of a new route. While power recentralization and [economic] austerity are necessary, there lies a danger: "Ten years of hard toil later, we return to the prereform era overnight." We have witnessed the Polish and Czech retreats, which are measured in decades; it is dreadful to start all over again. I now want to explore a third choice, the possibility of going forward, out of the crisis or quagmire, rather than turning "the deepening of reform" into an empty phrase. I fear that the present policy of "improving

the economic environment and rectifying the economic order"[2] may completely wash away "the deepening of reform."[3]

Yan: Where is the crisis? Much confusion has appeared in the reform and seems to have no solutions; people's attitudes are very important, their disappointment may cause some sort of retreat or stagnation. When the retreat or stagnation reaches a point, there will definitely be demands for new reform; but if this period [of retreat or stagnation] lasts five to ten years, irreparable damage will be done to China. In Soviet history, Khrushchev was an important reformer. While Tito had recognized the problems with the socialist system much earlier, it was Khrushchev who truly touched on the problems with the Soviet socialist system. The Khrushchev reform, once caught in a mire, stagnated for some two decades under Brezhnev before reentering the road of reform under Gorbachev. The Gorbachev reform started after the long period of stagnation and drew upon the experiences and lessons of the Khrushchev reform debacle. I hope that China will not enter into a long-term Brezhnevian stagnation when faced with difficulties.[4]

Wen: Very good point.

Yan: If stagnation does last for five to ten years, it will create new problems and make China more backward. By then, China cannot help but call for reform again and rely on figures like Gorbachev.

Wen: Right!

Yan: I hope today's Chinese leaders can all strengthen their convictions in reform; rather than seeking the route of retreat, they should continue to reform to overcome problems of reform. The primary problem now is to find a way out.

Four Factors Preventing Retreat

Wen: In assessing the current situation, I think it is very important to realize that the current economic situation has not become that serious. Comparing today's crisis with the difficulties of 1962,[5] I think the present economy is much stronger than then

and people are not in dire poverty as they were. The current problems, including market shortages and the [social] contradictions in supply and demand, do not compare with the poverty of 1962. There might be grain shortages next year, but it's not that serious. I like the stand of the *World Economic Herald* [6]: "Do not be frightened by the current situation." That is, don't become panic-stricken and thrown into confusion by the current situation; it would be even worse to disrupt the current reform and get rid of the reformers. I think that we do not lack ways out; at the moment, what is important is the question of confidence. For instance, while the state lacks funds, some individual producers, private entrepreneurs, and a considerable stratum of people have become rather rich, with a lot of money in their hands.

Yan: That's right.

Wen: There is the problem of "profiteering," but you can't say all activities are "profiteering." I believe that four factors in China make retreat from reform impossible. First, after agricultural reform, the practical farmers cannot be expected to go back to learn from Dazhai and earn work points;[7] there are also the township enterprises. In many areas that I visited, such as the southern Jiangsu region, the township enterprise entrepreneurs do not fear austerity. If you [the government] institute a bird-cage economy,[8] their sparrows can fly through the cage. They have their ways of flying, as they have done for years. They are not afraid of your adjustment and control, though they are affected. This is vitality. Second, can the revitalized coastal regions, especially in the south, retreat? Can they follow your orders completely? That's impossible. Moreover, it is evident that though they are affected, their ability to weather inflation and panic purchasing is stronger. They are much less affected by the tightening, adjustment, and control, and they are much less dependent on state banks [than other areas]. Third, in an open society, with thousands of students studying overseas, tens of thousands engaged in exchanges, millions of tourists, thousands of joint ventures—all these entail cultural exchanges—it is impossible to cut China off completely from information. Each major action in

China will have ever greater international feedback, including that of the media exerting, as at present, tremendous limits on China. We [the government] after all have to take a look at the effect of China's major political decisions on the Hong Kong stock market; if the market falls sharply, we have tremendous pressure upon ourselves. Moreover, we have to mind the mood of foreign investors. The present situation has already caused some disappointment, or lack of confidence, among foreign investors in the domestic market; foreign investment has declined visibly, forcing us to make announcements from time-to-time. Fourth, in the past few years, a large group of modern-type, new-culture managers, entrepreneurs, thinkers, theorists, cadres, even leaders have gradually matured, and they will not go back. I visited the Stone Corp.,[9] where none of its 700 people wants to go back to the "iron rice-bowl"; even if all 700 had to leave, they would not seek the "iron rice-bowl."[10] This is irreversible. This is vitality.

If Each Contributes His Share, the Situation Will Not Be So Serious

Wen: China now lacks money, lacks funds, including shortages in bank investments. [But] large sums of money are in the hands of individual entrepreneurs, who do not put the money into banks, but bury it under the old Chinese scholar-tree, inside the walls, or spend it on wine and liquor, or use it for feudal things.[11] . . . It is naïve to think that a few elites, planning in closed quarters, can find a way out for reform! Only with transparency derived from political structural reform can more Chinese agree with the government and have a sense of participation. Yesterday, Mr. Chen Guying[12] argued, in an excellent speech at Beijing University, that "the people's democratic dictatorship" should be changed to "people's democratic participation." This is the real dominant trend; only in so doing can we get the people to realize sacrifices are necessary in reform. I think that if all the people, as they did just prior to the Anti-Japanese War, contrib-

ute whatever they can, money or labor, then the situation will not be so serious. Aren't we afraid of runs on banks? Panic-buying? Would it still be serious if each could contribute? Conversely, if the money in people's hands is converted into stocks, then you have liquid funds [for development]. What is apparent now is that people have money. In the past few years, banks have attracted some one billion dollars in foreign exchange deposits and experts estimate that people hold some four billion dollars of foreign exchange. . . .

I believe that to get more people to contribute, further political reform is a must. Personally I don't see any lack of a way out. I am an optimist.

Yan: I think there is the question of assessing the situation; it has been recognized the world over that ten years of reform, in the first place, have made great achievements.

Wen: Right.

China's Reform Lacks the Principle of Fair Competition

Yan: It won't do without this point. There can be no retreat; retreat will lead to even more serious problems. There should be a clear understanding of China's problems. I think there are two problems. First, in our attempt to introduce the market mechanism, there was no corresponding reform in the ownership system. As a major element of the national economy, the ownership system has not had its ills cured. We have introduced the market mechanism without reforming public ownership and therefore property rights are not well defined and the concept of the contract is lacking. With no proper laws, "competition without rules," or "competition lacking rules" is the result all over the country. We are changing a society that had a high level of administrative control and lacked competition into one of imperfect competition without proper rules.

Wen: Correct.

Yan: Thus I believe our present problem is to change our society into one of competition with proper rules, not to retreat to

a society that has no competition and has to rely on a high degree of administrative control as a catalyst.

Wen: Exactly.

Yan: The present competition is one with no or few rules.

Wen: Or competition with no fair rules.

Yan: Yes, competition lacking fair rules, not no rules.

Wen: Let me elaborate. We are now engaged in "improving the economic environment, rectifying the economic order," and "deepening reform." I think the most crucial "order" and "environment" is the construction of legal rule. Recently, in anticipation of the seventieth anniversary of the May Fourth Movement, I raised the point that "Mr. Democracy" and "Mr. Science" only are not enough, we should add a third, "Mr. Law."[13] We should promote democracy, science, and legal rule. It is more important to establish rules and customs, [just as you need] rules for playing cards; this is a necessary precondition for China's march into the world and towards cosmopolitanism. Foreign distrust arises first of all from the lack of rules, or mercurial changes of rules in China.

Beware of Irrational Political Behavior

Wen: In particular, faced with the rather serious situation of the present, completely irrational political behavior may appear. It is evident that such irrational political behavior is playing its role now, wielding big sticks and issuing unprincipled criticisms; such irrational political behavior will cause China to retreat and the ten years of the cultural revolution have already taught us such painful lessons. I am particularly appreciative of what reform in all socialist countries must do—further reflect on history. This is the enlightenment being offered us by the Soviet reform and this is precisely why the Soviet reform has caused so much stir all over the world. We still have a long way to go in reflecting on history and we have told far less of the historical truth to the rank and file. In reassessing major events of history, Gorbachev has acted surefootedly; in reason and justice, he has

shouted a loud slogan: "Tell the historical truth to the people." Who can object to this point? No one. I think our leaders, faced with the present situation of reform, must be bold in pushing forward political structural reform and in dealing with the errors they have committed.[14] I think communists should be open and aboveboard. And this is the occasion.

Yan: In so doing, no difficulty is beyond solution.

What is science? Science does not merely refer to subjects such as mathematics and physics. Science is first of all a spirit, a belief in whether we can find a way out in the face of obstacles. Why do we [the Chinese people] feel despondent? I think the basic cause lies in politics, lies in the lack of a political environment that gives free rein to the scientific spirit and guarantees the freedom of exploration and the freedom of discussion. Though we enjoy more freedom of expression than ten years ago, people continue to avoid major issues and cannot conduct fruitful studies of these problems. The outlet for economic reform is not to retreat to the pure planned economy but to introduce the market mechanism into the Chinese economy more effectively. So the major issue in economic reform is to relate the ownership system to the market economy; this requires applying the spirit of science to our studies. Without effective reform in the ownership system, the promotion of enterprise mergers at present can only cause various confusions.

Wen: That's true. With nepotism, the mess is getting worse.

Yan: The source of all problems continues to lie in the ownership system. Why hasn't the question of ownership been properly studied? Because, on fundamental issues, we are still bound by various ideas and lack political guarantees for the freedom of exploration.

Wen: Right.

Multidimensional Reform and the Question of the Decision-Making Mechanism

Wen: I read your *A History of the Ten-Year "Cultural Revolution."* Though I think this is still an initial step, it is highly

important to sort out the historical materials on the Cultural Revolution for the first time. The party rectification [of 1982–85] was intended to negate completely the Cultural Revolution, but how could that be done without studying the Cultural Revolution? We have to start by telling people the facts. I heard that some memoirs have touched on some political nerves. How absurd! Haven't party documents repeatedly called for the complete negation [of the Cultural Revolution]?[15]

Yan: What a contrast with what is happening in the Soviet Union. The entire world can see this.

Wen: We should be indirectly inspired by the Soviet reform. I think that it is unnecessary to be psychologically so weak in our reflections on historical problems. Through my reading of memoirs on the "Cultural Revolution," such as *A Factual Record from Maojiawan*,[16] I came to understand how the fate of China's billions was decided in a temple, in an absurd manner. What a tragedy for the Chinese nation!

Yan: Thus the present problem is still one of the political system, one of the decision-making mechanism.

Wen: Definitely. Shouldn't we draw some lessons from these realities, from this history? For me, reflections on history are not to blame one particular person, any individual's responsibility was limited; I like the saying that "the entire nation should have a sense of repentance." Some people overseas ask: "Was the Gang of Four solely responsible for the Cultural Revolution?" I think the Gang of Four originated from the Chinese "cultural soil"; without getting rid of this soil, there will be new irrational political behavior and mechanisms for its emergence. This is a danger facing the Chinese reform. What China needs is an all-round reform, including political reform. When it comes to political reform, we cannot just hear the sound without seeing it.

The Constitution Is the Highest Authority

Yan: In the present reform, I think our main task is to find a solution for solving problems, a solution that is widely accepted. I think this is yet to be done.

Wen: Right. We'll eventually have to realize that, in order to find such a solution, the status of law must be raised, which entails the strengthening of legal construction and the enhancement of legal authority. I recently ran into an interesting episode. When I was taking a taxi recently in Shanghai, I was fleeced by the driver, who rudely said to me: "Who do you think you are [to question me about the fare]? I am driving the city government's car."

Yan: This was due to the lack of fair rules of competition.

Wen: I answered: "All right, that's simple, I will go to the mayor." I wrote a letter to Mayor Zhu Rongji,[17] who, in a bold manner, instructed that the taxi company stop work and undergo reorganization and be fined 1,500 yuan. However, recently in Shanghai, I was fleeced again. Thus, it won't do to rely on good mandarins; we have to rely on legal rule. I was told by journalists how Hong Kong regulates taxi drivers with law. A taxi driver, driving from Kaitak Airport to a hotel, should charge HK$50; but he charged a customer coming from the mainland HK$200. The customer told this story to relatives, who sued the driver. The driver was convicted of swindling and sentenced to one and a half years in prison.

Yan: Our press always says "we should do this," "hope that it will be this way," but has no sense of legal rule. This won't do. Violations of law should be punished legally, rather than trying to persuade people they "should do this" or "hope they will do this."

I believe the lack of a sense of legal rule in China arises from, first of all, the constitution's lack of authority. I think the political and economic reforms are equally important. In the future, a foremost question for Chinese political reform is to revise the constitution in the 1990s. The supreme law in China should be the constitution, followed by the various laws, ordinances, administrative regulations, and local regulations, including the fair rules of competition in the economy.

At present, political realities diverge from what is written in the constitution. The constitution stipulates that the National

People's Congress is the highest organ of power, while in reality everyone knows that it is not. This is the constitution; in comparison, violations of traffic rules and fleecings by taxi drivers are minute. If the constitution as the supreme authority can be disregarded, the Cultural Revolution and the tragedies suffered by Liu Shaoqi can of course result. Therefore, the first rule in China is to establish the supreme authority of the constitution and the laws, not some other sort of authority.

Civil Rights Should Include Property Rights

Yan: Our constitution does not explicitly stipulate the protection of private property rights. Many people have grievances in reform, because many of their rights have been violated from time-to-time; state-owned and individual enterprises have been subject to all sorts of apportionment of expenses, illegal taxes, and fines. This leads me to ask what the rights of a citizen are. Besides stipulating general civil rights, such as freedom, freedom of expression, and the right to vote (we have not gone far enough even in these), the constitution should also explicitly stipulate the right to private property as one of the civil rights.

China needs a property law, the violations of which, including illegal taxation, should be punished by law. This law should be very strict, and obeyed by all citizens and public servants. Lack of rules causes confusion. There should first of all be rules for the government.

The Cultural Revolution-Style, Nonprocedural Transfer of Power Must Not Be Repeated

Yan: I believe China faces a tremendous problem, that is, to prevent a repeat of the sort of nonprocedural transfer of power that Khrushchev and Liu Shaoqi suffered. The CCP leadership is established by the party congress and the highest party leadership should be collectively responsible for the whole party; the collective leadership system is one of collective responsibility rather

than one of two-line struggle of the Cultural Revolution style. China can no longer stand the Cultural Revolution-style non-procedural transfer of power, which many sense is in the making;[18] this is why people believe China is in crisis. As one of the people, I think I should put forth my worries about China's future forthrightly. No leader is perfect and devoid of errors; if the leader can face up to his errors and is determined to correct them, the house can be put in order. Then [at the start of the Cultural Revolution], it was merely a [play] called *The Dismissal of Hai Rui*, but some made the connection from Wu Han [author of the play and vice mayor of Beijing] to Peng Zhen [mayor of Beijing], and from Peng Zhen to Liu Shaoqi [president of China], thereby causing the nightmare of the "Cultural Revolution."[19] Today, some people want to magnify a small matter like "River Elegy,"[20] causing much stir. Anyone who cares for our motherland and is responsible for China's future should be filled with confidence in the future of China. We believe that the CCP and the Chinese government are capable of solving China's problems and we do not condone certain people being irresponsible, using certain political actions (not just opinions) to cause turmoil in Chinese politics. Faced with difficulties, frustrations, and crises, there must be courage to face up to the difficulties and errors rather than use these difficulties and certain mistakes as pretexts for power struggles. Since the Chinese political system has not rid itself of the elements of the Cultural Revolution or power struggles, a repeat of the Cultural Revolution is possible if the worst comes.

Wen: Moreover, I think that, faced with a serious situation, [the leaders] should be tolerant [toward each other]. Now is not the time for mutual blaming and censure.

Yan: I now sense such a sort of "crisis": some people who have always been resistant to reform, now seeing the mess China is in, will see China's difficulties as opportunities for power; they are ready to jump in and push China into a long period of stagnation or retreat. Beware of those people who gloat over China's difficulties as their own hope.

Wen: That's true. As China's reform is faced with a difficult situation and steps into the quagmire, we should issue a loud appeal to society that the Chinese reform has made great achievements recognized the world over. Reform allowed China to achieve great progress.

Yan: Despite much confusion, the Chinese people support the party and government to advance further reform.

Wen: Also the Chinese people should be asked to remember better those who worked hard to push the Chinese reform forward. . . .

Yan: . . . and those who did not work for reform at all and are waiting for its failure.

Wen: They want to retaliate.

Yan: Beware of those who take advantage of the confusion in China to prevent reform.

Wen: We should also pay attention to those idle critics who have in the past always been ready to attack the men of action, who have also made mistakes. If these men of action did one out of ten things wrong, the critics totally deny the nine right things, and attack the entire person. This is a sort of mentality in Chinese traditional culture. Those who made no contributions and no advances are always those to claim they are in the right; reform should be wary of this.

Yan: I agree with how you put it. People's worries over the confusion of reform are related to this. China cannot afford a long-term Brezhnevian stagnation.

Wen: Well said! Well said! The appearance of such a stagnant period is even worse than the failure of reform.

Yan: This is a nice way of putting it: "Stagnation is worse than failure." The emergence of a Brezhnevian twenty-year stagnation will push back China's modernization by fifty years or even longer.

Notes

1. Wen Yuankai, noted reformist thinker, made his name with his reforms in educational administration. He is a professor of applied chemistry and chair-

man of the Department of Applied Chemistry in the Chinese University of Science and Technology in Hefei, Anhui Province. He also served as the deputy director of the Anhui Provincial Education Commission, but lost his position as a result of the 1986–87 student demonstrations. He is believed to be in political trouble owing to his views and actions in 1989.

2. This slogan was official party policy as authorized at the Third Plenum of the 13th Central Committee, September 26–30, 1988. It is particularly associated with the views of Li Peng and Yao Yilin, premier and vice premier respectively.

3. "The deepening of reform" is a slogan associated with Zhao Ziyang.

4. Yan's faith in Khrushchev's reforms seems misplaced, for market-oriented reforms were certainly not central to Khrushchev's agenda. For recent Chinese views of Khrushchev's legacy, see *Xinhua wenzhai* [New China Digest], no. 4 (April 1989), pp. 55–64.

5. This is apparently a reference to the "three hard years (1959–61)," caused by the Great Leap Forward. By 1962, millions had died of starvation. Industrial production and investment had all but collapsed.

6. *Shijie jingji daobao*, the outspoken proreform weekly journal published in Shanghai. It was closed down in May 1989 on orders from Jiang Zemin, then first party secretary in Shanghai and now CCP general secretary.

7. Dazhai, a village in Shanxi Province, was praised as a model of the self-reliant collective during the Maoist period. Actually, Dazhi commune was heavily subsidized by the state.

8. This is a view put forward by Chen Yun, China's most influential economic leader, on the proper mixture of plan and market. The bird is the market, the cage the plan. If there is no cage, or the space between the bars is too wide, the bird will fly away (cause chaos), but if the cage is too tight, the bird will suffocate.

9. Stone Corp. is a private electronics firm that was held up as a model of high-tech successes under reform. It established a private think tank which played a major role in the democracy movement in 1989. Wan Runnan, Stone's founder, is now in exile with Yan Jiaqi, serving as the secretary-general of the Front for a Democratic China.

10. "Iron rice-bowl" is the Chinese colloquial reference to "permanent jobs."

11. Fearing policy changes, people hide or consume much of their newly acquired wealth!

12. Chen Guying (Ch'en Ku-ying) is a Chinese-American scholar working in the field of Chinese philosophy. He has held appointments at the National Taiwan University, the University of Chicago, and the University of California, Berkeley.

13. The two major goals of Chinese intellectuals during the May Fourth Movement of 1919 were to establish "Mr. Democracy" and "Mr. Science" in China and overthrow Confucianism. The "Spirit of May Fourth" is conventionally held to have given impetus to the founding of the Chinese Communist Party.

14. Interestingly, while Gorbachev has encouraged deeper historical evaluations of Stalin and Brezhnev, he has not, as of mid-1989, encouraged the study of his own mistakes. Here Wen Yuankai is not calling for further assessments of Mao, but of the errors the current leadership has made in the reform period.

15. While calling for a complete negation of the Cultural Revolution, party leaders have suppressed new writings on the CR. For an overview of Chinese scholarship on the CR, see Michael Schoenhals, "Unofficial and Official Histories of the Cultural Revolution—A Review Essay," *Journal of Asian Studies*, 48 (August 1989) 563–72.

16. Zhang Yunsheng, *Maojiawan jishi: Lin Biao mishu huiyilu* [A Factual Record from Maojiawan: The Memoirs of Lin Biao's Secretary] (Beijing: Chunqiu chubanshe, 1988).

17. Zhu was appointed Shanghai party secretary after Jiang Zemin became CCP general secretary in June 1989.

18. Yan is implying here that conservatives will try to oust Zhao Ziyang from power without recourse to stipulated party procedures.

19. Mao and others saw this play, about an upright official in the late Ming Dynasty who was dismissed for criticizing the emperor for not fulfilling his duties, as an analogy to Mao's purge of Peng Dehuai, the blunt-speaking Minister of National Defense who had criticized Mao and the Great Leap Forward in 1959.

18. "River Elegy" [He Shang], a controversial television miniseries, is highly critical of China's traditional political culture and world view. Its argument is similar to Yan's essay, "China Is No Longer a Dragon" (Text 7).

1989

Before the Democracy Movement

17 | Enlightenment from "Plymouth Rock"

Editors' Introduction: These comments were written in early 1989 when China was on the eve of a major crisis that culminated in the June Massacre. While reflecting on his extensive foreign travels, Yan seeks to confront and grapple with the mounting crisis in China. He repeats a number of the themes appearing in previous essays, in particular the importance of democracy and the primacy of reason. He argues that it is the spirit of the Enlightenment and democracy that has allowed the industrialized nations to achieve so much. China, he concludes, needs both to prosper.

Yan's comments on democracy in the section on "The Expansion of the Collective Spirit" are worth noting. In an attempt to rebut CCP critics of "bourgeois democracy" and "extreme individualism" which they see as characteristic of the West, Yan argues that in fact democracy enhances the collective spirit, protects the basic rights of the citizenry, and allows for social trust and cooperation. Therefore, democratic political reform will serve China well.

Yan may have made this argument for political reasons, but there is good reason for us to think that this is also his belief. Moreover, this belief about democracy resonates strongly with the ideas of Liang Qichao (1873–1929), perhaps the leading Chinese intellectual at the turn of the century, who saw democracy in collectivist terms and as a means of governing that served

broader state interests. (For a discussion of this aspect of Liang's thought, see Andrew J. Nathan, *Chinese Democracy* [New York: Alfred A. Knopf, 1985], chapter 3.)

The Chinese version of this essay was to be published in *Xin qimeng* (New Enlightenment), no. 5 (1989), which we have not seen. This translation is based on a manuscript the translators received from Professor Yan. Its subtitle is: "the significance of the 'scientific spirit' and 'democracy' to China's modernization."

* * *

On a sunny day last September [1988], I visited Plymouth Plantation near Boston. The plantation borders on the Atlantic Ocean. Not far from the plantation, a replica of a ship, named Mayflower II, is anchored. As I ascended the Mayflower, my heart stirred just like the ocean waves.

On November 11, 1620, a group of lowly Britons suffering from ideological persecution boarded the Mayflower in Leiden, Holland. When they crossed the ocean and arrived in America, they had little of anything; with bare hands, they found themselves in the wilderness. For quite a while during that sunny morning, I stood beside Plymouth Rock where that group of Britons landed. I wondered, how could these penniless European emigrants (and their children) build a high-level civilization in the wilds of North America over three hundred fifty years ago? Why does China, which boasts of a history of five thousand years, lag far behind the advanced levels of the contemporary world?

In 1988, I visited some twenty cities in Europe, North America, and Japan. . . . The farther I went, the more impressed I became with the striking contrast between the modern West and China. To be sure, I also saw poverty and backwardness abroad, such as in the town of Jellico, Tennessee, in the United States. But I found that the poverty and backwardness of modern Chinese society do not arise from material scarcity, but from an extension of a diffident and pessimistic spirit.

In 1620, the European emigrants who landed at Plymouth Rock in North America confronted neither the inflation nor the social unrest of today's China. What they faced was a wilderness, vast wilderness; behind them was a boundless expanse of ocean. They found themselves . . . completely isolated from the civilized world. However, they had two things that are lacking in today's China and other underdeveloped countries.

First was the spirit of science. This does not refer to such sciences as mathematics and physics themselves, but belief in the power of human reason and wisdom, and an indomitable spirit of brave struggle.

Second was the spirit of democracy. These emigrants who were on board the Mayflower in 1620 had, before landing, concluded a pact of self-rule for the Puritans—the Mayflower Compact. The spirit of the pact reflected the principles of democracy: people had the right to express their own opinions and the obligation to obey decisions made by the majority.

The Wellspring of Human Optimism

Half of the emigrants who came to North America . . . died during the first harsh winter. At Plymouth Plantation, I saw the simple huts they lived in; the modern Chinese live in far better quarters than did the Plymouth settlers. Yet none of the immigrants lost hope in the future. They believed that after escaping from dictatorial politics and ideological oppression they could create a better life using their own wisdom and their own hands. Ten years ago in China, after ending the "epoch-making" "Great Cultural Revolution" and embarking on reform, people seemed to be full of confidence in their future. Yet, why would a gloomy sentiment spread all over China in 1989, when the ship of Chinese reform has encountered some storms?

Whether in the Netherlands, in the United States, or in Japan, I constantly contrasted and compared what I saw with what was in my motherland. Despite considerable progress in science and technology, I found that in today's China when Chinese search

for routes to overcome the obstacles in the social sciences, they use numerous taboos and construct layers of ideological defenses so as effectively to prevent themselves from using their minds to search for ways to overcome the difficulties. Science should be a world of "three-nos," with no forbidden zones, no idols, and no pinnacles. Yet, in front of each forbidden zone, people stop their explorations. In such circumstances, how can the ways out be found amid difficulties? Science is the wellspring of human optimism. A people who erects all sorts of forbidden zones against theoretical exploration and cannot fly freely in thought is a people who has abandoned the most precious wealth nature can endow—reason and wisdom. Under such circumstances, people can only sigh and groan in the face of obstacles and frustrations. . . . I believe the direction the giant wheels of Chinese reform are going seem obscure to many. "For a ship travelling blindly, all winds are contrary winds."

The Expansion of the Collective Spirit

China's progress needs two bedrocks, scientific spirit and democracy. The Mayflower Compact concluded on the Mayflower in 1620, when the United States was yet to be born, was not exactly reflective of the "American spirit." The spirit the pact reflected belonged to the whole world; this was the democratic spirit. The essence of this spirit lay in the fact that each member of the collective had the right to express his own opinions, to participate, directly or indirectly, in the formulation or revision of the rules of the collective, and to influence, directly or indirectly, the decisions of the collective. If the rules of the collective are formulated voluntarily by all members, and can be revised according to generally accepted procedures, then these rules will naturally take as their basic principle the protection of the rights of its members; relations of mutual respect, mutual trust, and friendly cooperation will naturally be dominant in such a collective and make for strong cohesive forces within it, thereby engendering the love of the members for the collective. Similarly, the

spirit of "patriotism" was not the love of an abstract noun, but the expansion and extension of one's love for the collective to which one belongs.

For each country, the most fundamental rules are the Constitution and the laws. During the "Cultural Revolution," when the Constitution and the laws were trampled on, when the life and security of the state president [Liu Shaoqi] could not be guaranteed, and when people's freedoms were deprived, protest and rebellion against the "Cultural Revolution" were "patriotic," and unprecedentedly so. Only when people enjoy the right to express themselves freely, only when people have the right to influence, directly or indirectly, state policies, only when people's freedoms and rights are protected in their country, can they truly link themselves to the future and fate of their country. Concern for the future and fate of the country reflects in itself a strong patriotic spirit.

As I stood by Plymouth Rock and looked over the vast ocean, I pondered that China's prosperity was not that far away. Yet a highly developed commodity economy, a good social order, popularization of the spirit of "legal rule," and universal attention to public morality, all these depend on the promotion of the spirit of science and the spirit of democracy. But the Chinese marching toward the 1990s are not the settlers with only their bare hands; they are the Chinese with a long cultural tradition. With the spirit of science and the spirit of democracy taking roots and growing in the Chinese civilization, a highly civilized, modernized China will stand on earth.

(January 11, 1989)

18 | Two Bases of Social Justice

Editors' Introduction: This essay, published in early 1989, shows Yan's growing preoccupation with many of China's social problems: galloping inflation, rising income inequalities, and widespread corruption. For Yan and many of China's reformist intellectuals, these growing problems can only be dealt with by adopting thorough reforms, rather than half-baked reforms or by stopping reforms altogether.

This rather philosophical essay makes the argument for fundamental reform through a discussion of the concept of fairness. Instead of "equality of outcome," by which Yan is referring to narrow wage differentials, Yan advocates "equality of opportunity," particularly in regard to access to impartial markets. He also reiterates his calls for the rule of law to undermine inequalities caused by "special privilege."

In a short essay dealing with a huge subject, the discussion is necessarily incomplete. For example, Yan does not discuss many of the complexities associated with these issues—such as whether positive discrimination (affirmative action) should be used to counteract the effects of previous unfairness, and the question of market power. Markets may be very fair, if perfect competition exists. But the structure of many markets is often highly unequal (i.e., monopolies or oligopolies, or when one or a small number of consumers dominate the buying segment of the market).

This essay was originally published in *Guoqing yanjiu* (Studies on National Conditions), no. 1 (1989), under the title "Gongping de liangge jichu (Two bases of justice). The present title was adopted by Professor Yan.

* * *

The question of fairness has become a major problem in our society. If a state takes a laissez-faire attitude toward the widespread manifestations of injustice in society, it harbors sources of unrest. It should be said that the unrest by no means arises simply because a certain theorist airs a particular opinion, or publishes an article. To hold such a belief is to exaggerate the influence of theorists. The American political scientist Samuel Huntington believes that the various social contradictions and grievances formed in the process of modernization will lead to increasing popular demands for political participation; such demands, in the absence of political institutionalization, can easily cause political uncertainty or unrest.[1] I believe that the grievances in society are often closely related to injustice. Therefore, political stability ultimately has to rely on the "institutionalization of politics," that is, to rely on the establishment of various systems, laws, and regulations in order to regulate effectively the various social contradictions, including what are perceived to be unfair practices.

Fairness does not equal the "equality of outcomes." For a long time, socialism was regarded as a society in which "equality of outcomes" existed or nearly existed. After almost a decade of economic reform, the concept of fairness held by the Chinese is undergoing a major change. The concept of "equality of outcome" as fairness is being discarded in favor of "equality of opportunity" as fairness. It should be said that this is a step of marked progress for Chinese society.

I think fairness has two bases. One is the universality of rules, that is, laws or systems; there is "fairness" only when all are equal before rules, laws, and institutions and regulations. The other is the market principle in economic life; all have equal

opportunities in the market. Yet, to this day, these two principles are far from established in our society. Furthermore, there are various disagreements over how to analyze these issues.

I believe that it is impossible for people not to differ from one another in a society. People differ from one another in at least three aspects: first, in income and wealth. Despite the [near] absence of private property during the Cultural Revolution, people still had different salary levels. The second is in power, for people's positions in decision making cannot be equal in a society. The third is in reputation and influence. I think this classification by Max Weber is a reasonable one.[2] These differences arise from people's social and natural variations. People's natural variations (in language, race, level of education, and ability) may cause social differences, as in power, position, wealth, and reputation. So I think that ultimately fairness means that a society has accepted a set of just rules for the distribution of these things. Without fair distribution, people will have a sense of injustice. For instance, if people do not start at the same place in a race, those who have to start farther back will definitely have a feeling of injustice. Indeed, phenomena like this occur in great abundance in present-day economic life. At present, with some 220,000 individual businesses in the whole country, not to mention the many cases of "official businesses," the income and wealth differentials among the people have began to grow.[3] I think the sense of injustice arising thereof is not due to the inequality of outcome, but to the inequality of opportunity. Relying on power and other scarce opportunities, some people earn huge sums, thereby creating the problem of unfairness.

Or take for instance the present price reform. What is price? Price should be the signal reflecting the supply and demand relationship on the market. The market should be the mechanism for fairness. Yet do we have such a fair market? Theoretically, the market includes all the buyers and sellers who influence the price of a certain commodity. The market is not what we usually call the "East Wind Department Store" or other places such as the food stalls. Rather, different commodities have different mar-

kets—the world, a country, or a region. The oil market is world-wide. What is our concept of price? I think it is entirely different. When marketing a product, there should be a mechanism for the price of the same commodity to be the same everywhere, thereby making the market a fair mechanism for distribution. But our "market" is different, since the rise in commodity prices is not decided by the buyers and sellers but by the government. Without a true market mechanism, price rises are not decided by the buyers and sellers; and the people have no choices. This creates an ever-growing problem of "unfairness." A complete market can eliminate the price differences rather quickly. Thus the inequality in the economic realm can be solved through the market. However, an unbridled market may also create great differentials in outcome. People then will have another sort of "sense of unfairness." This inequality will need to be regulated by the state tax policy (such as a progressive tax) and social policy. Nevertheless, in making such an adjustment, the laws and regulations must apply equally to everyone.

The principle of fairness requires that a rule or law be equally applicable to all people in a particular category, so as to avoid making different concrete decisions in the case of different people. In the political and social realms, fairness must be guaranteed by applying the principle of "legal rule." Under the rule of law, people are entitled to do what the law does not forbid them from doing, while holders of state power are prohibited from doing what the law does not permit. However, ours is now far from being a country ruled by law; instead, it is a country with "a high degree of administrative control." Our society allows power holders to do what the law does not allow them to do, but often prohibits people from doing what the law permits. The so-called *"quan da yu fa"* (power above the law) means holders of administrative power can make various decisions in disregard of legal regulations. In a society that is devoid of the concept as well as the spirit of "rule by law," numerous unfair phenomena arise from "power above the law."

With regard to the varieties of problems of inequality in soci-

ety, I think that, first, they must be acknowledged; second, "equality of opportunity" and "equality of outcome" must be clearly distinguished; the concept of "equality of outcome" must be discarded in favor of the concept of "equality of opportunity"; third, the market economy must be strenuously developed to serve as the mechanism for "fairness"; fourth, we should build our country into one ruled by law, making "the law is supreme" the basic principle of our country, and guaranteeing that "all are equal before the law."

Notes

1. See Samuel Huntington's *Political Order in Changing Societies* (New Haven, CT: Yale University Press, 1968), esp. chapter 1. Huntington argues that political institutionalization must exceed demands placed on the political system if political stability is to be insured. Huntington favors the "demobilization" or suppression of popular participation until political institutions are stronger. Believers of "new authoritarianism" in China, which advocates power vested in a benevolent despot (i.e., Zhao Ziyang) combined with protection of basic human rights, say Huntington is their inspiration. Huntington, interviewed by the Shanghai-based *Shijie jingji daobao* [World Economic Herald] (March 20, 1989), p. 13, criticized the putative links between his writings and the theory of "new authoritarianism." For an overview of "new authoritarianism," see *China News Analysis*, no. 1387 (June 15, 1989), pp. 6–8.

2. Weber, the great German social scientist (1864–1920), focused on the general question of domination in his scholarly work.

3. Yan used the very low figure of 220,000. Some estimates of the number of private enterprises have put the figure at 14 million, though the economic austerity program currently in force has forced numerous private businesses into bankruptcy.

19 | Democratic Politics Is Both the "Politics of Procedures" and the "Politics of Responsibility"

Editors' Introduction: This short essay was written around May 4, 1989, but published after martial law was declared in Beijing on May 19. As the title indicates, this essay represents part of Yan's attempt to educate the public about the virtues of democracy. Here we find Yan at his best, producing a concise statement that is at once rational, persuasive, and elegant.

Yan points out that democratic politics is both the politics of procedures and the politics of responsibility. His emphasis is clearly on the latter, arguing that "the government and its decision makers must be responsible to the people" and that "the cause of all turmoil lies in the lack of democracy and the rule of law." Left unstated is the question of government legitimacy. Indeed, by mid-May, Yan and a majority of the Beijing residents had come to the conclusion that the government headed by Premier Li Peng was losing its mandate. From there, it was logical for Yan to write the "May 17 Declaration" (see the next selection) and for other reform-minded intellectuals to sign it.

This essay originally appeared, on May 23, 1989, in *Guangming ribao* (Illumination Daily) as part of a discussion on the traditions of the May Fourth Movement of 1919.

* * *

For a long time, we have held many specious views on the question of democracy. [One view] holds that, in the promotion of

democracy, chaos can easily result because you have your idea and he has his. Further, in promoting democracy, decisions are made by the majority and, [therefore], no one would be responsible; there would be different decisions daily and things would only get out-of-hand. This sort of understanding makes many people fear democracy when they have to speak of it.

For a group, when members want to come to a decision while they disagree as to goals, values, and views, the only way [to a solution] is to follow the principle of democracy and make decisions by following pre-determined procedures and the views of the majority. This is called the democratization of decision making. The formulation of rules and regulations of a group and the selection of its leaders are also "the making of decisions." [Moreover], "majority decisions" can have "majorities" of different percentages, such as a simple majority or a majority of two-thirds. Since decision making is affected by various factors, both rational and irrational factors influence decision making. Consequently, democracy does not mean the making of the right decisions, but lies in the timely correction of wrongs by following predetermined procedures (such as elections, recall, removal, votes of confidence, citizen voting, and restrictions on terms of office). A political party or a social group has democracy if it has such a mechanism for decision making and the correction of mistakes. Thus, democracy is composed of two major elements: one is compliance with predetermined procedures, the other is implementation of the principle of majority decision making.

The premise of democracy is for members of a group to have the right to express freely their opinions, besides the right to know, freely, the opinions of other members. When a group with a lot of members adopts such tactics as "small group discussions" and "reports to higher levels by lower levels," and thus makes communications among members of the group difficult, then this group can hardly make decisions well. For a country, democracy needs the protection of the constitution; without the freedom of speech, the freedom of the press, and the freedom of publications, there is no democracy to speak of.

The democracy of a state political system entails the relations between the people and the state political power. For a country, the political ideas and values of the highest decision-making stratum fundamentally influence the direction, policy, and measures of development in a country. Democratic politics means that the people, through direct or indirect channels, decide on the choice of persons for the highest decision-making stratum of a country, thereby influencing the direction, policy, and measures of development of that country. The "general line," "Great Leap Forward," and "People's Communes" of the 1950s and the "Cultural Revolution" of the 1960s to 1970s were all related to Mao Zedong's political thought. Although it brought China numerous calamities, the people could not change Mao's orientation of decision making through predetermined procedures.

Democratic politics is also the politics of responsibility. In democratic politics, the highest decision-making stratum is, directly or indirectly, responsible to the people. A ruling party ought to convert the principles and policies of that party into state laws, and government policies and measures through procedures provided by the constitution and the law. The party should not replace the government and rule the country itself. In democratic politics, the decisions of the government have binding effect on all who are under the jurisdiction of the government. No modernization is possible if orders are not carried out and prohibitions not enforced. However, the government and its decision makers must be responsible to the people. That is political responsibility. First, people's deputies or representatives must be responsible to their electorate; second, the government must be responsible to the institution of the people's deputies or parliament, or the government assumes responsibility to the electorate. Our country had so many problems including the turmoil of the Great Leap Forward and the "Cultural Revolution," yet no one assumed definite political responsibility for them. Thus, democratic politics is far from built in our country.

For a country, democratic politics ought to be built on the basis of "the rule of law." The basic principle of the "rule of

law'' is that the constitution and the laws are supreme, no one's power can exceed that of the constitution. The implementation of ''the rule of law'' means, for the public citizen, that a citizen can undertake all actions not prohibited by law; for the organizations and officials in control of state power, they can only exercise the powers specifically provided for by the law.

When a country has established democratic politics, people's wishes, demands, and sentiments can be expressed through normal channels, all sorts of major mistakes can be corrected through the reelection of representative organs, and through the peaceful change of government. The cause of all turmoil lies in the lack of democracy and the rule of law. Meanwhile, the root cause of the pessimistic sentiments that are enveloping the whole country lies also in the fact that the people have no normal channels to express their wishes, demands, and sentiments, and they cannot influence the major decisions of the country through normal procedures.

Naturally, in establishing democratic politics, each country can adopt its own features. The United States did not have to copy its democratic system from Great Britain. The long-term rule of one party in Japan cannot easily turn into a French-style multiparty system. Yet, whether it is in the East or in the West, democratic politics is both the ''politics of procedures'' and the ''politics of responsibility.'' This principle is the essence of human civilization. We have no reason to refuse, on the pretext of ''peculiar national conditions,'' the democratic principle which is a progressive and universal achievement of human civilization. Democratic politics can only grow after the recognition of the democratic principle.

1989

The Democracy Movement

Editors' Introduction: The next seven essays and interviews are products of Yan's participation in the democracy movement of April–June 1989, and his reaction to the Tiananmen Massacre of June 3–4, 1989. They are grouped together here because of their common focus. Only one of these writings appeared in the official PRC press, and that was at a time when the press was almost free (between May 10 to May 20, the press was largely unsupervised).

These essays largely speak for themselves. Prior to the massacre, Yan was highly optimistic that democratic principles and fundamental political and legal reforms would be instituted, and that the widely disliked premier, Li Peng, would either resign or be removed from office. After the massacre, and Yan's narrow escape from China, he is filled with indignation and revulsion. He is confident that democracy will ultimately triumph in China, but he is so angry with the current power holders that most of his attention is devoted to denouncing them and analyzing their infighting. The events of June are simply too recent and overpowering for Yan. Thus in these essays he devotes no real attention to speculating on how democracy will triumph in China. Nevertheless, Professor Yan has assured the editors that, despite his new responsibilities as president of the Paris-based Front for a Democratic China, he will continue to pursue his research interests and we look forward to reading his thoughts on these and other salient issues related to China's future.

20 | The May 17 Declaration

Editors' Notes: This declaration, drafted by Yan Jiaqi, was signed by Yan and dozens of prominent intellectuals. It was originally published in *Ming Pao* (Hong Kong) and other publications on the same date.

* * *

Since 2:00 P.M. on May 13, over three thousand students have joined in a hunger strike for more than a hundred hours on Tiananmen Square; over seven hundred of them have already fainted. This has been an unprecedentedly moving and yet tragic event in the history of our motherland. The students demand a refutation of the April 26 *People's Daily* editorial,[1] and live broadcasts of a student-government dialogue. While the sons and daughters of our motherland are falling one after another, their just demands have yet to be recognized, and this is why the hunger strike cannot stop. At present, the problem of our country is fully exposed before the people of the whole country and the entire world; that is, because the dictator has grasped unlimited power, the government has forfeited its responsibility and lost any sense of humanity. Such an irresponsible and inhuman government is not a government of the republic, but one controlled by a dictator.

It has been seventy-seven years since the downfall of the Qing Dynasty. Nevertheless, China still has an emperor who only lacks a formal title, and a dictator who is senile and incompetent

[Deng]. Yesterday afternoon, General Secretary Zhao Ziyang openly announced that all of China's major decisions have to be approved by this senile dictator. Without the approval of this dictator, the April 26 *People's Daily* editorial cannot be refuted. After conducting hunger strikes for over a hundred hours, the students have no other alternative. The Chinese people can no longer wait for the dictator's open admittance of mistakes. They have to rely on themselves. Today, we proclaim to the whole country and the whole world that the great student hunger strike of over a hundred hours has achieved tremendous success. The students have proclaimed with their action that this student movement is not turmoil, but a great patriotic democratic movement that will eventually bury the dictatorship and bury the monarchy.

Let us shout the great triumph of the hunger strike! Long live the spirit of nonviolent protest!

Down with personal dictatorship! The dictator will come to no good end!

Refute the April 26 editorial!

Gerontocracy must end!

The dictator must resign!

Long live university students! Long live the people! Long live democracy! Long live freedom!

Note

1. Authorized by Deng Xiaoping, this editorial branded the student demonstrations as turmoil.

21 | Solve China's Current Problems with Democracy and the Rule of Law

Editors' Notes: This essay was originally published in *Ming Pao* (Hong Kong), May 26, 1989 and other newspapers. Yan co-authored it with Bao Zunxin, a senior research fellow at the Chinese Academy of Social Sciences. The original title was "Zai minzhu yu fazhi guidao shang jiejue dangqian Zhongguo de wenti—jian gao Li Peng shu" (Solve China's current problems along the track of democracy and the rule of law—also a letter to Li Peng).

* * *

The present student movement in China has developed into a nationwide all-people protest movement. This is an epoch-making event in contemporary China, and its irresistible force has greatly advanced the Chinese democratic process. The student movement has announced to the whole country the basic principle of democratic politics, namely, all the powers of state belong to the people. The power of the ruling party which organizes the government and the power of the government itself is not inherent, but comes from the people. The people have the power to overthrow a government they do not trust. In the student movement, the slogan "Down with Li Peng!" is heard all over the country. For a long period of time in the past, propaganda machines in our country regarded the criticism of party

and government leaders as "attacking the party and government leadership." The student movement has completely discarded such an outmoded idea, depriving Li Peng and others of any excuse to prohibit the people from condemning the perverse acts of the government. If a government head, despised by the people, refuses to resign of his own accord, the people can dismiss him by following the procedures as provided by the constitution.

According to Article 57 of the constitution, the National People's Congress (NPC) is the highest organ of state power, and it has the power to recall or remove from office the premier of the State Council. The NPC standing committee, as the NPC's permanent organ, has the power to abrogate the administrative decrees and regulations, decisions and orders issued by the State Council which run counter to the constitution and the laws. Our current problem [challenge] is first of all to convene an emergency meeting of the NPC standing committee to make decisions on the following two issues:

1) Abrogating the "State Council's Order on Imposing Martial Law in Some Areas of Beijing Municipality," which was signed by Li Peng on May 20;

2) Holding an emergency session of the NPC in the near future.

The order imposing martial law in some Beijing areas was issued by the State Council five days ago. Over the five days, "social order in Beijing has been the same as usual, and the life of residents has been roughly as usual," "in the martial law areas designated by the municipal government, no unusual situation has occurred that is different from that of the previous days," and "social order in Beijing continues to develop in the direction of stability."[1] In contrast (to what the *People's Daily* has reported recently), it was the proclamation of the martial law order that caused students and residents to become extremely worried. To prevent the martial law troops from entering the city, Beijing residents have spontaneously set up roadblocks at all crossings of roads leading toward the suburbs. Facts over the past five days have fully proved that the State Council martial law

[proclamation] is unnecessary. Furthermore, due to the resolute resistance of students and residents, and the common views shared by soldiers, students and residents, it has been impossible to execute the martial law order.

According to Article 29 of the constitution, our country's armed forces belong to the people. The armed forces can be used only when the state is facing a foreign invasion, or when a serious armed riot has occurred in the country. Now Beijing faces neither invasion by foreign armed forces nor an armed riot. Under such circumstances, sending troops to Beijing to "enforce the martial law" is an act which violates the constitution. Therefore, we strongly urge the NPC standing committee to hold immediately an emergency meeting and revoke the martial law order.

Over the past month, Li Peng, as premier of the State Council, has committed extremely serious mistakes or even crimes on the following two issues: first, he turned a blind eye to the petition of more than 3,000 students on a hunger strike, causing more than 1,000 students to faint. In the history of the whole world, not a single government has turned a blind eye to several thousand students staging a hunger strike. This fact fully shows that Li Peng has become a premier who lacks the most basic human feelings.

On May 20, Li Peng, as premier of the State Council, issued the order to impose martial law in certain Beijing areas against students in a peaceful demonstration and residents who are unarmed. This has enraged all the people of Beijing and of the whole country; this has also invited public condemnations by the whole country and the whole world. The use of troops by Li Peng to deal with unarmed students and residents seriously violates the constitution.

Democratic politics is the politics of responsibility. Article 63 of the constitution stipulates that the National People's Congress has the power to remove the premier of the State Council. Article 61 of the constitution stipulates: "A session of the NPC may be convened at anytime the standing committee deems this neces-

sary, or when more than one-fifth of the deputies to the NPC so propose." We strongly demand that a NPC session be held as early as possible to examine the acts of Li Peng in April and May of this year, which have betrayed and opposed the people, and to dismiss him from his post of prime minister.[2]

For a long period, due to the displacement of government by the party, the nonseparation of party and government, the constitutional stipulation that the NPC is the highest organ of state power has remained an empty phrase. Now is the time for us to change completely the situation that the party is lording over the highest organ of state power. As long as the reasons for holding an NPC session comply with the stipulations of the constitution, the session can be held without the approval of Li Peng, who holds important party and government posts, or other persons. Must a meeting of the NPC standing committee aimed at abrogating the martial law order issued by Li Peng, and an NPC session aimed at dismissing Li Peng from the post of premier be held with the approval of Li Peng, or some other persons? At present, the serious political crises in our country can only be solved along the track of democracy and the rule of law. Therefore, we call on each and every people's deputy to cast his sacred vote to abrogate the martial law order and to dismiss Li Peng from his post as premier. When the Chinese people see that the NPC has truly become the highest organ of state power, our people's deputies will realize that they have made an unprecedentedly great and historic contribution to the building of democratic politics in China.

At present, the NPC standing committee meeting has not been held, and the martial law order has not been abrogated. Power is still in the hands of Li Peng. While [NPC] Chairman Wan Li issue an appeal to solve the current problems in China along the track of democracy and the rule of law, Li Peng and others might resort to violence to suppress the people. If the NPC standing committee meeting and the NPC session cannot be held, and if massive bloodshed occurs because of the suppression, Li Peng will further commit unpardonable crimes in addition to his previ-

ous two mistakes. This will bring Li Peng as premier to trial in accordance with the law. We wish to offer a piece of advice to Li Peng: your wisest choice is to resign of your own accord to reduce the catastrophe brought to the country and the people. If Li Peng resigns of his own accord before he commits further mistakes and crimes, we propose that we refrain from investigating and affixing his responsibility for the serious mistakes of dealing with the students on a hunger strike in an inhuman way, and of proclaiming the martial law order on May 20. What course to follow—it is now the time for Li Peng to make his final choice. If Li Peng resorts to violence to quell the student movement, and if he truly resorts to arms to maintain his tottering rule, millions upon millions of Chinese people vow to forge China's democracy with their life and blood.

Notes

1. These quotations were apparently taken from current reports of the *Renmin ribao* (People's Daily).

2. Attempts were made in the last ten days of May to convene a NPC standing committee meeting, but no meeting was convened until after the massacre, when the NPC standing committee rubber-stamped the action of the military.

22 | An Open Letter en Route to France

Editors' Notes: This open letter, written on June 24 while Yan was in Hong Kong, as published in numerous Chinese newspapers on June 26, 1989. Yan left this letter for publication before leaving for France, where he and his wife, Gao Gao, are in exile. This translation is based on the Chinese version published in *Tansuo* (The quest) (New York), no. 67 (July 1989), p. 27.

* * *

China is presently shrouded in white terror. I had to leave Beijing soon after the Beijing Massacre.[1] At present, Deng Xiaoping, Li Peng, and Yang Shangkun[2] are intensifying their efforts to carry out a "massive roundup" across the country. They are pursuing an ultrafascist extermination policy in a vain attempt to kill all upright Chinese people who possess ideas of democracy and freedom. The wholesale massacre and roundup since June 4 have made Deng Xiaoping, Li Peng, and Yang Shangkun the public enemies of the Chinese people and the whole of mankind. Their extermination policy will not only intensify the deep-seated hatred that the Chinese people have for them, and sow the seeds of democracy and freedom in the hearts of more and more people, but will also hasten their doom.

After the events of 1956 in Hungary,[3] Tito in Pula commented on the Hungarian political situation: "What they sowed was a breeze, what they are harvesting is a hurricane." In China of

1989, Deng Xiaoping has planted a storm of hatred, yet the terror politics and the extermination policy will not bring the reactionary clique of Deng Xiaoping, Li Peng, and Yang Shangkun a few years of peace and tranquility. They have sowed a storm of hatred. Before long, they will reap a hurricane sweeping across China with an invincible force. They will face the solemn and just trial by the people, and the Deng Xiaoping empire, a mansion of autocracy and dictatorship on which their existence hangs, will crumble in no time.

I hope, in China of the future, after the public trial of Deng Xiaoping, Li Peng, and Yang Shangkun, China will draw up a durable constitution, and eradicate, once and for all, those political disasters such as we are experiencing today. I hope that the separation of powers, the federal system, and the noninterference by the armed forces in politics and state affairs will become the basic principles of the constitution, that the constitution will enjoy supreme authority, and that the rule of law will replace personal rule, so as to end the dynastic cycle which has a history of several thousand years.

The people will not shed their blood in vain. The tide of democracy is surging forward and China has a bright future.

(June 24, 1989)

Notes

1. Tiananmen Massacre of June 3–4, 1989, when the Chinese army bloodily suppressed the democracy movement of April–June. Perhaps the best source to date about the massacre is Amnesty International, ''Preliminary Findings on Killings of Unarmed Civilians, Arbitrary Arrests and Summary Executions Since 3 June 1989,'' August 30, 1989, 49 pp.

2. Chairman of the Central Military Commission, premier, and president of the PRC, respectively, at the time of the massacre.

3. Tito was the leader of Yugoslavia from 1945 to 1980.

23 | The Massacre Has Dashed All Hopes About the Chinese Regime

Editors' Notes: This is an interview with Yan Jiaqi by Jiang Suhui, journalist for *Zhongguo shibao* (The China Times) (New York and Taipei). The interview took place in Paris on July 13, 1989. The present translation is based on the Chinese version published in *Huaqiao ribao* (Overseas Chinese Daily) (New York), July 14, 1989.

* * *

Q.: What is the state of mind of mainland intellectuals after the June 4 Massacre?

A.: Around 2:00 [A.M.] in the wee hours of June 4, I heard heavy firing. I stood on the balcony of my apartment on the fourteenth floor and, through a pair of binoculars, I saw crowds of people running for their lives on the Jianguomen overpass. Then I heard intensive machine gunshots being fired all over the inner city. My initial reaction was disbelief and intense grief. In the morning of June 4, we were together with a number of friends. With tears in our eyes, we were deeply grieved, sad, angry, and full of despair; we could not imagine something so brutal happening. The June 4 Massacre has dashed the last hope that intellectuals had about the current regime on the Chinese mainland.

Q.: How was your situation and that of other intellectuals then? What was the cue that made you plan for your escape?

A.: After the June 4 Massacre, my friends advised me to leave Beijing immediately, so as to avoid being killed by random machine-gun shooting. After escaping from Beijing, I lived in the countryside in southern China and planned to return to Beijing after a month or two. I had correctly predicted the development of many significant political events in the past. This time, however, I neither thought of such an insane massacre occurring in Beijing, nor thought of such savage arrests after the massacre. On June 12, I heard over the radio Notice 14 issued by the army enforcing martial law and then made up my mind to leave the motherland where I have lived for decades.[1] With the help of numerous friends both at home and abroad and after undergoing many dangerous incidents, I finally made it to the foreign land.

Q.: You now live overseas and know the world public opinion [on the massacre]. What is your comment on the June 4 Tiananmen event?

A.: The June 4 Massacre was the darkest page written on Chinese history. On that day, the autocratic and dictatorial nature of the present system on the Chinese mainland was fully exposed. More and more people have come to realize clearly that this country, called "the People's Republic," is neither of the people nor a "republic." The June 4 Massacre has fully revealed that Deng Xiaoping is an emperor without a formal title, and a truly cruel dictator. Deng Xiaoping, Li Peng, and Yang Shangkun outmatched Hitler in the destruction of humanity and the devastation of mankind. The June 4 Massacre has made Deng Xiaoping, Li Peng, and Yang Shangkun public enemies not only of the Chinese people, but also of mankind.

Q.: As you recall what occurred on Tiananmen Square, what was the most memorable and most tragic scene for you?

A.: As I recall what happened on Tiananmen Square, the most painful and most memorable thing was that machine guns were used to fire upon unarmed peaceful demonstrators, that tanks and APCs (armored personnel carriers) even rolled over [the demonstrators]. That a government could have adopted such cruel tactics against its own people is beyond the comprehension of the

normal mind. One possible explanation is that this dwarf Deng Xiaoping not only hated the people, but his heart was full of hatred for mankind. Therefore, since Deng Xiaoping assumed dictatorial power, he had deliberately been planning his revenge on mankind.

Q.: As honorary president of the Democracy University on Tiananmen Square, what aspirations and expectations did you have?

A.: On June 3, the army was trying to come to the inner city of Beijing. On that evening, I was at the Jianguomen overpass, trying, like thousands of others, to block the entry of army vehicles. I returned home at 10:30 P.M. and then received a call from someone speaking on behalf of the writer Zhao Yu. I was asked to go to the square immediately to attend the opening ceremonies of the Democracy University. I arrived at the square at 11:10 P.M. After Zhang Boli, president of the Democracy University, announced that I was the honorary president, he asked me to speak. I spoke for twenty minutes, first talking about the meaning of democracy, freedom, the rule of law, and human rights, second calling for the voluntary resignation of Li Peng. I said that if Li Peng, instead of resigning, tried to crack down on the people, he would be tried; the people would forge democracy for China with blood and life. My expectations were: first, overthrow the Deng-Li-Yang clique, bring Deng, Li, and Yang to a public trial, erect, on Tiananmen Square, with the Mao Mausoleum as a base, a new statue of the "Goddess of Democracy" that would be many times taller than the one [that was overturned by the army]; the Goddess of Democracy would step on Deng with her feet. Second, popularize around the country the main course of the Democracy University at the square—the meaning of democracy, freedom, the rule of law, and human rights, promote the reform of China's political system, and make the future China one that is truly built on the principles of "democracy, freedom, the rule of law, and human rights."

Q.: What do you think the future course of Chinese politics will be? What do you think of the road of reform and opening up on the mainland?

A.: The Fourth Plenum [of the 13th Central Committee] of the CCP chose three new Politburo standing committee members.[2] The choice of Jiang Zemin as general secretary was the outcome of Deng Xiaoping's attempt to check the Li-Yang clique and play "the trick of political balance." Deng Xiaoping recently admitted that the student movement was due to corruption [in the party] and said that "there will be a limit to the number of people killed." Jiang Zemin also said: "We must strictly distinguish between two different kinds of contradictions, strictly carry out our policies and do our work according to the law." After the wanton arrests and summary executions, Deng Xiaoping now wants it to be known that he himself does not advocate such wanton arrests and summary executions. Therefore, Li Peng, who presided over the wanton arrests and summary executions, will become the scapegoat. Li Peng's ouster is merely a matter of time. Among the standing committee members, Deng Xiaoping has already chosen his favorite for the position of premier in the future.[3] Even as the Deng-Li-Yang clique controls power, it will take over some of the slogans of the student democracy movement on the Chinese mainland and perform limited "reform" in a system of autocratic dictatorship, so as to soften the social contradictions. But this sort of "reform" can't save the system of autocratic dictatorship.

Q.: Mr. Liu Binyan [noted Chinese journalist] said in Hong Kong that the political power of the Chinese communists cannot be without change within two years. Do you agree with this view?

A.: I agree with Liu Binyan's estimate. Within two years, the Deng-Li-Yang clique will fall. The Chinese mainland has presently seen the strengthening of restrictions on news and publishing and the enhancement of police rule; China is shrouded in white terror. Such terror politics can only intensify people's hatred for and resistance to the Deng-Li-Yang clique. Besides, the Chinese mainland cannot overcome the wholesale crisis, which it already faces, of politics and economics. A still stronger storm is gathering its forces.

Q.: You [Yan and his wife, Gao Gao] wrote *A History of the Ten-Year "Cultural Revolution."* Now how do you compare the June 4 Tiananmen event with the Cultural Revolution? Are there similar tricks or political tactics?

A.: The Chinese democracy movement of this year is of an entirely different nature from the "Cultural Revolution." The criticism of Deng Xiaoping during the "Cultural Revolution" strengthened Mao Zedong's dictatorial power; in contrast, the denunciation of Deng Xiaoping during the democracy movement of 1989 is a great patriotic democratic movement aimed at overthrowing dictatorship and tyranny. Of course, the "April Fifth Movement" [of 1976] late in the "Cultural Revolution" can be compared to the democracy movement of 1989. However, in terms of scale and significance, the democracy movement of 1989 far exceeds the "April Fifth Movement" of thirteen years ago. The June 4 Massacre also far outmatches the suppression of the "April Fifth Movement."

Q.: What convictions do you hold about the building of democratic politics on mainland China?

A.: After the fall of the Deng-Li-Yang clique, freedom of the press must be strengthened. The Chinese mainland will then enter a period of "de-Dengization" and "de-Maoization." Then, China will put on the agenda political reform, especially the drawing up of a durable constitution. Ultimate authority of the constitution, the division of powers, the federal system, noninterference of the armed forces in politics and state affairs, the direct election of parliament, judicial independence, the protection of human rights, and so on, will become the fundamental principles for formulating the new constitution. Centering around the drafting of a new constitution and direct elections, China's politics will become increasingly pluralistic and Chinese democratic politics will thus steadily grow on these bases.

Q.: What are your goals of struggle for the future? What is your state of mind at the moment?

A.: My goals of struggle are to devote my entire life to the construction of democratic politics in China. The present dark-

ness only foreshadows the coming of brightness. I will always be fully confident of the beautiful prospects for China.

Notes

1. Notice 14 called on the leaders of the various associations formed during the democracy movement to surrender or face arrest. Yan Jiaqi was one of the founders of the Beijing Association of Intellectuals.

2. It was convened on June 23–24, 1989. It officially removed Zhao Ziyang from power and appointed Politburo member and Shanghai first party secretary Jiang Zemin as general secretary of the CCP.

3. This is presumably a reference to Li Ruihuan, former mayor and first party secretary of Tianjin, who was added to the Politburo standing committee at the Fourth Plenum. Li has been charged with supervising propaganda work.

24 | A Letter to Heads of State

Editors' Notes: Drafted by Yan Jiaqi and Su Wei on July 13, 1989, this open letter was published in various newspapers in Hong Kong and Europe in the name of the Beijing Autonomous Association of University Students and the Beijing Association of Intellectuals. Su Wei, who was a member of the Institute of Literature at the Chinese Academy of Social Sciences, is now a member of the Front for a Democratic China and a visiting scholar at Princeton University. The present translation is made from the handwritten original.

*　*　*

On the occasion of the bicentennial of the French Revolution, we extend our holiday greetings to those heads of state and heads of government who have gathered here in Paris and present our compliments to those heads of state who are devoted to freedom, democracy, the rule of law, and human rights.

July 14 is not only a holiday for the French people, but *a holiday for mankind.* It is a great anniversary of mankind's struggle against autocracy, dictatorship, and tyranny. It was on this day [two hundred years ago] that the ideas of democracy, freedom, the rule of law, and human rights began to become more widespread day-by-day throughout the world, bringing one after another of those dictatorial and tyrannical rulers to the tomb of history. The student movement and democracy movement of

1989 in China inherited and developed greatly the spirit of the French Revolution.

In the twentieth century, the world has seen *two strong anti-democratic forces*: one is fascism as represented by Hitler, the other is the social dictatorship initiated since Stalin. With the end of the Second World War, fascism has gradually died out. However, the social dictatorship that has spread for over half a century continues to run rampant in certain countries or regions. *Social dictatorship promotes autocracy and dictatorship in the name of "socialism."* And it is lording wantonly over the Chinese people with unparalleled ferocity. The recent Beijing Massacre of June 4 and the ongoing roundup and executions are the most savage and malicious challenge that social dictatorship has posed to the Chinese people and mankind, and is the wholesale reaction against the path of human civilization that was opened up by the French Revolution.

China is presently shrouded in white terror. Many of our colleagues who contributed so much to China's reform and democratization have been imprisoned or are facing the danger of purges. In the meantime, the scope of the roundup and persecution of intellectuals and democracy activists continues to widen. In human history, it is rare for a government, like the one headed by Deng Xiaoping, Li Peng, and Yang Shangkun, to be angrily despised and openly condemned so widely and for so long. It is as rare for a government, like the one headed by Deng, Li and Yang, to use means so despicable and so brutal in the suppression of the people of its own country, while using such shameless lies to deceive public opinion both at home and abroad.[1] Dear top leaders from various countries, we sincerely call your attention to the fact that the current power holders in Beijing have completely lost the confidence of the 1.1 billion Chinese people. The Chinese people have in fact ceased to recognize this utterly inhuman regime. This regime, which takes the people as its enemy, *has totally lost its legitimacy.* After the Beijing Massacre of June 4, governments in most countries and nations of the whole world expressed their deep sympathies with and concerns about the

suffering of the Chinese people, and sternly condemned the brutal criminal activities of the Beijing power holders and imposed sanctions [on the Chinese regime]. On behalf of the Chinese students and the Chinese people, who are savagely suppressed and persecuted, we wish to express our heartfelt thanks to the peoples of all countries and their heads of state. A government is not tantamount to a nation. We love our motherland, yet we completely abhor the regime which is ruled by the Deng-Li-Yang clique and excels in hurting the people. *Condemnations and sanctions against the present regime in China are support for the Chinese people and support for the just cause of entire mankind.* On the occasion of the bicentennial of the French Revolution, we call on the heads of state and heads of government in the world to:

1. Organize an international group of the United Nations in order to investigate the truth of the Beijing Massacre of June 4 and the post–June 4 roundups and executions, so as to expose the monstrous lies of the Beijing regime.

2. Pay close attention to the grievous situation of roundups and executions being carried out by the Beijing regime and try every possible means to rescue those fighters for democracy who are being persecuted and suppressed on the Chinese mainland.

3. Adopt all means to continue the condemnations and necessary economic sanctions against the current regime in China, and cancel all high-level exchanges and visits at the head-of-state level with the Beijing regime.

A French historical figure once said: There are only two strong forces in the world, guns and ideas. *In the long run, guns have always been conquered by ideas.*[2] For two hundred years since the French Revolution, despite the numerous attempts by various autocratic rulers to kill with guns the ideas of democracy, these ideas have become irresistible like mountains being piled up or rivers following into the ocean inexorably. At present, Deng Xiaoping, Li Peng, and Yang Shangkun, using tanks, guns, executions, and arrests, are *turning the whole of China into a giant Bastille.* However, we believe that a new and stronger storm is

soon to arise that will bury the rule of dictatorship. The oldest and most obstinate stronghold of dictatorship will be conquered by the power of the people. The banner of the *republic based on "freedom, democracy, rule of law, and human rights"* will fly high over the Chinese land.

(Paris, July 12, 1989)

Notes

1. After the massacre, the Chinese government went to great lengths to excuse itself from any responsibility for the massacre, saying, among other things, that the military was putting down a counterrevolutionary rebellion and that no one died in Tiananmen Square on June 3–4.

2. This seems to be a quotation from Victor Hugo, whose original words are translated into English as: "A stand can be made against invasion by an army; no stand can be made against invasion by an idea." *Histoire d'un Crime, La Chute*, X.

25 | China Is Not a "Republic"

Editors' Notes: This essay originally appeared in *Ming Pao* (Hong Kong) on July 23 and 24, 1989. It also appeared in numerous other publications.

* * *

The Beijing Massacre of June 4 was the darkest page in the annals of Chinese history. On that day, Deng Xiaoping, Li Peng, and Yang Shangkun unveiled the true face of the "republic." The people of China and the world have clearly seen that the so-called "People's Republic" is neither of the people nor a republic. A republic cannot permit anyone to become a titular or de facto emperor or king, cannot permit the supreme powers of the state to be held by one single person for life. Deng Xiaoping, as the de facto last emperor of China, charges that the student movement and the democracy movement were subverting the republic. Yet, the true people's republic is not to be subverted by anybody. The largest student movement and democracy movement that has ever occurred in Beijing last spring powerfully shook the imperial structure that is dressed up as "socialist" and as a "republic," and sounded the knell of the Deng Xiaoping–Li Peng–Yang Shangkun autocratic system.

Three Characteristics of the Autocratic System

During the rule of Deng Xiaoping, a typical autocratic political system, instead of a "republic," was built on the Chinese main-

land of today. For many countries, the autocratic system has long become something of the history books. People have always believed that the overthrow of the emperor or king was the end of the autocratic system. The history of contemporary China shows, however, that in a country, even without an emperor or king in name, called a "republic," and dressed up in the feathers of "socialism," the autocratic system may still exist.

In terms of structure, the autocratic system has three distinct characteristics. First, the supreme power of the state is concentrated in the hands of one person, and brooks no sharing by any other person or institution. As Deng Xiaoping made it clear in his speech on June 9, [1989], China could not adopt the "system with a division of three powers" [i.e., the executive, the legislature, and the judiciary], and must "continue to adopt the system of people's representative congresses."[1] The recently convened standing committee session of the National People's Congress again shows that [the NPC standing committee] had to obey Deng Xiaoping, the dictator, though it in name is the "permanent institution of the highest organ of state power." While ordinarily the standing committee of the NPC appeared to have been able to decide on the convening of its meetings and their agendas, in reality, when the dictator intervenes, the NPC standing committee cannot decide to convene a meeting of its own accord. Even when a meeting is convened, the agenda of the session must have been approved by the dictator. When Deng Xiaoping says that China cannot adopt the "division of three powers," he means that the highest organ of state power and the supreme organ of state administration must rank below the power of the dictator. On June 4, the Supreme Court directly cabled the standing committee of the Political Bureau of the Chinese Communist Party and branded, according to Deng Xiaoping's wishes, the student movement and the democracy movement as a "serious counter-revolutionary turmoil." Under such circumstances, there is no "judicial independence" to speak of.

The second characteristic of the autocratic system is that the supreme power held in the hands of one person does not allow

transfer. Mao Zedong's lifetime tenure brought tremendous suffering to China and made people realize the necessity of "abolishing the lifetime tenure of the highest leaders." After Mao Zedong, Deng Xiaoping time and again refused to serve in the position of the highest state and party leader. For many years, people have formed the good impression that Deng Xiaoping wished to relinquish his power voluntarily. Time and again, Deng Xiaoping expressed his desire to retire, adding that he had not retired only because the people could not agree [to his retirement]. When the people agreed, he would retire. The June 4 Massacre fully exposed the true face that Deng Xiaoping has deliberately kept veiled for many years. In the face of the angry denunciations of the people, he not only did not relinquish supreme power, but, exactly because the people asked for his retirement and removal, Deng Xiaoping ordered the use of tanks, APCs, and machine guns to suppress unarmed students and civilians. A moribund eighty-five-year old man, in the face of opposition from people of the whole world, still sought, after the "datusha" massacre of June 4, to search and arrest, at all costs, all those who resented and suspected him. In a talk given on June 24, Deng Xiaoping explicitly stated that if "the image and prestige of the third generation leaders cannot be established," that is, if the Chinese mainland cannot produce a leader who is totally obedient to him and yet can completely control power, Deng Xiaoping will never give up the supreme power.

The third characteristic of an autocratic political system is the unprincipled way in which the highest power is transferred. Historically, the kings, emperors, and heads of state repeatedly chose the imperial successors. Yet, as soon as the powers of the successors-designate expand a little, the change of the successor-designate becomes inevitable. The struggle for the inheritance of the imperial position makes the transfer of the supreme power follow no predetermined procedures. In contemporary China, Mao Zedong and Deng Xiaoping held great power to the end of their lives. For them, nothing was more important than the transfer of that power. Though Mao Zedong chose Liu Shaoqi as "heir-

apparent,'' when Mao believed that Liu Shaoqi, Deng Xiaoping, Peng Zhen, Lu Dingyi, Luo Ruiqing, and Yang Shangkun[2] formed a ''small clique'' that threatened Mao's supreme power, he went as far as to launch the ''Cultural Revolution'' in order to reduce Liu Shaoqi's power and influence. When Lin Biao, Mao Zedong's ''closest comrade-in-arms and heir-apparent,'' formed another ''small clique'' with Huang Yongsheng, Wu Faxian, Ye Qun, Li Zuopeng, Qiu Huizuo, and Chen Boda, Lin Biao's end became inevitable.[3] After Lin Biao, Wang Hongwen was chosen as ''successor-designate.'' In the Tiananmen Square Incident of 1976, Mao Zedong saw the protest against Wang Hongwen, Zhang Chunqiao and others [the Gang of Four], and finally chose Hua Guofeng as ''successor-designate.'' After Deng Xiaoping gained dictatorial power, Hu Yaobang and Zhao Ziyang became Deng's ''successors-designate'' one after another. However, Deng Xiaoping cannot avoid the dilemma faced by all dictators in human history either: as soon as the will of his successors-designate clashed with his, he changed, at all costs, the transfer of supreme power by discarding all procedures.

In contemporary China, Deng Xiaoping is an emperor without the emperor's formal title. He is a true dictator. Deng Xiaoping's power permits no division and no transfer, and the transfer of the highest power lacks any procedure. The People's Republic is a republic in name only.

The Massacre of June 4 Strengthened the Power of the Li-Yang Clique

The Li Peng–Yang Shangkun clique shares some common interests with Deng Xiaoping, but also differs from the latter. When it comes to preserving the system of dictatorship and their personal powers, they have no disagreements. The June 4 Massacre closely tied them together. However, when it comes to the question of what Deng Xiaoping refers to as ''reform and opening,'' the Li-Yang group, particularly Li Peng, Yao Yilin, and others, do not agree with Deng Xiaoping completely. Since Li Peng became the premier of the State Council, his policy orientation

has been to return to the "pre–Cultural Revolution" days; the disagreements and clashes between Li Peng and Zhao Ziyang over the question of "reform and opening" were inherently a sort of resistance on the part of Li Peng to Deng Xiaoping's policy of "reform and opening." Not long ago, Deng Xiaoping said that the report to the Thirteenth [CCP] Congress made by Zhao Ziyang on behalf of the CCP Central Committee emphasized the continuity of reform and opening. At present, this report to the Thirteenth Congress allows no alteration. Deng Xiaoping said, the [democracy] movement shouted numerous slogans, including "Down with Deng Xiaoping," but no one heard "Down with reform and opening." This showed that the people are satisfied with reform and opening. It is evident that those words by Deng Xiaoping were aimed at the Li-Yang group. He [Deng] will not allow anyone, including Li Peng, to negate [the policy of] reform and opening, which he has championed for ten years.

The June 4 Massacre was a bloody and reactionary military coup in contemporary China. Though the order to carry out the massacre was issued by Deng Xiaoping, it was the Li-Yang group that directly carried out the massacre and the massive roundup that followed. The massacre and roundup have made it impossible for the opposition forces within the ruling group on the Chinese mainland to raise their heads. The massacre and roundup, with its ultrafascist extermination policy and terror politics, have temporarily strengthened the power and influence of the Li-Yang group in the Chinese ruling strata.

Deng Xiaoping Faces New Challenges

Autocratic politics shows itself in two common forms. In one, the dictator is extremely powerful and, in the "highest power circle," no one is able to form a "small clique," and every powerful figure is loyal to the dictator directly. In the other, the dictator suffers in reputation and is not that powerful, and, within the highest power circle, two or more "small cliques" will form. In order to maintain his supreme power position, the dictator has to

resort to the "techniques of political balance" so as to juggle the various political forces into "political balance." Since Deng Xiaoping has made one wrong decision after another in recent years (e.g., pushing Hu Yaobang to resign, rushing price reform by disregarding actual conditions, and his speech on the "turmoil" on April 24),[4] his actual prestige has declined appreciably daily and he has had to resort to the use of the military power in his hands and the use of "political balance" in order to maintain his power. The newly formed standing committee of the Political Bureau at the Fourth Plenum of the Thirteenth CCP Central Committee was in reality the outcome of Deng Xiaoping's "trick of political balance." In order to restrain the expansion of the power and influence of the Li-Yang group, Deng Xiaoping adopted two important measures. One was to place Jiang Zemin, Li Ruihuan, and Song Ping on the Politburo standing committee, another was to make Jiang Zemin, who does not belong to the Li-Yang group, the general secretary [of the CCP].[5]

In a talk he had with Li Peng and Yao Yilin, Deng Xiaoping emphasized that the leading group should center on Jiang Zemin and [warned them] not to form small cliques out of lack of respect [to Jiang], saying that forming small cliques would come to no good end. Deng Xiaoping said that the new leadership group must not be incompetent, and this was pointedly aimed at Li Peng's incompetence. The Fourth Plenum established a new pattern in the ruling strata of the Chinese mainland; Deng Xiaoping used Jiang Zemin, Li Ruihuan, Qiao Shi, Song Ping, and others to counterbalance the Li Peng–Yang Shangkun–Yao Yilin group, whose power and influence has increasingly expanded. For Jiang Zemin, his power came neither from bestowal by the people, nor from intraparty democratic elections. Jiang Zemin's becoming the general secretary leaves quite a number of people "unconvinced." Sooner or later he will find that use of his power as the general secretary will face the same problems that his two predecessors, Hu Yaobang and Zhao Ziyang, faced.

Deng Xiaoping's Talk Presages the Certain Fall of Li Peng

The convention of the Fourth Plenum of the Thirteenth CCP Central Committee and Deng Xiaoping's recent talk indicate that, after the massacre and the massive roundup, in order to add moral force to the power built on the basis of military suppression, Deng Xiaoping will not only take over some of the slogans that the student movement and democracy movement put forward, but will sooner or later seek scapegoats and will sooner or later make an example of the stupid and incompetent Li Peng.

In the mutual relations within the "highest power circle," three possibilities exist in the future for mainland China.

The first possibility is that, in the face of new and stronger resistance, the forces represented by Jiang Zemin and the Li-Yang group combine and paper over their disagreements in order to present a united front against China's democratic movement. The second possibility is that, in order to expand its power further, the Li-Yang group stages a resolute resistance against the [power] pattern that was arranged at the Fourth Plenum by Deng Xiaoping, and seeks to undermine, through various means, the power and influence of Jiang Zemin, Li Ruihuan, and others.

The third possibility is that, at some appropriate moment, Li Peng and even Yang Shangkun will step down from office as scapegoats, so as to placate the hatred of the people for the massacre and the roundup. Deng Xiaoping recognizes that the student movement [was caused by corruption], indicating that "there would be a limit to the number of executions." Jiang Zemin also said that "we must strictly distinguish between two different sorts of contradictions, strictly carry out policies, and strictly do our work according to law." After the massacre and roundup, Deng Xiaoping, in his talk, wants to make clear to the people that he himself does not advocate wanton killing and wanton arrests, that responsibility [for such killing and arrests] is not his.

Among the three possibilities, owing to the extremely ruthless

massacre and suppression, it would be difficult for new and large-scale protests by students and civilians to occur; therefore, the first possibility is small. As to the second possibility, because the Li-Yang group has completely lost the confidence of the people, all their efforts to expand their power and influence will meet with the resistance and opposition of the whole people and cannot therefore succeed. Therefore, in the future, China's political situation will likely develop according to the third possibility. Li Peng's fall from power cannot be avoided and is merely a matter of time. Among the new standing committee members of the Politburo, Deng Xiaoping has already chosen the person who is to become the future premier.

The "Republic" Ought To Be Reconstructed

The struggle centered on the right to succeed to the supreme power will become an important feature of Chinese politics in the post-June 4 Massacre period. This will be a struggle for power carried out in the name of "ending quarrels" and "strengthening unity." Each person within the highest power circle on the Chinese mainland must work and talk with extreme caution at all times for fear of one's own problems being seized by the opponent. "The lifetime tenure system of the highest power holder" has fully exposed its mortal defect. Autocratic politics has come to its deadend in contemporary China. To this day, not only have 1.1 billion Chinese people come to realize the bitter suffering caused by autocratic politics, but the late Hu Yaobang, the Zhao Ziyang of yesterday, and today's Jiang Zemin and other Politburo members, have also come to be deeply troubled by this kind of unpredictable political danger. The iron law of autocratic politics is that power is not distributed according to contribution. Li Ximing and Chen Xitong, who did an "exemplary" job in the massacre, were not awarded more power.[6] The June 4 Massacre, at the price of the blood and life of thousands of people, has made more and more people realize that China must carry out a serious political reform after the overthrow of the Deng-Li-Yang

clique. At present, neither the word "socialism," nor the words "People's Republic" can hide the true nature of the modern autocratic system which has a tradition of thousands of years and has taken on new features. For the prevention of a recurrence of another June 4 Massacre or a revival of the "Cultural Revolution," for "democracy, freedom, the rule of law, and human rights," for the long-term stability of Chinese politics, [for a future in which] win or lose in a political struggle, one does not have to pay with blood, life, and liberty, China faces the following most pressing tasks. First, [we must] fully expose the true face of political autocracy and dictatorship on the Chinese mainland, completely unveil the false cover of the "People's Republic," and let more people realize that the China called the "People's Republic" is not a true "republic." Second, [we] must firmly and steadfastly overthrow the reactionary rule of the Deng-Li-Yang clique and struggle for the construction of a great republic that is both of the people and democratic.

Notes

1. Text in *Beijing Review*, July 10–16, 1989, pp. 18–21.

2. Peng, Lu, Luo, and Yang were seen as a clique and purged prior to the real onset of mass mobilization in the Cultural Revolution. Peng was mayor of Beijing, Lu was head of the party Propaganda Department, Luo was chief-of-staff of the army, and Yang, a member of the party Secretariat.

3. On Huang, Chen, Wu, Li, and Qiu, see Yan's "From 'Traditional' to 'Democratic Politics,' " included as Text 14 in this volume. Ye Qun was Lin's wife.

4. In the early stages of the democracy movement in 1989, Deng Xiaoping gave a highly critical and inflammatory speech on April 24, 1989 which became the basis for the April 26th *People's Daily* editorial, equating the demonstrations with turmoil.

5. Jiang, Li, and Song were added to the Politburo standing committee to replace the purged Zhao Ziyang and Hu Qili. All three were Politburo members prior to their elevation. Jiang and Li were key local leaders in Shanghai and Tianjin respectively. Song heads the CCP's Organization Department, and much of his career was spent in the State Planning Commission.

6. Li Ximing is a member of the Politburo and first party secretary of Beijing. Chen Xitong is a member of the Central Committee and mayor of Beijing.

26 | On the June 4 Massacre and China's Crisis

Editors' Notes: This is the record of an interview that Yan had with Du Nianzhong and Liang Dongping, journalists for *Zhongguo shibao* (China Times Weekly) (New York and Taipei). The interview, originally entitled "Zhao Ziyang weihe buneng zuzhi datusha?" [Why couldn't Zhao Ziyang prevent the massacre?] was published in the same journal, August 5–11, 1989, pp. 15–17.

* * *

Q.: You are both a participant in the democratic movement and a theorist in the social sciences on the mainland. It has been nearly two months now since the Tiananmen event occurred. How do you view that event in theory?

A.: The outburst of that crisis had indeed some unavoidable causes. Ten years ago, China realized the futility of a pure command economy and decided to embark on the road to a market economy. Over the ten years, the economic views of Chen Yun and Yao Yilin[1] were forced to the corner while those who advocated the market economy, including Zhao Ziyang, of course, and also Deng Xiaoping, gained the upper hand. In August 1988, Deng Xiaoping decided to "brave the barrier [of price reform]." This showed that he wanted a market economy and price reform. There was nothing bad with such an idea. It should be said that it was good to reform the price system. However, Deng Xiaoping

disregarded objective laws and insisted on "braving that barrier," thereby causing serious problems.[2] The failure of price reform and the outbreak of China's democracy movement shows another problem, namely the establishment of a market economy cannot be accomplished without clearly defining property rights. The so-called official profiteering and the unfair distribution [of wealth] were both due to the lack of a market basis. The basic reason was: an economy in which public ownership is dominant and property rights are ill-defined cannot be combined with a market economy. The democracy movement and the massacre that followed illustrate this point.

Q.: Can you please further explain the cause-effect relationship between the failure of the market economy and the massacre?

A.: My point was that, under the premise that public ownership must be dominant, and when property rights are ill-defined, the attempt to develop a market economy resulted in the phenomena of official profiteering and the serious unfair distribution [of wealth]. The phenomena of official profiteering and the serious unfair distribution caused resentment in people's hearts. Although reform was what the great majority hoped for, the outcome of reform brought on the wrath of the people. As a result, Deng Xiaoping's prestige has in fact been declining since the beginning of 1987,[3] and this decline is closely related to his inability to solve the problems of reform. Whether it was Deng Xiaoping or Zhao Ziyang, neither was able to solve the difficulties encountered in reform. Zhao Ziyang was in fact a weakling. Some people believed that our hope ought to be placed in him. But the weakness of Zhao Ziyang was closely tied in with his actual inability to solve the problems encountered in reform. Whether it is Li Peng, or Zhao Ziyang, or Deng Xiaoping, none of them has solutions for these difficulties. Zhao Ziyang's attitude was also basically this.

Q.: During his meeting with Gorbachev on May 16, Zhao Ziyang said that major affairs within the communist party were still decided by Deng Xiaoping. For the overseas community,

this forebodes the outburst of a succession crisis on the Chinese mainland. What is your view on this?

A.: It is a succession crisis. I say that Chinese politics is still dynastic politics. The most important problem for dynastic politics is the search for successors. All old imperial systems faced the problem of choosing successors for the imperial position. The most salient feature of imperial succession is that the successor-designate is changed after a number of years, always vacillating. Deng Xiaoping replaced Hu Yaobang with Zhao Ziyang, and now he has chosen Jiang Zemin. This is a very common phenomenon in imperial succession. I used a lot of space in my *On Leadership: A Comparative Study* to illustrate this point. The imperial succession in ancient Rome was rather like what is occuring now [in China]. It was not a hereditary, father-to-son transfer of power. Rather it was a search for the right successor; this search was often futile when [the leader] was quite old. Succession in the present-day Chinese mainland differs from the past in that the successor must be approved by the Central Committee of the Communist Party.

Q.: You said that the Li Peng government will fall within two years. Weren't you too optimistic? What was your evidence?

A.: The fall of Li Peng does not mean the reversal of the [official] verdict on the democracy movement of 1989. Moreover, whoever replaces him may still be against China's democracy [movement], taking an attitude of suppression toward the student organizations. Li Peng cannot in fact maintain himself for more than two years. In terms of more scientific estimates, [I] should say two years or a little longer. No one is a prophet. However, beset by problems both at home and abroad, that is, with the economy in extreme difficulties, faced with the opposition of the people, stained with blood all over, and condemned by world opinion, he cannot make visits abroad. He will in fact be tantamount to being the interior minister of state, possessing no ability to conduct foreign relations. This series of factors will prompt China's highest leaders to consider the question of whether or not to replace Li Peng. Consequently, we say that the

collapse of the Li Peng regime does not indicate the solution of the problems. Thus this is not an optimistic estimate.

Q.: There have been various speculations as to your relationship with Zhao Ziyang. Some say that your support for democracy also means support for Zhao Ziyang. Can you please clarify this issue?

A.: I do not have any relationship with Zhao Ziyang. Moreover, I support democracy. As I just said, the fall of Zhao Ziyang had deeper reasons. His so-called theory of "the primary stage of socialism" is wrong in itself.[4] He himself realized that even if he held power he could not solve the economic problems. The reason lies exactly in the [theory of the] primary stage of socialism. For, if a theory is not trusted by the people, problems will follow. China at present still needs theories, but the theory of the primary stage of socialism was a mere basket into which everything was thrown in. In this way, the theory cannot stand up to scrutiny. This is the way that Zhao Ziyang and Deng Xiaoping work; the so-called "one center and two basic points" is entirely unscientific.[5] Although Mao Zedong's theory of "continuing the revolution" was wrong, it was complete and could be put into practice in some sense, that is, to wipe out his opponents. Zhao Ziyang's theory is a mixture and is incapable of solving any problems. Therefore, in the face of these difficulties, Zhao Ziyang appeared weak and helpless.

Nevertheless, Zhao Ziyang would not adopt such brutal tactics [as used in the massacre]. He still retained the spirit of humanism and was humane. He represented the more enlightened faction within the communist party, but he was not a democrat. My conclusion about Zhao is: he is a humane and open-minded leader and he made contributions to reform and opening, but his understanding of democracy is rather poor. In addition, he did not dare to stand up before the masses and this was one of the reasons for his failure.

Notes

1. Chen and Yao are two older conservative officials who favor combining planning with the market, with the market in a subordinate position.

2. Price reforms were introduced in the summer of 1988, and contributed to a sharp rise in inflation.

3. Presumably a reference to Deng's demand that Hu Yaobang resign as general secretary in January 1987.

4. A major thesis in Zhao's report to the Thirteenth Party Congress in October 1987. It stated that China would be in the primary stage of socialism for a considerable length of time and anything which contributed to China's development was acceptable.

5. One center: adhere to the leadership of the communist party. Two basic points: 1) adhere to socialism, 2) adhere to reform and opening.

Index

David Bachman is an Assistant Professor of Politics at Princeton University and the author of *Chen Yun and the Chinese Political System* (1985) and *Bureaucracy, Economy and Leadership: The Institutional Origins of the Great Leap Forward* (1991).

Dali L. Yang is a doctoral candidate in the Department of Politics at Princeton University. He is the editor of *Zouxiang minzhu zhengzhi* (1990), a Chinese edition of Yan's writings.